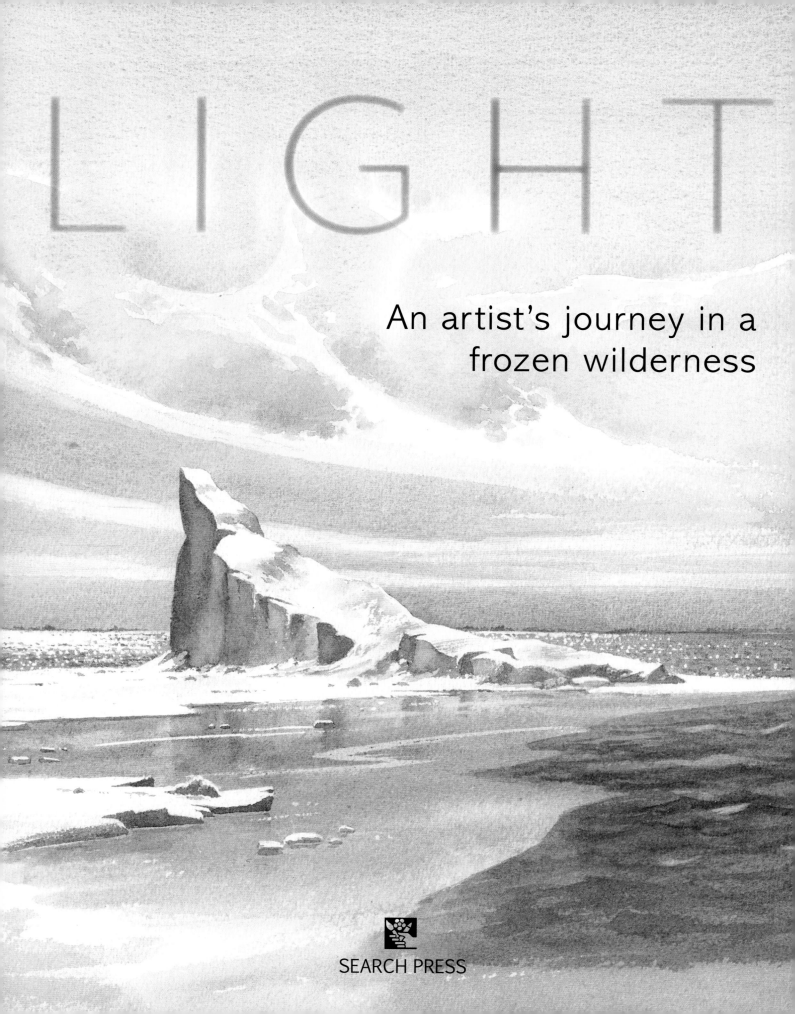

LIGHT

An artist's journey in a frozen wilderness

SEARCH PRESS

Suppliers
If you have any difficulty obtaining any of
the materials and equipment mentioned in
this book, visit the Search Press website for
details of suppliers:

www.searchpress.com

You are invited to visit the author's website
at: www.davidbellamy.co.uk

ACKNOWLEDGEMENTS

I would like to thank Katie French, Head of
Editorial at Search Press, for her enthusiastic
commissioning of the book, Juan Hayward for
the design, Sophie Kersey for editing my rambling
text, Jenny Keal, Glenn Morris for the loan of
his Arctic artefacts, Kim Petersen of World of
Greenland Arctic Circle, Torben Sorensen for
information, photographs and much-appreciated
support, Mark van Weg, and Will Williams for
his photographs.

Page 1:
GHOSTLY ICEBERG
AND FULMAR

Pages 2–3:
THIN ICE

Below:
MUSK OX IN BOG COTTON

Opposite:
PACK ICE

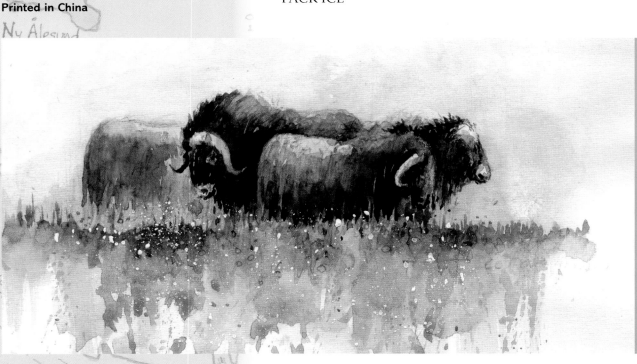

Contents

INTRODUC

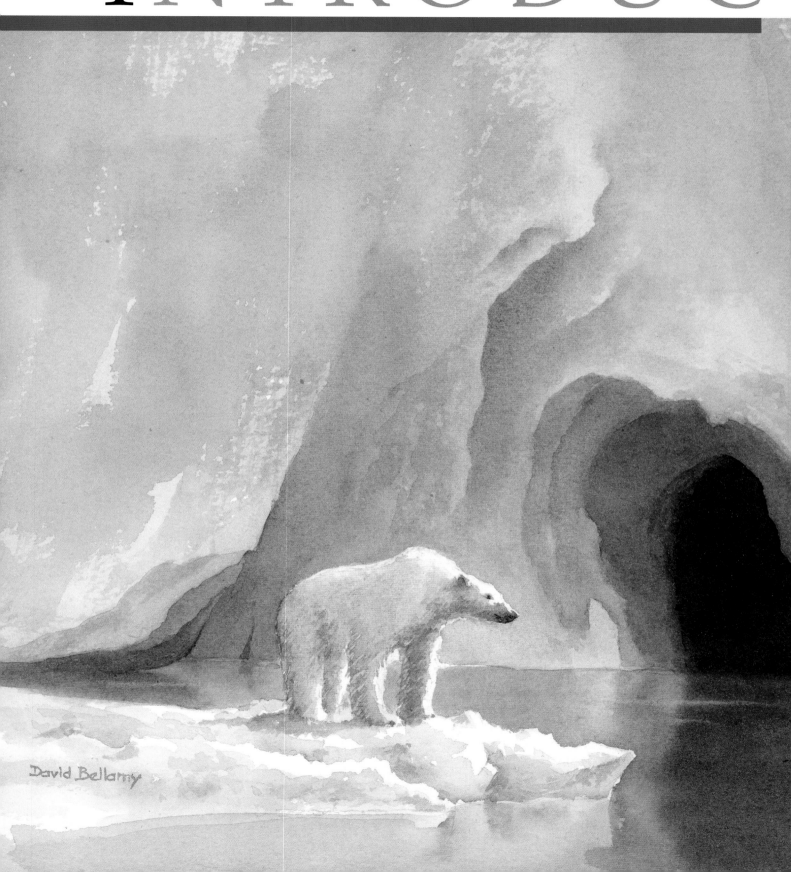

David Bellamy

TION

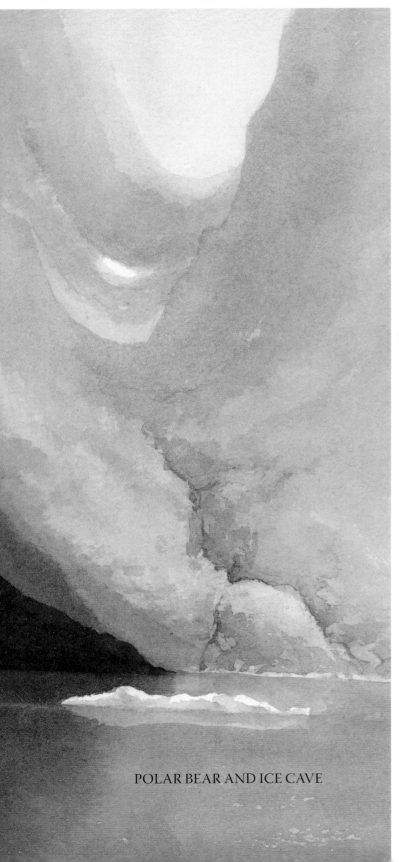

POLAR BEAR AND ICE CAVE

The mist has closed in to a complete whiteout. In deep snow, I can't make out anything other than my feet, and although I am standing just outside the settlement, the absolute silence and my inability to see anything are unnerving. Not too far away lies the polynya – a stretch of open water that is a great attraction for polar bears with its abundance of ringed seals, and I am aware that a bear has been spotted this morning. In North America my appalling singing certainly dampened the grizzlies' appetite for something artistic on the menu, but would it work here? In this mist, even having a gun would be pretty hopeless, as you wouldn't have time to aim and fire before something big and nasty came flying at you out of the all-encompassing white. A faint glimmer of light shimmers through the mist, getting stronger, till sunlight gleams off a snowy mound – probably an upturned boat buried in the winter snows – and I can see my way back into Ittoqqortoormiit, past lines of chained huskies.

This experience is part of everyday life in the remote settlements of the Arctic, where people are more attuned to nature than those in Europe. Wild places have always played a major role in my work and I revel in travel to the more extreme landscapes, whether mountain, desert or Arctic scenery. While my main purpose has always been to seek out the landscapes, it is always, without fail, the peoples of these remote places that have the strongest impact. In my sojourns in the Himalayas, the Andes, Africa, or wherever, I have probably encountered more wildlife than in the Arctic, but here the polar bear, walrus and musk ox in particular have imparted a profound sense of fascination and awe that I have rarely found elsewhere – perhaps only in Africa.

However, the combination of wildlife in the raw icy world where survival is toughest, and the stunning beauty of the mountains, fjords and glaciers give the Arctic an edge that is so appealing, it lures me back again and again.

There is also something special about the profound silence of the Arctic, so striking and obvious to anyone who has visited. There we can detach ourselves from crude civilisation and contemplate life in the utmost peace. 'Nature's peace will flow into you as sunshine flows into trees,' as naturalist John Muir so eloquently put it in his book *The Mountains of California*, 1894. Wherever I am, I often sit silently sketching, and wild creatures approach me, unaware of my presence until they suddenly spot me and gaze in wonderment as I look back, statue-still. Doing this in the polar wastes gives me an even greater sense of detachment, and as silence is precious to me, I value these intense and solitary moments. I recall with deep affection so many times in the settlements where I have sat and worked in extreme peace and contentment, looking out on unadulterated Arctic scenes as I painted or wrote.

CALVING GLACIER

Although the vessel appears to be close to the glacier, it is in fact some distance away. A calving of this magnitude would cause a minor tsunami.

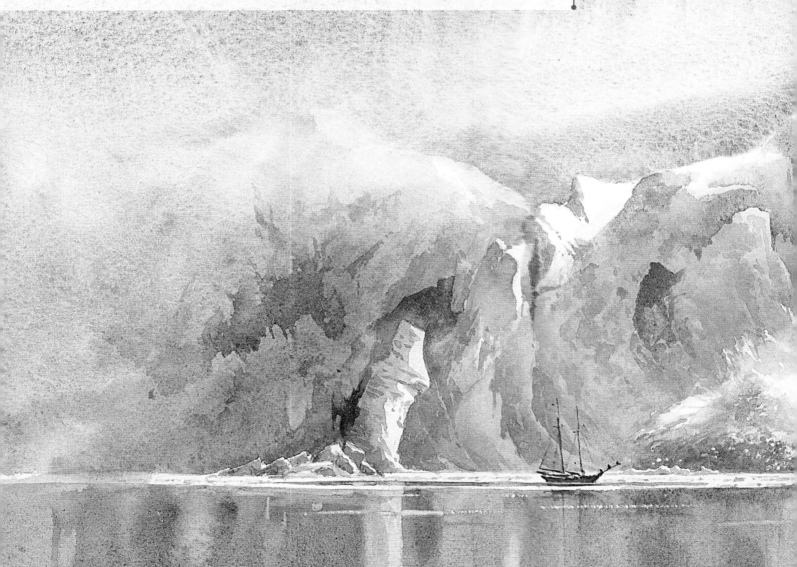

David Bellamy

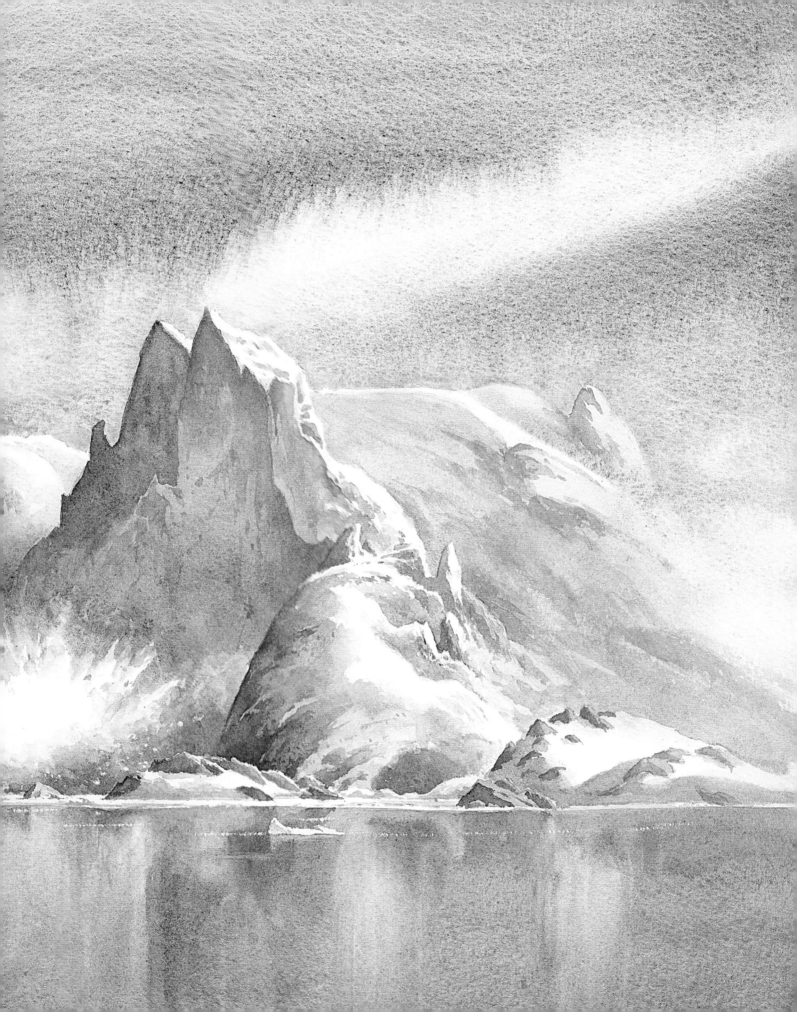

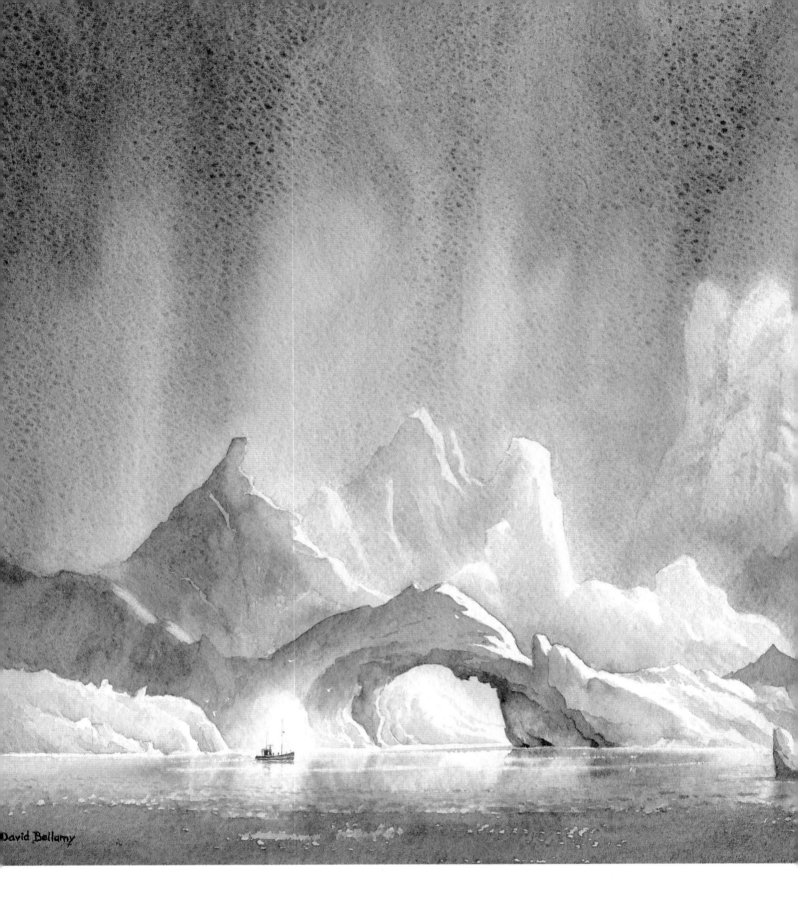

David Bellamy

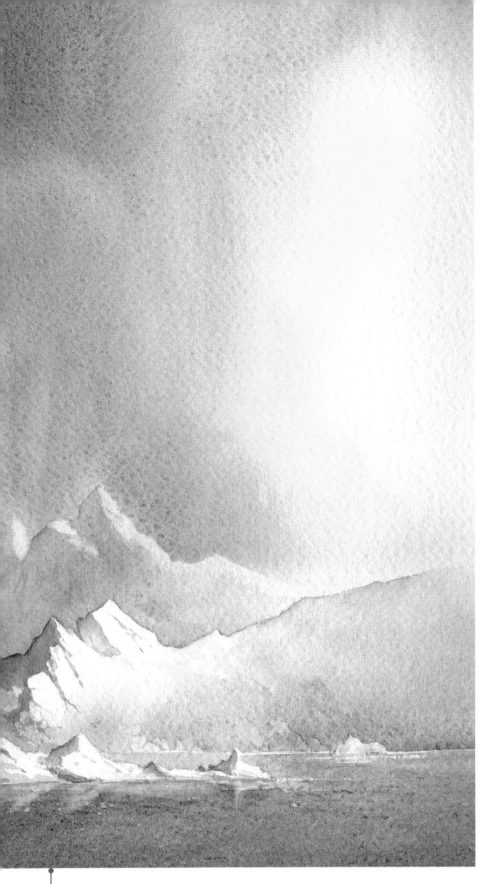

MOUNTAINOUS ICEBERGS, ILULISSAT, WEST GREENLAND

Without the boat, the incredible size of the icebergs would not be apparent.

My visits and expeditions to the Arctic have always been of my own making: I have never sought sponsorship or to join official enterprises. I prefer to choose companions who are good company and trustworthy, and to have greater control over where I go and my prime objectives, despite the increased expense. One downside is that the established officialdom tends to regard the loner with a certain amount of suspicion – where did he come from? Thus, they can be rather wary of you when you approach them with an eye to cooperating post-expedition. Travelling on a cruise ship is not for me, as I can't stand the feeling of being unable to get out into the rough stuff, or meet the Inuit, and again there is little control over where one goes.

I relish the meticulous planning of the expeditions, which is critical, as much can go wrong: forgetting a vital piece of gear can be disastrous, and the equipment must be of the highest standard for such rough work and, at times, extreme conditions.

I regard myself as incredibly lucky to have had several great companions on my trips, all of whom have added immeasurably to the enjoyment of the expeditions. Meeting the locals is, to me, an important aspect of the journey, and without exception we have always been given a great welcome in the polar north. Engaging hunters as guides is immensely rewarding, even when you don't speak the same language. A smile and a piece of artwork go a long way, and you pick up so much from these fascinating people. I find that some seek me out when I am working in a settlement, as they are curious about what I get up to with my sketching, especially if I am drawing one of the local characters.

These encounters often lead to hilarious and enriching outcomes.

My normal way of working is to sketch on location and work up the paintings back home in the studio from these sketches, supported by photographs. If you are interested in my working methods, you will find more about this in the Sketching and Painting in the Arctic chapter, page 160. Before going to the Arctic, I had been doing this in various countries for many years. All my paintings are from first-hand experiences, and a great many have a tale to tell. Nothing appeals to me more than being able to wander freely in remote places and sketch the scenes I love. Being close to nature is vital for me: nature washes away the cares of life and energises me in so many ways, especially in my art. It is unforgivable that so much of the natural world is being trashed even by those who propound the need for conserving our environment, and many

in government do not seem to recognise that some of their so-called green remedies are actually making things worse. Like Britain's Royal Navy during the golden age of exploration, they prefer to go their own way and ignore the often superior knowledge and methods of the local inhabitants. In fact they show not only a gross irresponsibility towards the natural world, but great ignorance about it and no little desire to profit from it.

Sadly the Arctic is becoming something of a punchbag for the developed nations, for the loss, over recent years, of larger areas of the Arctic ice is encouraging greater exploration for oil and minerals, with the inherent threat of conflict of interests as well as environmental damage. Many Greenlanders, for example, welcome a warmer climate, as this will enable them to grow vegetables – a huge problem especially in East Greenland, which few supply ships are able to reach on a regular basis – and warmer Greenlandic waters

ON SERMITSIAQ GLACIER

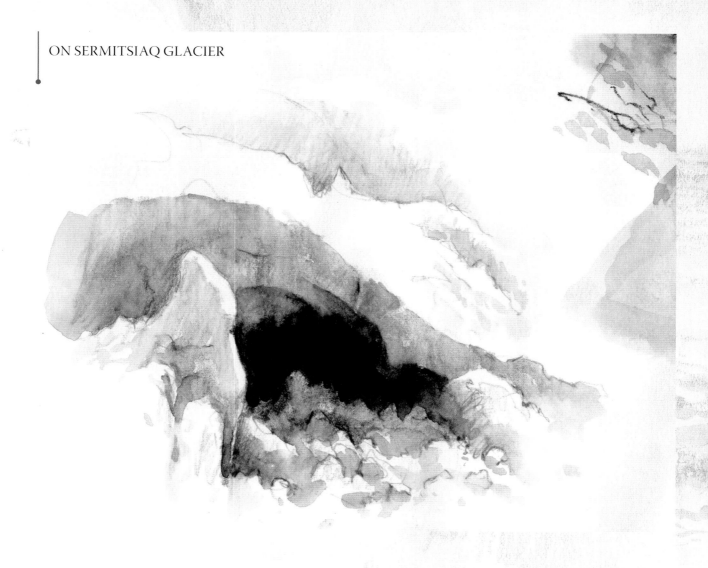

are enticing more fish. Locals argue that oil and mineral extraction would provide jobs and more wealth for a country not known for a lavish lifestyle or strong economy, and with the highest suicide rate in the world – though exactly how much these industries would benefit the locals or the economy is uncertain. Even subsistence hunting is on the wane, though less so in East Greenland – seals are killed for food and are a staple diet for huskies, but when the Inuit women make sealskin artefacts, a by-product of the seal hunting, they find resistance in the West to buying such items. The Inuit have always been adept at making the most of every part of the creatures they have to kill for their very existence, and could certainly teach us a thing or two about recycling. If the developed nations are to insist on having things their way, it is imperative that they aid the Greenlanders and don't pillage the country of its assets, with no benefit to the locals.

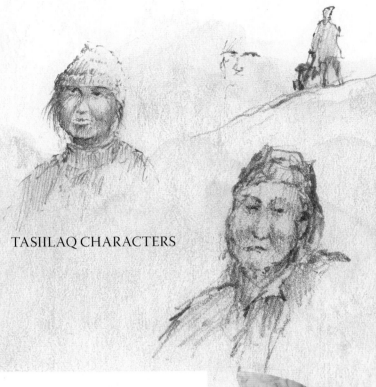

TASIILAQ CHARACTERS

WALRUS STUDIES, POOLEPYNTEN

I managed to cover several pages with drawings of walruses. On this page, some were abandoned, but most provide interesting detail. I particularly liked the juxtaposition of the two where one is lying down and the other appears to be sitting telling a bedtime story.

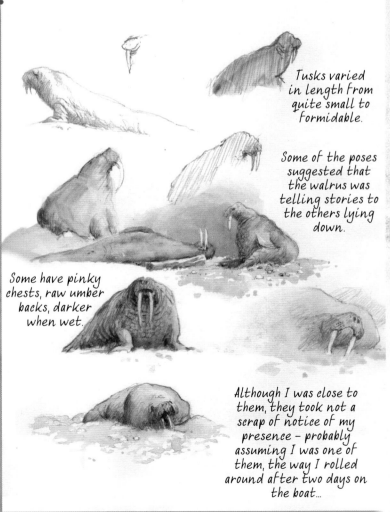

Tusks varied in length from quite small to formidable.

Some of the poses suggested that the walrus was telling stories to the others lying down.

Some have pinky chests, raw umber backs, darker when wet.

Although I was close to them, they took not a scrap of notice of my presence – probably assuming I was one of them, the way I rolled around after two days on the boat...

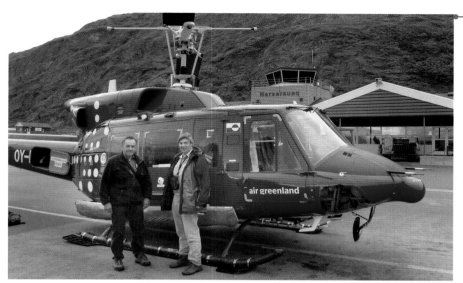

TORBEN SORENSEN AND THE AUTHOR
About to take off into the wild yonder.

KAP DAN, KULUSUK AND OUTLINE MAP OF GREENLAND
The map shows the locations from which our expeditions started, plus Nuuk, the capital.

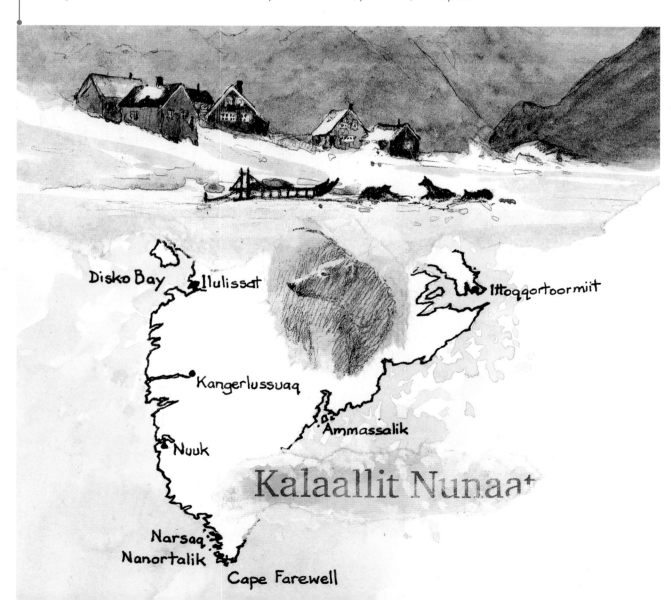

Disko Bay
Ilulissat
Ittoqqortoormiit
Kangerlussuaq
Ammassalik
Nuuk
Kalaallit Nunaat
Narsaq
Nanortalik
Cape Farewell

Wilderness is shrinking all over the world, as so many are ignorant of its true value: every bit we lose is gone forever. My aim in this book is to highlight the beauty of the Arctic, in particular the Scandinavian Arctic in Greenland and Svalbard and touching on parts of Norway and Iceland. It is a celebration of these amazing places, of the people and wildlife, and much more.

I am not going to join in the current vogue for predicting what will happen there in the next fifty or hundred years. That I leave to the computer-model aficionados, though the quality of their results is heavily dependent on the quality of the input data. At times, nature shows a fine capacity for confounding man's desire to control her, and usually for the better. Long may this be so.

TUPILAK

These grim talismans were once made by the Inuit to seek out and destroy enemies.

FAMILY OUTING ON THE GLACIER

I looked up from my sketching on the glacier and beheld a pair of barnacle geese wandering across the ice with three little ones – quite irresponsible of these parents, taking their young to such a dangerous place!

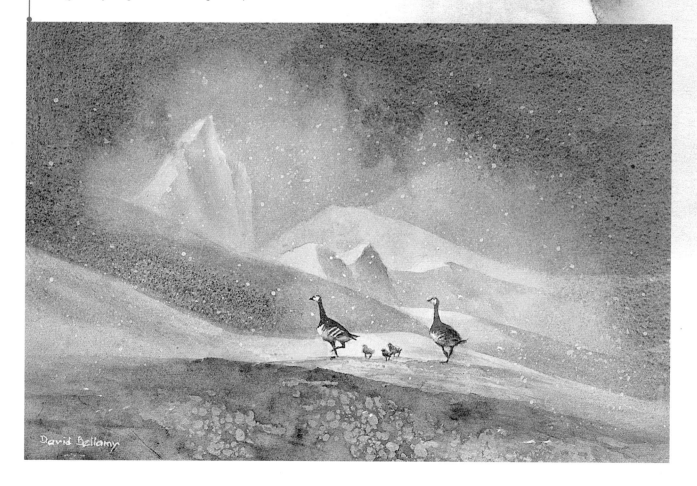

David Bellamy

SKETCHING ADVENTURES IN THE ICE

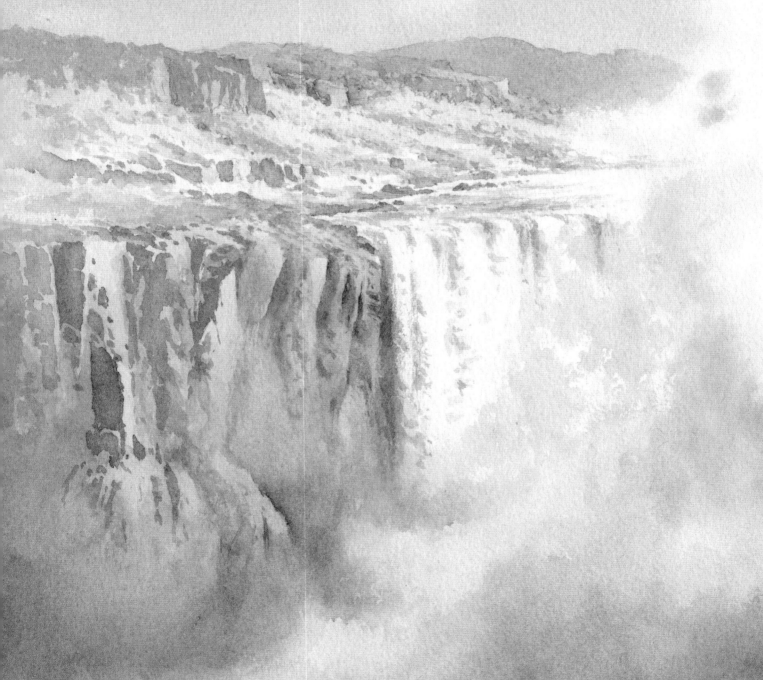

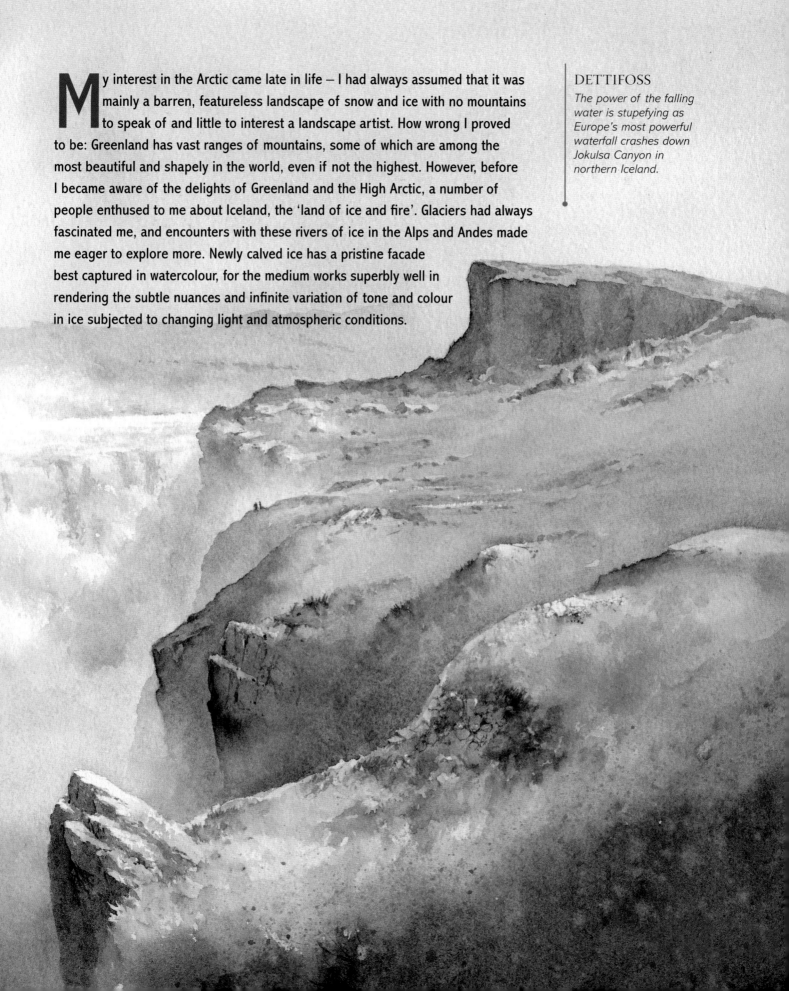

My interest in the Arctic came late in life — I had always assumed that it was mainly a barren, featureless landscape of snow and ice with no mountains to speak of and little to interest a landscape artist. How wrong I proved to be: Greenland has vast ranges of mountains, some of which are among the most beautiful and shapely in the world, even if not the highest. However, before I became aware of the delights of Greenland and the High Arctic, a number of people enthused to me about Iceland, the 'land of ice and fire'. Glaciers had always fascinated me, and encounters with these rivers of ice in the Alps and Andes made me eager to explore more. Newly calved ice has a pristine facade best captured in watercolour, for the medium works superbly well in rendering the subtle nuances and infinite variation of tone and colour in ice subjected to changing light and atmospheric conditions.

DETTIFOSS

The power of the falling water is stupefying as Europe's most powerful waterfall crashes down Jokulsa Canyon in northern Iceland.

Iceland, of course, falls several cricket pitches short of the Arctic Circle, but at this time I was not contemplating any Arctic expeditions. Iceland would, however, supply me with ice by the cart-load, and maybe even a volcanic eruption. Alas, nobody seemed interested in joining me, as most folk were wary of sitting on a freezing glacier while I carried out a protracted watercolour. Catherine, my daughter, however, was young and fit, and enjoyed exploring wild regions. She could easily keep up with me on difficult terrain, although she doesn't normally sketch.

After the warm weather of a holiday in Thailand, she suddenly found herself on a patch of lava-black Icelandic moonscape, surrounded by blackened and distorted lava-demons, statuesque and eerie in the mist, while rain and sleet sliced horizontally across this inhospitable prospect with the impact of Thor's hammer. But the Icelandic weather changes rapidly, and soon we were in sunshine.

CATHERINE IN FRONT OF A SMOULDERING LANDSCAPE

FUMAROLE ON NAMAFJALL, ICELAND
Sulphurous gases escape from this fumarole through minute vents in the volcanic mountain.

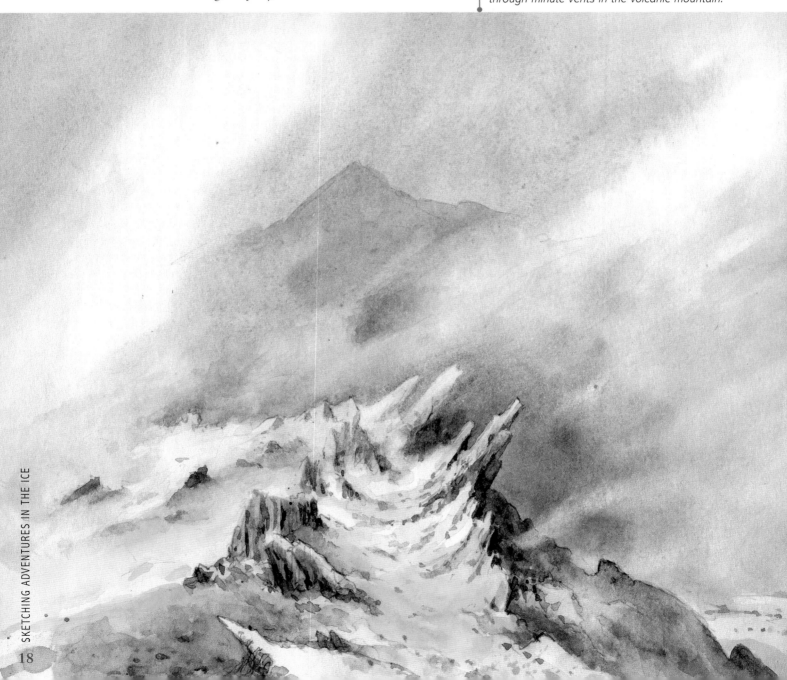

Blafjall from Dimmuborgir lava fields, black and bizarre!

BLAFJALL AND LAVA PINNACLES
Sadly no trolls greeted us in this landscape bordering on the primaeval.

Settlement in Iceland began in the 9th century when Norwegian Vikings arrived, although they found a number of Irish monks had actually beaten them to it. The country came under the sovereignty of Norway in 1262, then, with Norway, under the Danish Crown in 1380. In the late 16th century, Bishop Gudbrandur Thorlaksson drew a comprehensive map of the country, including glaciers and eruptions. Like many early cartographers, he let his imagination run riot when he turned his attention to the sea areas. He showed them swarming with the most weird and wonderful sea monsters of all descriptions, though most appear grotesquely lascivious rather than fearsome. To the northeast, a veritable army of polar bears on ice floes are approaching the Icelandic coast, and again the good bishop imbued some of these with a hint of naughtiness. In fact it is only occasionally that a polar bear finds its own way to Iceland these days.

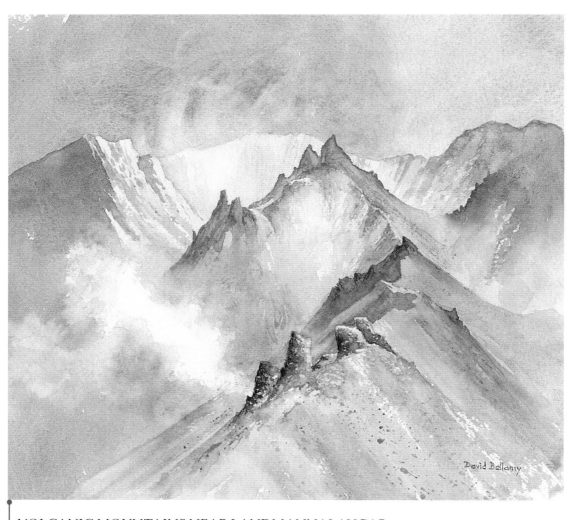

David Bellamy

VOLCANIC MOUNTAINS NEAR LANDMANNALAUGAR
From the black lava foothills of Hekla to the exotic colours of these peaks near Landmannalaugar, the Icelandic vistas continually leave you gasping for superlatives.

By the end of the Second World War, Iceland had become an independent republic. As it is one of the most active volcanic areas in the world, the topography undergoes slight alterations every few years.

At Reykjavik, Catherine and I found much of the bus station tastefully wrapped in cling film for some reason, and what appeared to be cow-dung sculptures arranged in silver foil – could this be some giant Icelandic public art expression? Alas, no one could provide an answer. The local service bus drivers enjoy a good laugh with the tourists: after passing through miles of stunningly beautiful scenery with one idyllic composition after another, they will stop in the most hideous and barren locations and announce a 'camera-stop'. Everyone obligingly gets out, looks around, snorts with derision and gets back into the bus. Icelandic buses drive up boulder-strewn riverbeds and savage gorges rather as we do our motorways, which makes them infinitely more interesting.

The absolute rawness of this tortured landscape, much of it newly formed and still hot two years after the last eruption, confronts the artist not only with intense lava black and snow white, but just about every other colour in between. Traversing this prospect torn from the bowels of Hell can be tough in places, but it is always exciting and full of interest. Without exaggeration, the Leirhnjukur lava field conveys the impression of being the world in its most primordial state. Trees are non-existent, replaced by the distorted shapes of bent hags, twisted creatures from the underworld, or lurking monsters of petrified lava that populate many Icelandic landscape paintings, often accompanied by trolls, elves and bog-eyed goblins. It is easy to become fixated with these visual imaginings when steam rises out of the ground or boiling liquid spurts forth from spiteful holes, accompanied by gurgling, spluttering and other unseemly noises from the bowels of the earth, like

a whole battery of witches' cauldrons. So obsessed are Icelanders with trolls that many place names incorporate the word 'troll', and images of these fascinating creatures adorn many tourist souvenirs.

Catherine was so fascinated by the strident colours in some rock pinnacles that she borrowed a set of my watercolour pencils, returning all forty a little while later looking as though they'd been through a tree shredder.

The icebergs in the Jokulsarlon Lagoon in East Iceland were the first I had ever encountered, and though miniscule in comparison with many Greenland ones, they fired me up with excitement. Watercolour is the medium sine qua non for sketching ice, and at Jokulsarlon, I had a field day. Here I found dramatic shapes and fascinating colours that changed when the iceberg moved, and no great need for precision. Changing mist with breaks of gentle sunshine added considerably to the mood. I peered through holes and tunnels in the ice, into light that transformed them into many-coloured jewels, sparkling where sunlight caught sharp edges, incandescent with breathtaking purity where the light glowed through a thin translucent shell of ice. Icebergs are a most efficient reflector of light, bouncing back beautifully subtle flashes of white against deep shadows of blue and turquoise. Within minutes I was hooked on them as a painting subject.

We climbed stunningly vari-coloured mountains, festooned with the most wonder-inducing pinnacles, deep red and grey, that looked as though they had just been plucked from the fires of Hell, and gasped at a drop so sheer that a tube of Payne's gray tossed over the edge would not hit anything for over 610m (2000ft). With heavy packs, we hiked inland to a lake with more icebergs floating around. To reach the start of the inland hike, we were transported on an ancient bus abandoned by the Americans after the Second World War, and drove through several large rivers, as there was a distinct lack of bridges,

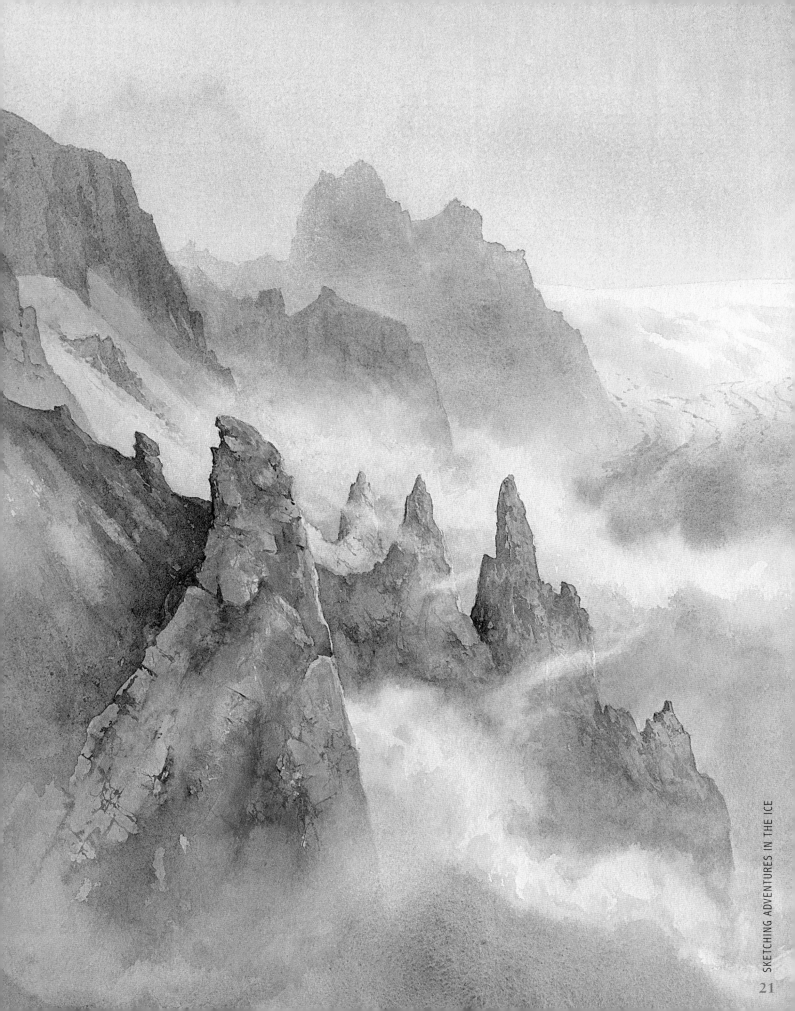

roads or signs saying 'Beware of Death,' on which our own Health and Safety Executive would surely have had something to say. We would have been swept away on foot, like spiders down a drainpipe. The bus had an extremely high wheelbase and bounced off many a submerged boulder. 'Am I dreaming this?' I thought, for it seemed so unreal. The driver would return for us in a few days' time, and our route back would end in a disturbingly steep descent down a side canyon. 'There are several,' said Hannes Jonsson, the driver and owner. 'Just make sure you can see the bottom of the one you are descending!'

The hike took us over rough terrain, past enormous waterfalls and wild canyons of the Nupsstadarskogar, where you half-expect trolls, monsters and mythical beasts from Nordic legends to appear from behind the falls. After two days we reached Graenalon Lake with its icebergs and bleak backdrop of mountains and the vast Vatnajokull ice cap, the largest glacier in Iceland. At times the icebergs explode like a cannon firing, and a piece the size of a block of flats may fall off and form another iceberg. Not far to the north of Graenalon lies Grimsvotn, sinister in both name and deeds: beneath this vast depression and its lake lies a subglacial volcano. Violent glacier bursts occur about once every five years, when water forces its way under the Skeidararjokull Glacier and causes extreme flooding in the coastal plain. These bursts are

SNOUT OF NORDURJOKULL GLACIER

Here at the end of the glacier, a stream issues forth into Hvitarvatn Lake through a chaos of rock and ice debris.

Icelandic Culinary Delights

While there is plenty of variety of food in Iceland, some of the more traditional dishes can take some swallowing for those of us with a delicate stomach. Why I plucked up the courage to try rotten shark meat, I don't know. It is known as *hakarl*, and the meat is buried in the ground for up to six months to release its toxicity. It is so ghastly that wildlife won't touch it, and when it sits on your plate smelling like a stale urinal, you wonder why you ordered it. Perhaps this partly explains why W. G. Collingwood, the artist, author and antiquary from the English Lake District said in his *Letters From Iceland* in 1897 that he was 'riding tired horses, painting hurried sketches, eating nasty food and sleeping in close and stuffy holes'.

When I took a painting group to Iceland, Anna, our local guide, explained, 'You will see puffins.' 'Oh, they are so nice!' said Jill, one of the painters. 'Yes, they are very tasty!' Anna replied, making everyone groan. The puffin is a delicacy in parts of Iceland. More acceptable to those of us lacking the Viking tradition is the Icelandic twisted doughnut, or *kleinur*. A bag of these will maintain energy while you walk and sketch, but apparently they are time-consuming to bake and need to be fried in sheep tallow for the authentic taste. There appear to be various ways to twist them and my sketch illustrates a delicious-looking example found in a cafe in south Iceland.

ICELANDIC TWISTED DOUGHNUT
This delicious-looking morsel, if not exactly cuisine minceur, will rekindle your energy when hiking the Icelandic peaks.

A whiter snow strip snaking across the glacier betrays the hidden crevasse, though they are not always so easy to spot. Also visible are dirt cones formed by deposits that protect the ice underneath from melting as rapidly as the surrounding area.

called jokulhlaups and can destroy everything in their path, including massive girder bridges that usually end up in a tangled mass of metal.

The weather stayed fine and the tent dry, and our wild campsites were always in pleasant spots, beside a stream or river amidst uninterrupted peace and beauty. Heading south, we skirted the western edge of the Skeidararjokull Glacier with imposing views across to the shapely Skaftafellsfjoll summits. On the last night, the tent stood with a backdrop of shapely peaks and a scattering of pink Arctic River Beauty (*chamerion latifolium*) in the river bed beside us. In Greenland the Inuit use the flower as a tasty salad to accompany walrus blubber steaks. Next day we enjoyed an exhilarating canyon descent and met up with Hannes Jonsson on time.

Glaciers and crevasses were fairly familiar terrain to me, and Icelandic glaciers are a joy to explore. Surprisingly these can be predominantly black, rather than white, as a result of the enormous quantities of lava dust that are thrown out by volcanic action. Some glaciers, such as the Nordurjokull, are festooned with miniature black slag heaps, a phenomenon caused by deposits of lava dust protecting the ice from the sun, so that the surrounding ice melts more rapidly, leaving a sharp peak in the shape of a shark's fin standing proud of the surface.

We hired a guide to accompany us on the Svinafellsjokull Glacier. Guides usually know where the more exciting ice formations are located and can save countless hours of searching for interesting features to sketch. I briefed Elin to find us 'something really nasty with a fascinating ice bridge or pinnacle in the middle'. She belayed me with an ice anchor as I climbed down into a deep crevasse to sketch a dramatic view of a natural bridge of ice. There is something profoundly satisfying about whanging an ice axe into the ice, possibly stemming from the desire to hit something and release aggression, but as my axe hit this concrete-hard, centuries-old ice, it sent a stab of pain up my arm, the pick biting only a few millimetres into the ice. The front points of my crampons dug in no further, so I hung above a vertiginous abyss on just a sliver of ice. Not at all comforting, either mentally or physically. Nevertheless, I was able to hang on, sketch and

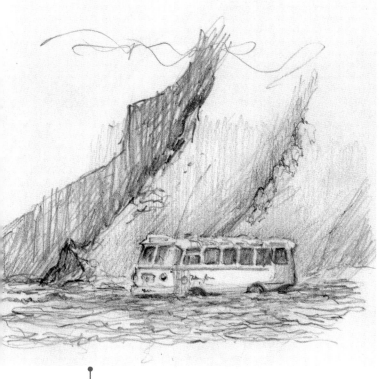

HANNES JONSSON'S BUS CROSSING THE NUPSA RIVER

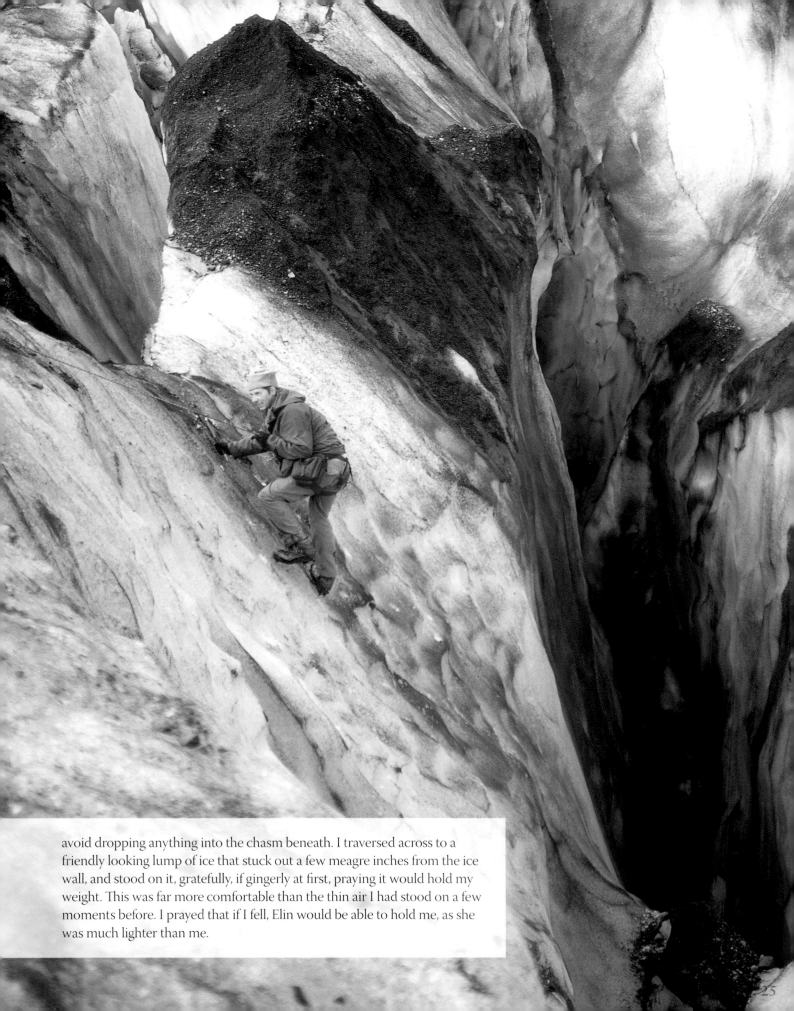

avoid dropping anything into the chasm beneath. I traversed across to a friendly looking lump of ice that stuck out a few meagre inches from the ice wall, and stood on it, gratefully, if gingerly at first, praying it would hold my weight. This was far more comfortable than the thin air I had stood on a few moments before. I prayed that if I fell, Elin would be able to hold me, as she was much lighter than me.

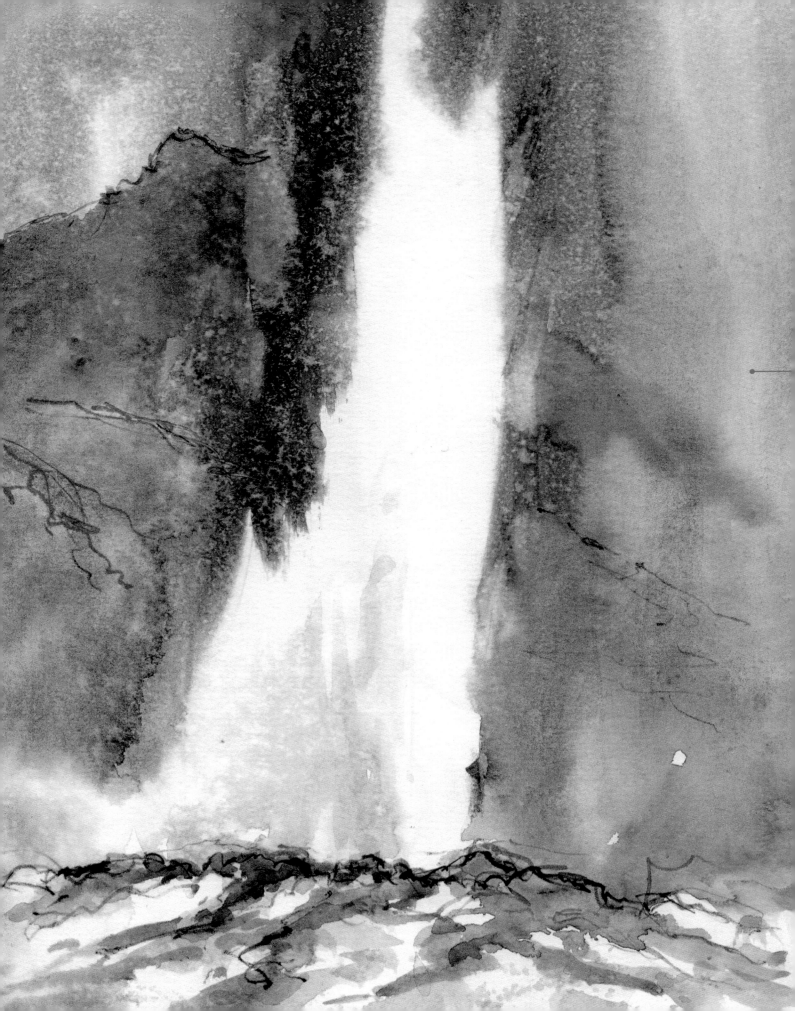

STROKKUR GEYSER

This is a demonstration sketch for a painting group, a rather rash undertaking given that the geyser is visible only for seconds every seven or eight minutes. In addition to my group, the place was packed with tourists. After positioning myself so that the white spume would rise against a dark background, I wetted the paper and loaded the brush with the dark colour of the hill beyond. We waited, but Strokkur is not to be rushed. I re-wetted the paper and waited. The tourists listened to my commentary and gazed in obvious incomprehension. Suddenly the geyser shot up and I applied the brush vigorously, creating a soft-edged column of white, then immediately drew into the wet paper using a black watercolour pencil to represent the rough ground around the geyser hole. Finally I gave the sketch a squirt of clean water from a spray bottle and it was finished. The tourists remained confused.

Extracting sketchbook, pencils, brushes, paints and water pot to work in such a ridiculously exposed and cramped position would test the most devoted alfresco watercolourist. This was the most perilous moment, as I had to let the ice axe drop on its strap and balance precariously while I retrieved the sketchbook from my waist bag. There was just enough of the ice lump to keep me in place without resorting to the axe, provided I didn't lose my balance. Gymnastics and tight-rope walking were never my strong points at school. On this occasion I decided to stick with a simple pencil rather than a full palette of watercolours. This was not the place to drop the sketchbook, already heavy with many sketches, the loss of which would be disastrous. If I lost a pencil, it wouldn't matter too much. In these situations, where you are conscious that every move has to be calculated carefully and you must keep reassessing your position for safety reasons, you need to work cyclically: observe the feature; respond with a few strokes of pencil; check your position is OK, the belayer is keeping the rope taut and the stance is firm; shake a leg slightly, then go back to observation, and so on until the sketch is complete. I usually photograph the scene first, then sketch. If I am using the larger sketchbook, then the awkward task of removing my rucksack, extracting the book and then either clipping the rucksack onto the rope with a carabiner or heaving it onto my back, is much worse. On this occasion I managed reasonably happily with the gear in my waist bag. The pain in my left leg increased as it took the brunt of my awkward stance, but this was not the place for knee-jerk responses, or even a quick scratch. A few more swipes of the pencil and I had enough visual detail. With the gear packed away, I was soon whanging my way back up the vertical ice wall, checking the security of each axe or crampon hold in the rock-hard ice before making the next move.

One morning, Catherine decided to relax in the tent and read. I took the opportunity to cross to the nearest glacier to seek out features to paint around the glacier snout. I soon came across a natural ice bridge spanning a fast-flowing glacial river. I began sketching and became totally absorbed in the subject, unaware of my precarious position. Until now the ground had appeared to be stable, with a lot of rock debris lying around and patches of old ice showing through here and there. Well into the watercolour sketch, I suddenly felt the ground begin to lurch ominously. Concerned, I applied another wash to the sketch rather more quickly; then again the ground I was standing on shook violently. Survival instinct took over and I grabbed all my painting gear, but a sudden drop in the level I stood on, together with an evil-looking crack in the disintegrating ice, threatened to cut me off from

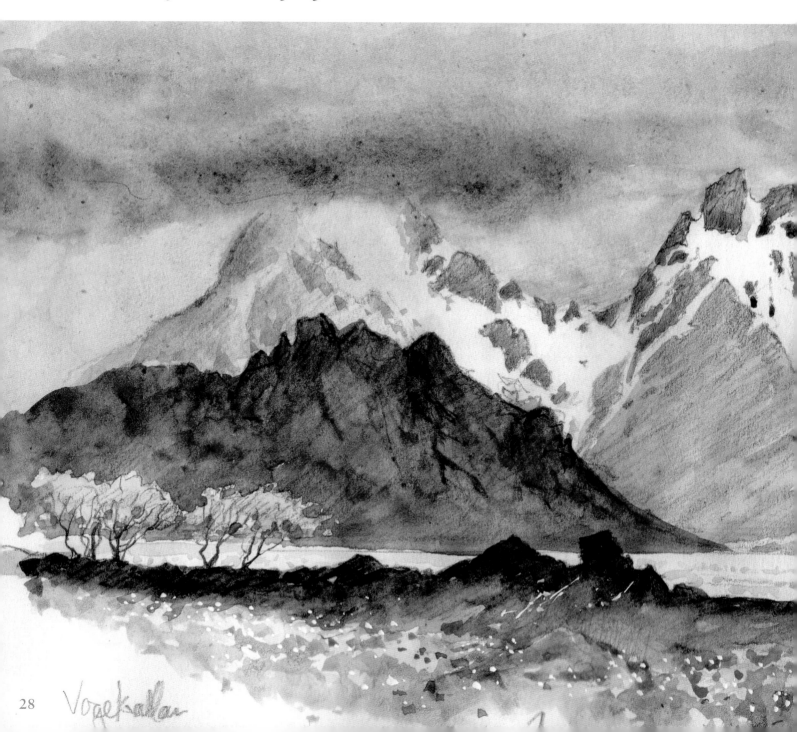

Vogeksallan

safety. The next watercolour glaze was achieved in record time, somewhat less than perfectly, as the ground beneath me tilted inexorably towards the wild-flowing glacial water, which looked dark, deep and decidedly cold. Once in, how would I get out of that mass of icy water that would probably drag me under the ice shelf? It was time to go, in fact to make the mother of all leaps from a standing position, sketchbook and no. 10 sable brush firmly in hand.

I would return to this extraordinary landscape, as Iceland has so much to offer the landscape artist. The pull of the northlands was becoming irresistible. Following this Icelandic interlude, despite serious deliberations to abandon life-threatening subjects and simply paint in flower meadows, I sought out the Lofoten Islands in Norway. Taking a painting group there

VAGAKALLEN PEAKS, LOFOTEN ISLANDS

Although the Lofoten peaks are not of great height, they appear spectacular and make handsome subjects.

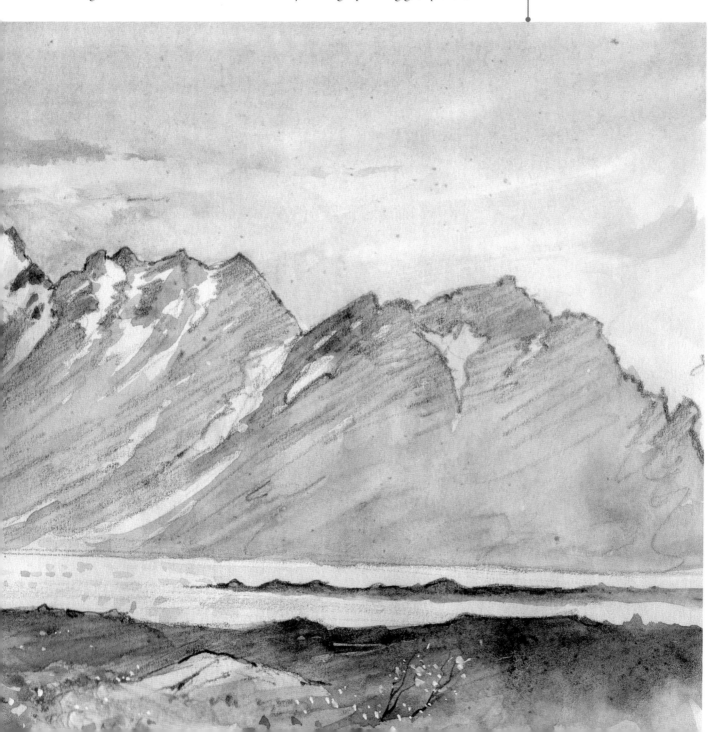

should be safe enough, I thought, and indeed it was, until I grabbed a few hours to myself and climbed one of the lower peaks. Despite its modest height, the sensational drops and some challenging moves in exposed positions on wet rock kept me on my toes, or in some cases, my knees. The views across to shapely neighbouring peaks, despite the weather's sullen mood, demanded a sketch. These stunning summits, glorious as they were in sunshine, become even more exciting when draped in the moody swirls of lowering clouds. Alas, I had left my paintbox and palette behind in my rush to the crags. I had to make do with a couple of tube colours and a banana as a palette – not the right shape and not white, so I couldn't see what colour I was mixing – but somehow it worked. Ludicrously, at times when I sketch with primitive 'found' materials, the results are so much better than when I paint with the most professional equipment. Many people believe my sketches are better than the finished paintings, which leads me to think that perhaps I would do well to ensure that I am always painting in the most excruciatingly painful position I can find.

The Lofotens in late spring are beautifully moody, with striking shapes to so many peaks, though they are climbers' and artists' mountains rather than those of the walker. I told myself I must come back one day, but for now my thoughts turned towards the Arctic. A different place altogether, the High Arctic would bring new challenges in some extremely remote locations.

WATERFALL AND KISSING ROCKS

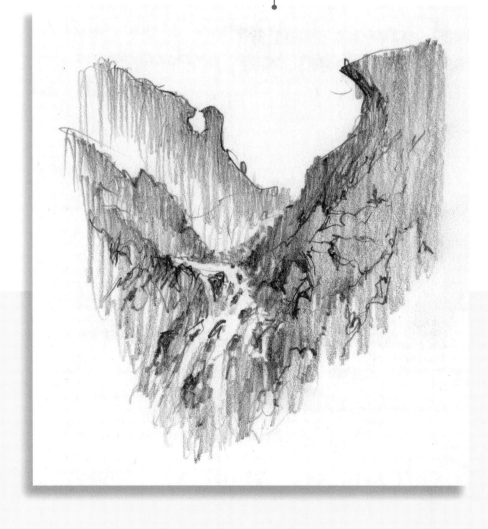

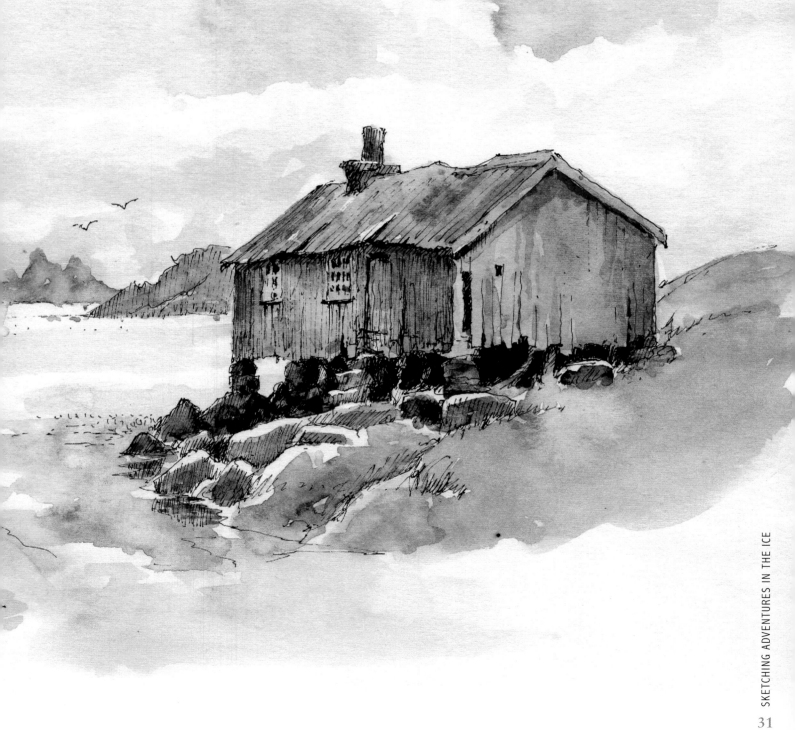

FISHERMAN'S SHACK AT STEINE
This is an ink drawing overlaid with watercolour on cartridge paper.

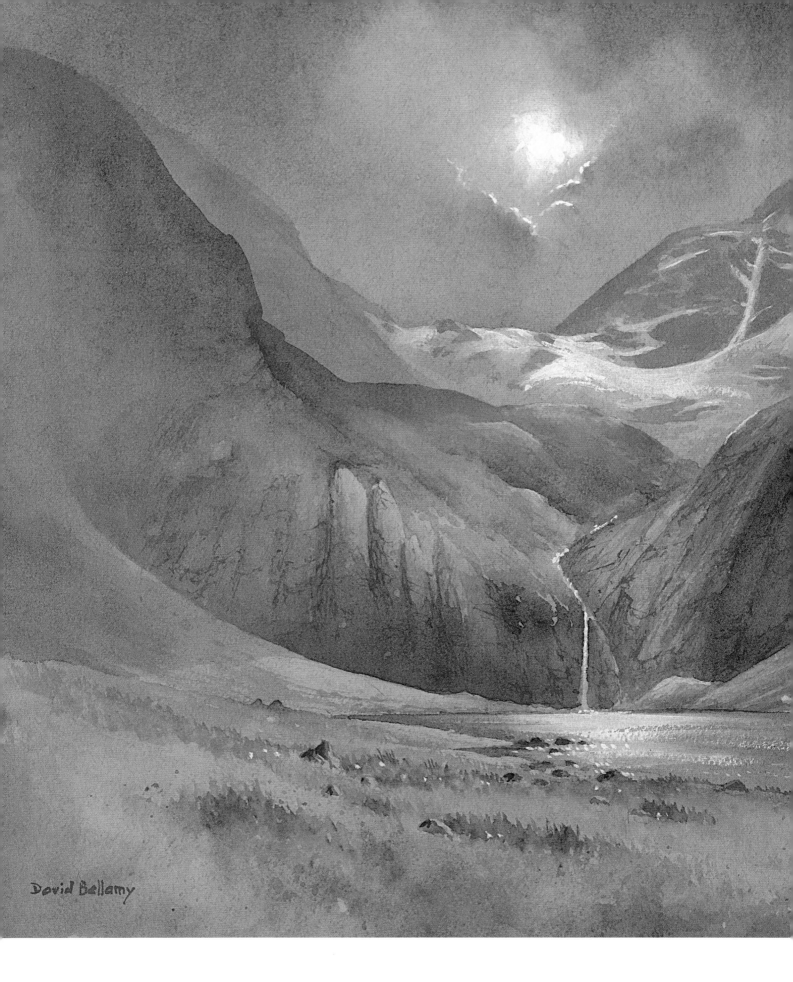

David Bellamy

MOODY MORNING, NEDRE HEIMREDALSVATRAT

This watercolour was done on blue-tinted paper, which is ideal for suggesting the moods of nature. It began to rain as I worked on the original watercolour sketch, resulting in a fine mess, but I achieved enough information for this painting.

SLEDGING ESCAPADES

Cold, gun-metal grey sea stretches interminably below us. The first indication of the approaching Arctic is an occasional block of stark white punctuating the grey. Soon these multiply. The edge of the pack ice drifts into view and a vast whiteness takes over, with only a few gaps and leads revealing dark water in between. White mountains appear and the pack ice merges imperceptibly with land. The Fokker 50 begins its descent. Snow-clad peaks flash past the window, alarmingly close on either side. Hopefully we are approaching some as yet unseen runway, but all I can see is a fjord ringed by icy peaks. The drama increases as the peaks rear up above the aircraft. There is still not a single sign of civilisation as we hurtle down into an icy wilderness, and, with a sudden jolt, hit something — but without disintegrating. Our wheels are clearly functioning; we seem to be on a flat surface, and to our relief, a shining modern airport building whizzes by.

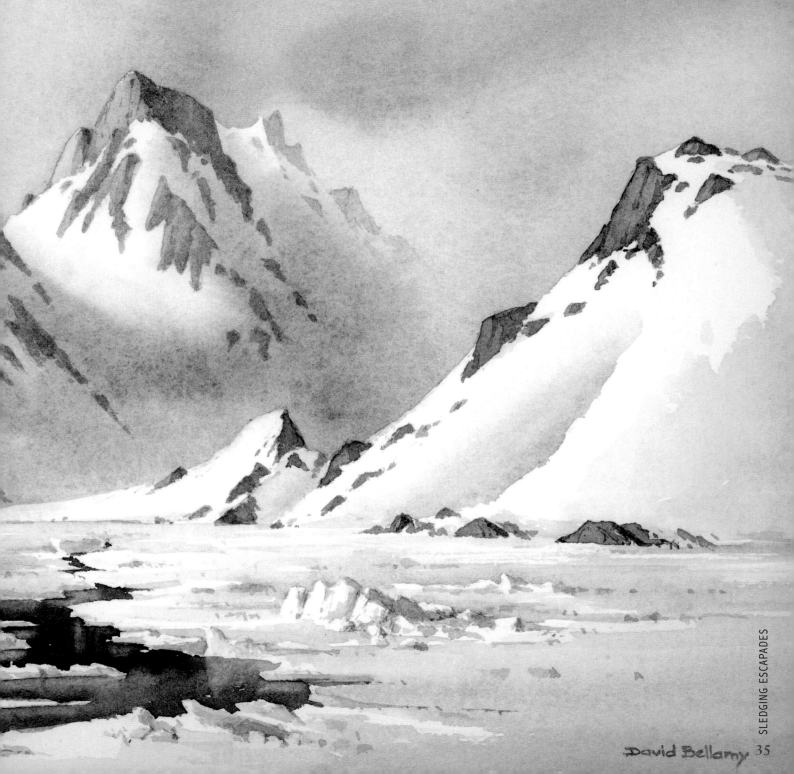

MELTING PACK ICE, KULUSUK, GREENLAND
With the onset of spring, open leads (channels of open water created as the pack ice parts) were appearing, enhancing this composition. Reducing colours to a minimum tends to emphasise the mood and sense of unity.

David Bellamy

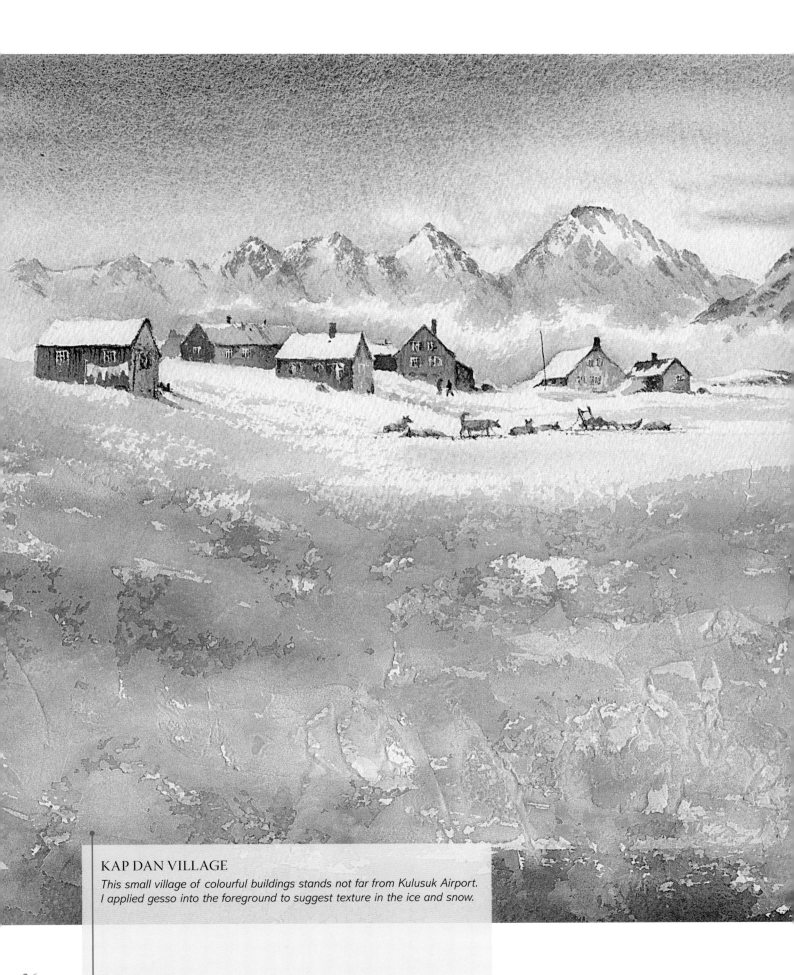

KAP DAN VILLAGE

This small village of colourful buildings stands not far from Kulusuk Airport.
I applied gesso into the foreground to suggest texture in the ice and snow.

This was my dramatic welcome to East Greenland. To the more sophisticated and populous West Greenlanders, 'Tunu', the remoter eastern side of Greenland, is a primitive backwater. It was not until 1884 that the first detailed account of the area was made by Europeans: Gustav Holm of the Danish navy, with Lieutenant Garde, left Nanortalik in South Greenland and travelled up the East coast in four umiaks heavily laden with expedition gear, rowed by Inuit women, plus an escort of seven men in kayaks. The umiak is a large, fragile flat-bottomed boat exclusively used by women, and can easily be hauled up onto the shore or ice floes. If damaged, it can easily be repaired. In August 1884 the expedition found 413 Inuit living in the various settlements around Ammassalik. Most had never seen a European. In Inuit society, the men hunted while the women turned the results of the hunt into food, fuel and clothing. Holm found many more women than men, and in families where there were no sons, the daughters learned to hunt like the men. Wife swapping and 'trial marriages' were common, involving a regular changing of partners, sometimes in quick succession. The small, isolated communities suffered from inbreeding and much alcohol abuse.

GEORGE PULLS UP A NETTED SEAL

Even in the 21st century, for most there is nowhere to go except to the next community, by boat in summer or sledge during the rest of the year. During the long winter nights, sitting in front of the television must only increase their sense of what they are missing in their confined world.

We were now in the true Arctic, and in April it is cold in Kulusuk, where the population is around 300, with probably just as many dogs. I saw deep snow and shapely mountains on most sides. My companion, Torben Sorensen, from Denmark, had not done any mountaineering, but he was keen on exploring wild places, and had always had a great fascination for Greenland since his father took part in the expeditions of Danish geologist and explorer Dr Lauge Koch after the Second World War. Those expeditions helped cement Denmark's relationship with Greenland, and even though today the country has a version of home rule, it is still heavily dependent on Denmark in many ways. Torben had been on several of my painting courses, and we had become great friends. Our first Arctic trip had only modest objectives: this was terra incognita to us. In the limited time we had I would be hard pressed to capture all my sketching objectives, which naturally included polar bears. Although I would have preferred to travel well away from the settlements and stay in remote huts, this was impracticable in the time we had available, so this trip would serve to whet our appetite and give us a little experience in these northern climes.

David Bellamy

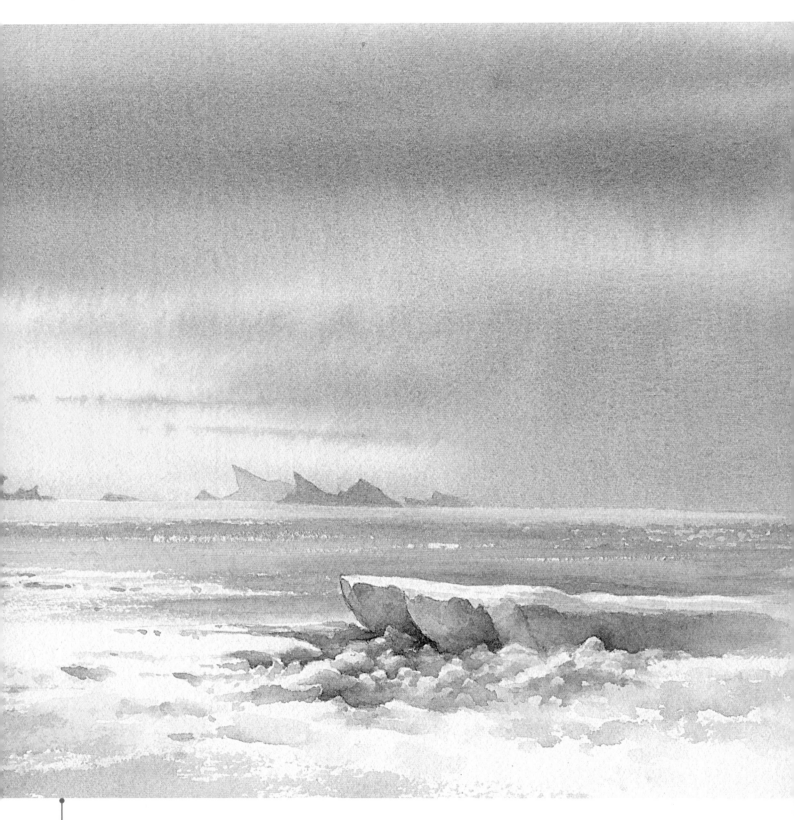

ACROSS THE SEA ICE
The mood is subdued, the distant icebergs about to be swallowed up in a squall.

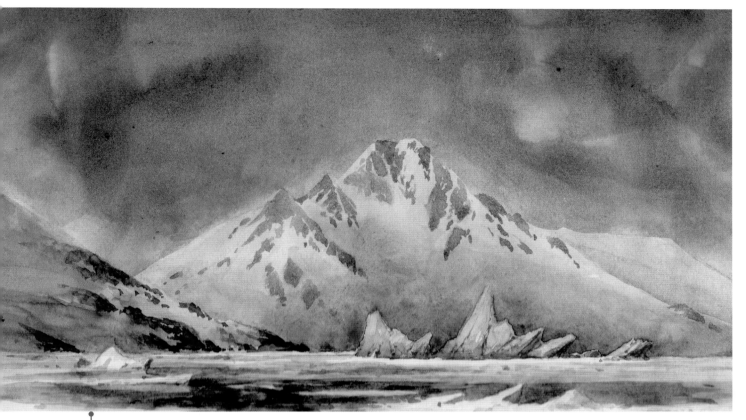

ICEBERGS CAUGHT IN THE EVENING GLOW
Tense moments sketching as the light faded, while imagining a host of hungry polar bears about to emerge out of the gloom.

The morning sun was casting silver sparkles across the ice, but it was ice-cool sitting on the sledges waiting to go. Dog teams leaped excitedly about, barking with eager anticipation of a morning run across the frozen wastes. Torben was sitting on the back of another sledge, and we each had an Inuit driver, who normally sat at the front, cracking his whip and giving the odd guttural command to the huskies. With a jerk we were away. Across the soft snow, the ride was smooth and dream-like. In the clear light, one could see great distances and happily sketch distant peaks without any need to hurry. The Greenland sledge is an excellent sketching platform while the going is smooth. Many times I drew Torben's sledge as a focal point in a sketch of the savage landscape. Eight to twelve dogs massed together can look like a shapeless mess in a drawing if you are not careful. Two or three heads are sufficient, with the blurring of flying powder snow an excellent device to lose most of those racing legs.

When something really exciting demanded a more considered drawing, I called a stop and we often took the opportunity for a hot drink as we sketched. After sitting for some time on the sledge, it was always welcome to stretch the limbs and follow the dogs' example of jumping about a bit to warm yourself up.

Our route lay across fjords, up mountain slopes and down the far side to the next fjord. There was no sign of life, no birds or beasts to relieve the grey desolation. Visually the weather ranged from sunny and benign to moisture-laden indigo nimbus broken here and there with white strands; the snowstorms obligingly keeping well into the distance. In this landscape dominated by blacks and whites, especially in flat lighting that tends to diminish colour, the starkness of the contrasts was striking. An artist has to be careful to seek out those nuances of intermediate tones that are present, but this was difficult to see against glaring white snow. I had to look hard for colour here, while at the same time watching out for rocks ahead that might overturn the sledge. I had lost enough pencils already – they flew out of my hands as we swerved, took off over an ice hummock or crashed into a snow bank. Huskies appear to have little concept of how annoying it can be to see your sketchbook disappear down an icy crevasse. At times I imagined the lead dog must have a grudge against artists, as so often he seemed to head directly for the most evil-shaped rocks sticking out of the snow.

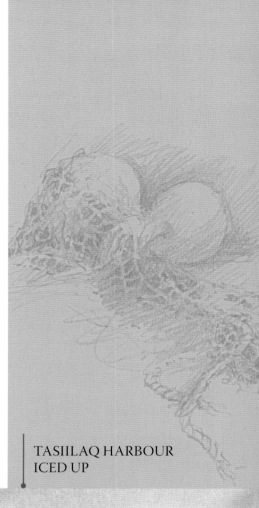

TASIILAQ HARBOUR
ICED UP

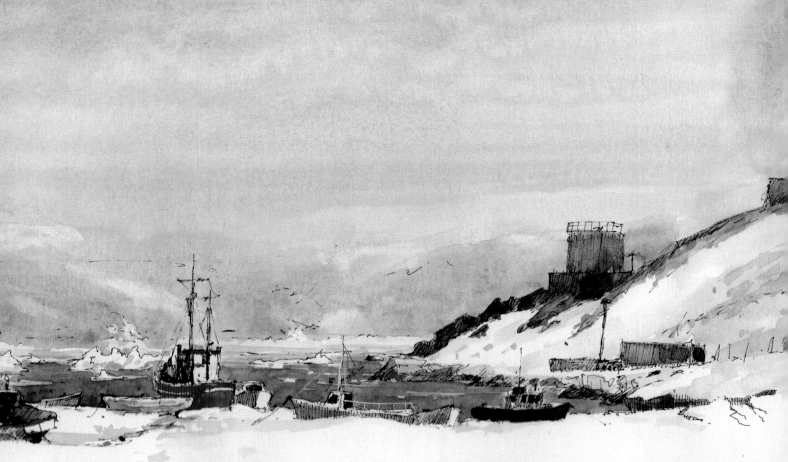

TUPILAKS

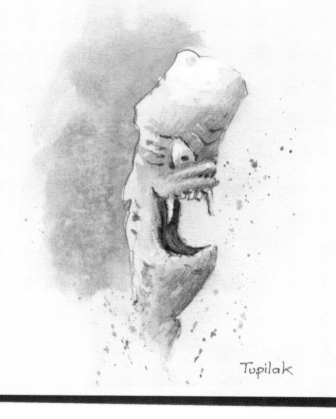

Originating from Ammassalik, the tupilak was designed to kill an enemy, or at least give him a lot of grief. Initially it comprised animal, plant or even human remains, and the various parts would be fastened together. Magical songs would be sung to ramp up the aggro. Once complete, the tupilak would be placed in the sea and left to carry out its deadly purpose. However, you had to be a trifle careful when putting all this together, as tupilaks can rebound on the sender if the proposed victim has even greater powers of wizardry, and so whatever fate you had in mind for the intended victim might befall you instead. Naturally, as the Europeans arrived in Greenland, the locals realised the value of selling tupilaks as souvenirs, and began carving them out of wood, and later reindeer antler, walrus or narwhal tusks. While most are the hideous representations of an imaginative mind, some are based on polar bears, birds or marine mammals. Naturally, the more terrifying and grotesque they can make these figures, the better the sales.

Tupilak

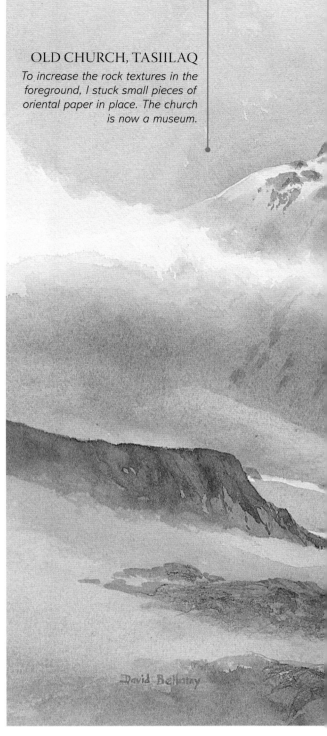

OLD CHURCH, TASIILAQ
To increase the rock textures in the foreground, I stuck small pieces of oriental paper in place. The church is now a museum.

David Bellamy

Sledging across hard sastrugis – ice ridges sculpted into the surface by the wind – can be likened to riding a road drill at high speed, as the ice is rock hard. At one point we stopped to check whether Bent, Torben's driver, had caught any seals in a net he had set a day or two earlier. A post driven into the sea ice marked the spot and the Inuit dug down until a patch of dark water was revealed. Sure enough, when Bent's friend, George, hauled

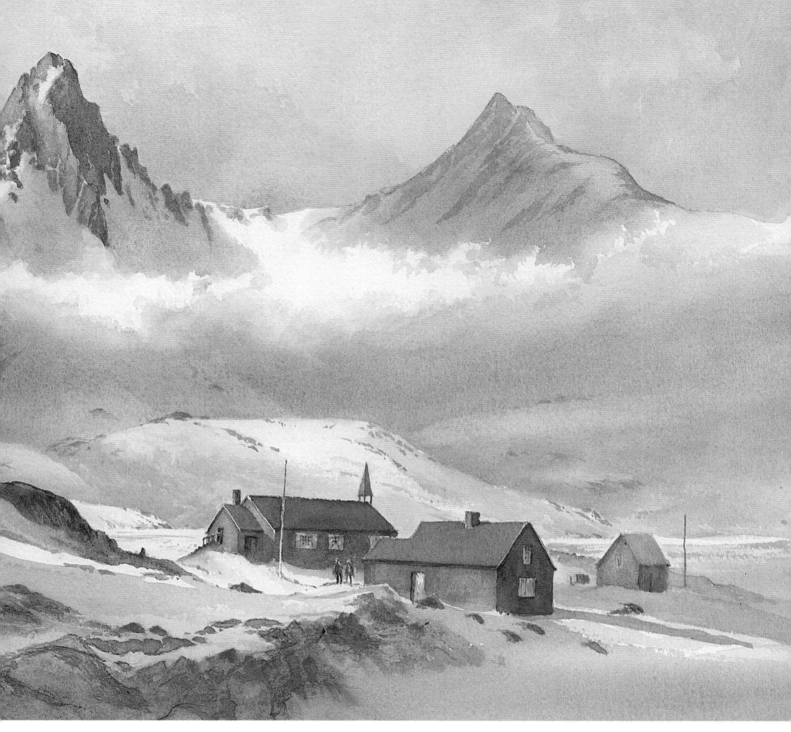

the net in, a small ringed seal had been caught. Torben had the pleasure of its rather smelly companionship on his sledge for the rest of the day.

In the evening we felt a desperate need to stretch our legs, so, clad in down jackets and snow boots, we emerged from the hotel and hiked across deep snow towards the fjord. Once away from the building, thoughts immediately sprang to mind of polar bears hiding behind every large icy eminence, waiting to jump out at us. We have no rifles, my largest weapon being a

no. 10 sable brush to fend off any bear attacks. Where land ended and the fjord began was not obvious, but we hoped the fjord ice was thick enough to take our weight. The evening was clear, with a sunset in the offing. Huge icebergs lay frozen into Ikaasaartik Fjord, waiting for the summer thaw to release them. Beyond the fjord, the snowbound slopes of Iperajivit were turning pink in the evening glow. To the west rose a range of sharply defined peaks. From where we stood, no sign of civilisation was visible, simply raw Arctic scenery.

Stopping near what we thought was the edge of the fjord, we extracted our sketching gear and began drawing. Removing a glove reminded me how cold it was. Another bear check revealed none in sight, though we knew full well that if one did appear, we would have no hope of reaching the hotel before it was upon us. The icebergs glowed a fiery red in the evening light, so watercolours were obligatory. The water was kept in a container in a neoprene pouch inside my jacket and as I poured it out, it turned into an icy sludge. Quickly I dipped a large brush into the sludge, flicked it into the paint and applied it to the sketchbook, but the brush hairs were already rock hard. I discarded the brush for a second one, just managing to get a wash over part of the background before the hairs froze. The washes instantly reticulated on the paper as they iced up. Normally, for rapid-fire sketching like this, I work into the wet washes with a watercolour pencil, but here it simply rattled across frozen reticulations, leaving a coloured line, but not the intense one I would expect working into a damp surface. The temperature was falling rapidly. Still no bears in sight. Torben was working away nearby and we exchanged howls of laughter at our pathetic efforts.

Over the years, experience has taught me that however hopeless a sketch may be, something positive always accrues from the work. Simply by looking at the marks you have made, however wild and incoherent, you find so much detail of the scene flooding back into your memory. Completing well-remembered or repetitive details immediately you return to tent, hotel, or wherever, will further enhance the sketch, although it can be self-defeating if you overwork it.

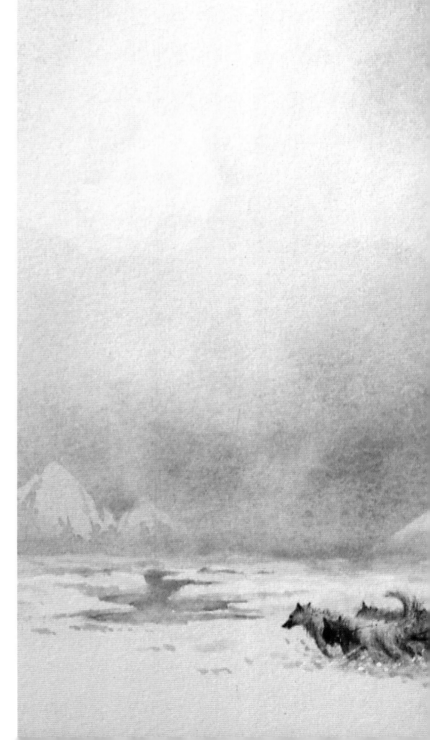

TORBEN AND FREDERICK ON SLEDGE

As I followed Torben's sledge over a pass, I noticed a wild tangle of legs and arms flailing about on top of it. Fred, like all drivers, had to get off on steep ground to help the dogs to the top, but sadly he was unable to keep up with the sledge once the dogs reached flatter ground. The idea is to run and leap onto the front, but being slow, poor Fred just managed to roll onto the rear end, and then had to crawl over Torben to reach the front – hence the melee captured here.

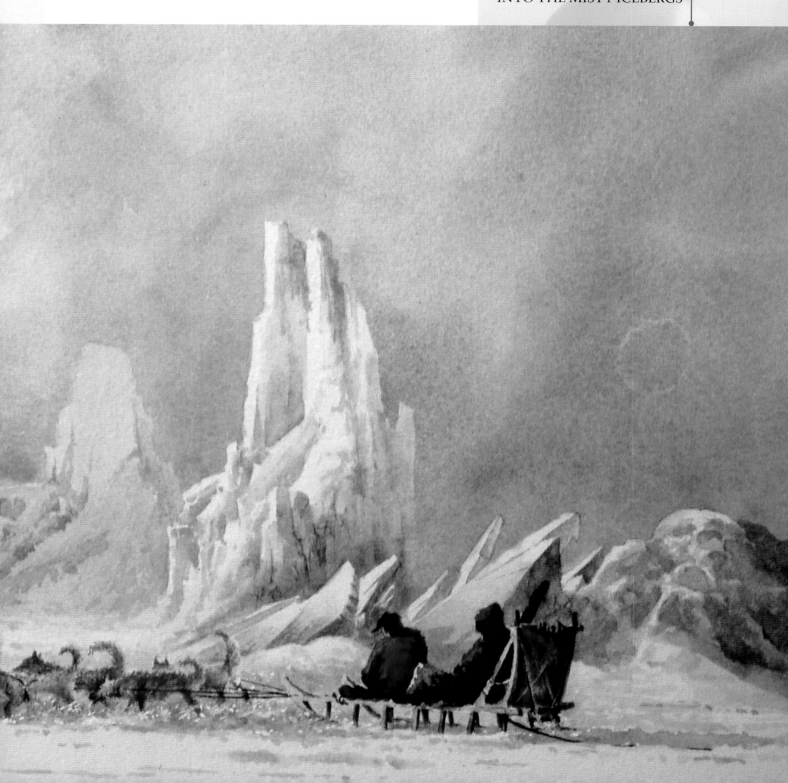

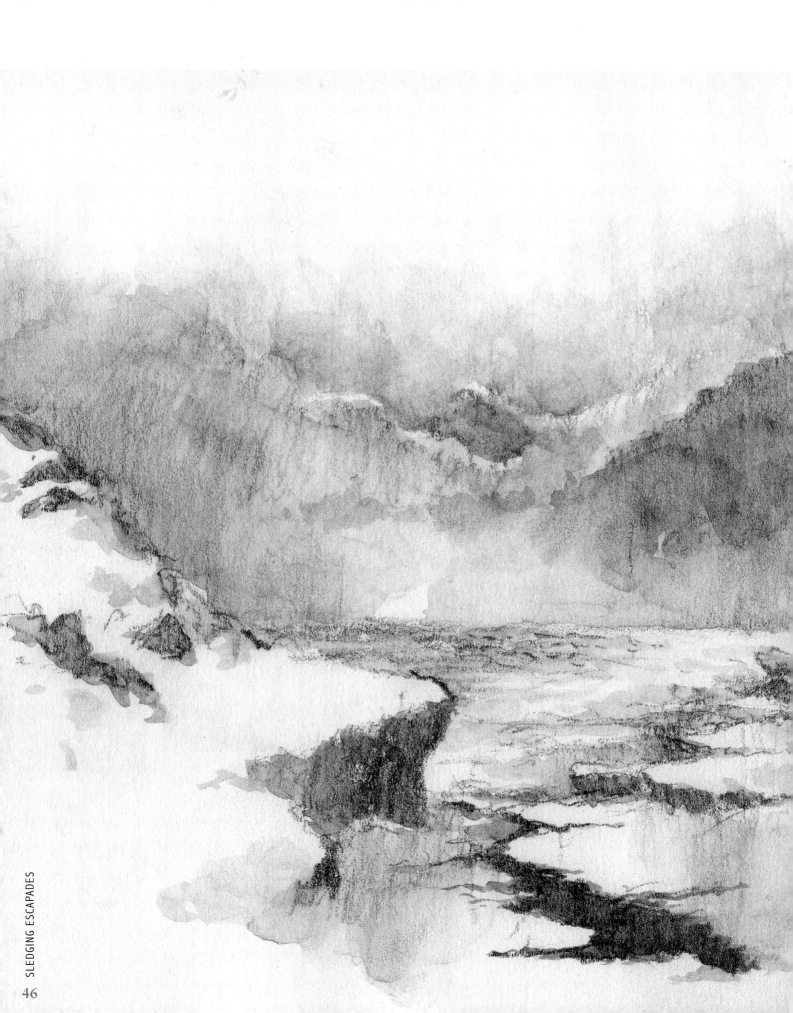

ICEBERG IN SERMILIK FJORD, GREENLAND

The mist came and went, so I sketched rapidly with water-soluble pencils to capture the dramatic atmospheric effects caused by the changing scene.

As we packed our pencils away, the light was fading, so it was time to return to base. Into the Arctic dusk we hiked, through deep snow, our thoughts enlivened by the imaginings of a whole host of polar bears in hot pursuit, as we continually glanced over our shoulders.

The helicopter skimmed a few feet above unstable pack ice torn in places by open leads as we headed for Tasiilaq, the largest settlement in East Greenland, with a population of around 1,800. A Danish colony was established here in 1894. Situated on the island of Ammassalik, the town has a grand setting, hugging undulating ground on the south shore of Kong Oscar Havn, with the shapely peak of Qimmeertaajaliip Qaqqartivaa, 1003m (3290ft) high, rising on the far side. This is the star of a horseshoe of mountains which encircle Tasiilaq, with a break on the seaward side.

The small harbour was choked with ice. All kinds of boats were frozen into the harbour, some barely visible under deep snow. In the gloom of the mist-wreathed afternoon, it made an excellent subject to sketch from a variety of angles. We then retired for afternoon tea at the tiny local cafe, crammed with books, the odd tupilak and other polar paraphernalia.

DWELLINGS

Only in the very north of Greenland are igloos built, these being simply temporary structures used during hunting expeditions. There is an excellent example of an old Greenlandic turf house reconstructed at the museum in Tasiilaq. These primitive dwellings were built of large stones and turf for the walls, with the skin roof supported by driftwood beams. They were low square buildings and their windows were made from translucent seal intestines, letting the light in but not allowing one to see through. Large sealskins were used as covers and to separate families. The houses would have been rather crowded, with up to twenty-five people living in the Tasiilaq example, which was around 7 x 4m (23 x 13ft). Norwegian explorer, Fridtjof Nansen (see page 52), was disturbed by Inuit domestic arrangements, which involved many almost naked bodies,

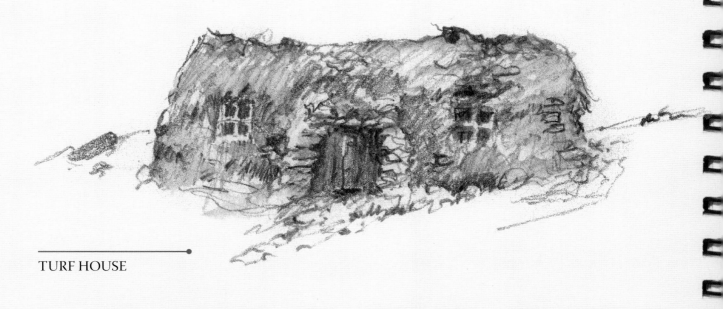

TURF HOUSE

Choice of refreshments was limited and basic, but the warmth and friendly welcome were cheering.

A bright, sunny day dawned for our dog-sledge journey to the tiny remote settlement of Iqattek, which lies across the mountains on the far side of the island beside Sermilik Fjord. Torben was being driven by an ancient Inuit by the name of Frederick, who had the most lovely, wrinkled face that had clearly seen many years of hunting in extreme conditions, and I wanted to sketch him at the earliest opportunity. Salo, my driver, was much younger, sporting a scrubbing-brush haircut. He said little, but grunted a lot. With the obligatory explosive jerk, as though fired from a catapult, we set off, the dogs eager as foxes in a chicken run. Immediately we were racing across Kong Oscar Havn, praying that we would avoid those nasty-looking leads I'd spotted earlier. The pace was fast and exhilarating as we headed up-fjord towards a gap between two shapely mountains, across a smooth surface with magnificent subjects all round. It was a great bonus to be able to sketch on the move.

and he commented on the atmosphere in Inuit dwellings: 'this powerful odour was well tempered with human exhalation of every conceivable kind.' Spring-cleaning was carried out by removing the skin roofs to allow the wind and rain to clean up the place.

Current dwellings in the settlements are colourful wooden buildings – with some rather drab ones as well. Most of the houses in Tasiilaq are constructed on a base of high concrete to keep the doors free from snow in winter. Traditionally the buildings were painted according to their use – domestic ones a deep red, medical ones yellow, trade buildings such as fish factories and shops blue, and so on. More recently, other colours such as purples and pinks have been introduced in places.

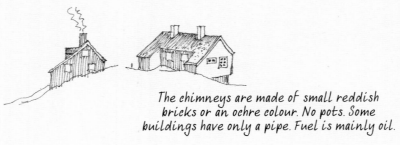

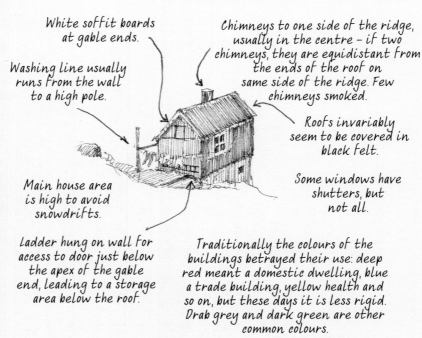

The chimneys are made of small reddish bricks or an ochre colour. No pots. Some buildings have only a pipe. Fuel is mainly oil.

White soffit boards at gable ends.

Washing line usually runs from the wall to a high pole.

Chimneys to one side of the ridge, usually in the centre – if two chimneys, they are equidistant from the ends of the roof on same side of the ridge. Few chimneys smoked.

Roofs invariably seem to be covered in black felt.

Main house area is high to avoid snowdrifts.

Some windows have shutters, but not all.

Ladder hung on wall for access to door just below the apex of the gable end, leading to a storage area below the roof.

Traditionally the colours of the buildings betrayed their use: deep red meant a domestic dwelling, blue a trade building, yellow health and so on, but these days it is less rigid. Drab grey and dark green are other common colours.

TASIILAQ DWELLINGS

From the head of the fjord, we began the upward leg, a shallow slope at first, but soon it became steeper and progress slowed to a walking pace. All around were steep snow slopes. I heard noises behind, but much as I tried to identify the sound, it was elusive. A chill ran over me: could it be a polar bear stalking us? At this pace a bear could easily catch us, but I couldn't see anything following. Salo seemed oblivious to the noises and there was no sign of alarm among the dogs, so I was clearly having foolish thoughts. The noise occured again, and though it was not a threatening sound, it was disturbing. When we reached the top of the pass, the sledges gathered speed as we descended the far side towards a frozen lake. In the exhilaration of speeding over this snowy waste, I forgot the noise. We continued for some time until we were at the bottom of a long, steep climb, and stopped for a break. This gave me the ideal opportunity to attempt a pencil portrait of Fred, and he seemed happy to pose.

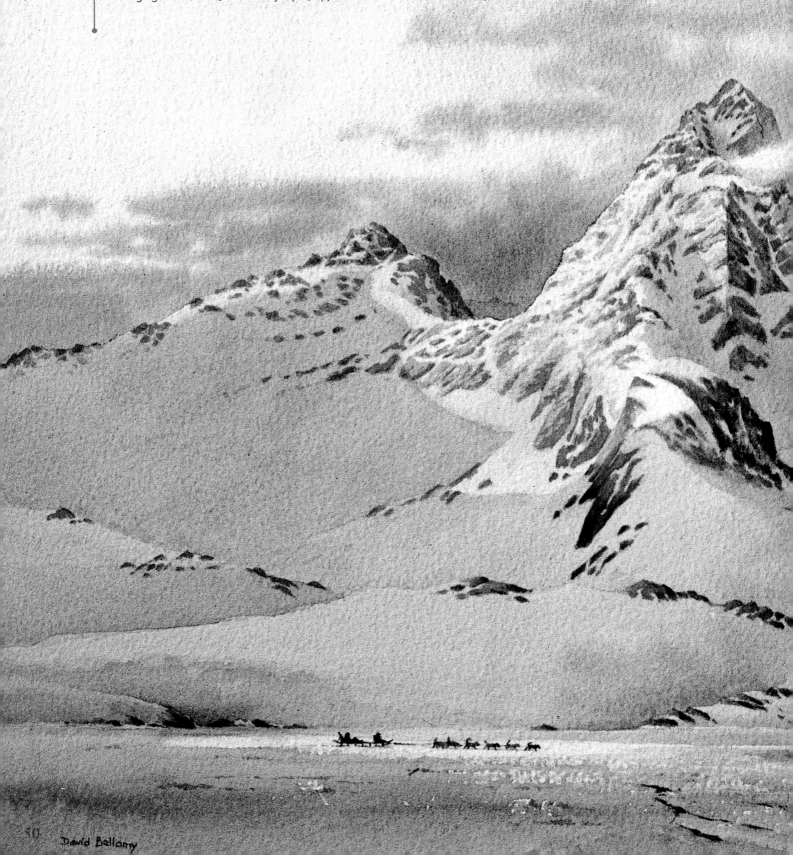

CROSSING KONG OSCAR HAVN, EVENING
Evening light catches Qimmeertaajallip Qaqqartivaa as we return to Tasiilaq.

50

David Bellamy

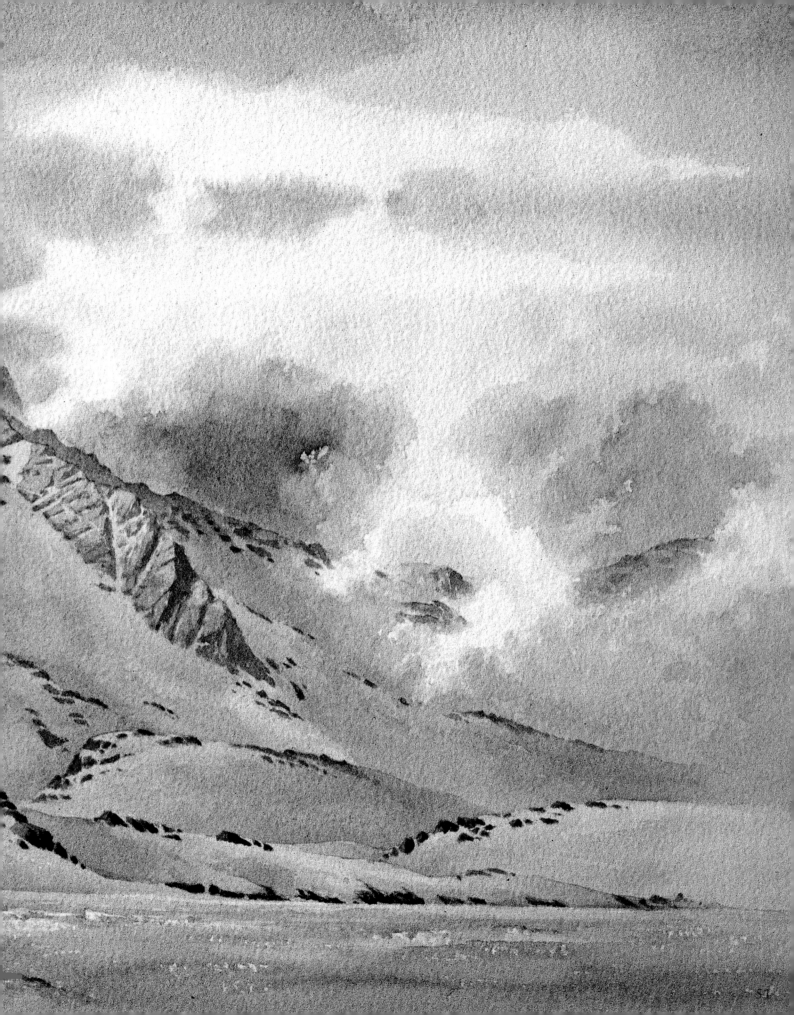

After the break and a long ascent, we crested a pass and had to descend a frozen waterfall. Most of the waterfall ice was covered in snow, and with everything white, it was difficult to see how great a drop it was to the bottom. We got off the sledges and attempted to descend in as dignified a manner as possible, but inevitably, gravity won. Suddenly we flew through the air down the vertical pitch. It happened so quickly that there was no time to think, and I uttered my first curse as I hit the bottom. Happily we landed softly in deep snow, in a state of merriment.

Shaking off the snow, we remounted our sledges and continued towards the coast ahead. A shallow slope took us into Sermilik Fjord, and once on the sea ice, for some reason known only to Fred, or perhaps his huskies, he and Torben shot off in a different direction, heading into a forest of misty icebergs. The sea mist was coming and going, one minute creating ethereal, atmospheric scenes for the artist, the next totally obliterating the scene. Soon we arrived at Ikkatteq. As we dismounted, Salo pulled a husky puppy out of the bag at the rear of the sledge – the source of all those strange noises!

FREDERICK

A few minutes later, Torben and Fred rode in a stately manner into town. Torben and I, both glad of some exercise, set off to explore the place. Ikkatteq comprises around five or six dilapidated huts, badly in need of repair and paint. It is not normally inhabited during winter, and we came across only two or three locals. Some shapely icebergs lay close by in Sermilik Fjord, so these and the huts kept our pencils busy for hours. Here in 1888 Fridtjof Nansen, the celebrated Norwegian explorer, planned to begin the first crossing of the Greenland ice cap, but on leaving the ship, he found it impossible to get through the pack ice to reach shore. Climbing onto an ice floe to avoid the two boats being crushed, the six-man expedition then spent some thirteen days drifting down the east coast of Greenland on their floe, with tent and boats, until eventually they met land. Despite such an inauspicious start, they did in the end achieve their goal.

On our return journey to Tasiilaq, our first challenge was to get the sledges up the almost vertical frozen waterfall. There was plenty of soft snow around, so was little danger, but with the dogs striving upwards, and given their penchant for relieving themselves 'on the run,' there was a distinct chance of significant unpleasantness as we pushed from below. We did, however, get up without mishap, and now things gathered speed.

Everything went well until we began descending the long steep slope into the Sermilikvejen Valley. This involved some 244m (800ft) of descent, with the sledges hurtling out of control – the crude brakes could not hold them, given the sustained incline. I hung on grimly to the edges of the sledge with spindrift and chunks of snow flying up in clouds, aware that the dogs were hard pressed to keep ahead. One of the dogs slipped, and the sledge splattered the poor animal into the snow like a Tom and Jerry cartoon. Just as in a cartoon, the husky popped up behind us, apparently none the worse for wear, as the snow was soft. Nearing the bottom, I saw only a narrow gap between massive boulders that we had to aim for at about 80kph (50mph), the hazard made worse by the fact that the final approach to this gap was over a ramp of solid snow that fell away steeply on both sides. At this pace, smashing into the boulders was a likely outcome. The last stretch was a blur

as we zoomed along the ramp, missed the boulders by a hairsbreadth, and thankfully emerged unscathed onto the flat lake beyond, to come to a gentle halt.

Torben and Fred, however, were not so fortunate. I waited with Salo in anticipation, unable to see what was happening on the far side of the great boulders. Suddenly their sledge appeared through the gap, empty and battered. In horror, I ran towards the gap to find Torben staggering along with Fred behind. They were winded, but otherwise fine. The sledge had got completely out of control, so Fred had leapt off as it approached the rocks, and Torben followed suit in the nick of time. Repairs were needed to their sledge before we could continue. This took a little while, but once it was patched up, we had no further incidents before reaching Tasiilaq.

Qaqqartivakajik is a small mountain, 679m (2227ft) high, rising immediately south of Tasiilaq, and it looked good for an afternoon outing, except, of course, for the fact that sketching can stretch a hike well beyond an afternoon. Deliciously coated with deep snow, it had been tempting me since our arrival. As we climbed, views out to sea revealed pack ice stretching to the horizon.

TORBEN AND FRIENDS
For some obscure reason, Torben always seemed to end up with one or two smelly seals on his sledge for company.

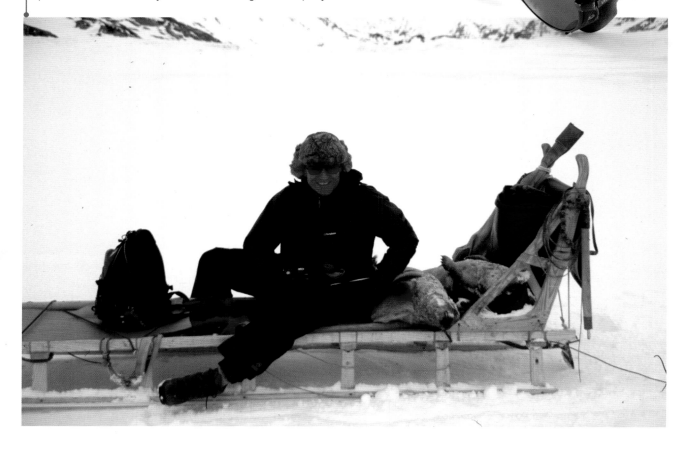

USING COLOUR IN FREEZING CONDITIONS

Because of the intricate subtleties of colour and tone in ice and snow, I tend to carry out many more colour sketches when working in the Arctic than in most other parts of the world, when pencil or monochrome sketches are perfectly adequate. This obviously causes quite some problems when using watercolour, so I have developed a variety of techniques to cope with below-zero temperatures. Here I illustrate three approaches to the problem, with the two Kap Hoegh sketches actually applying to the following chapter. Further methods on sketching in these conditions are discussed in the Sketching and Painting in the Arctic chapter, page 160.

ICE FORMATION NEAR KAP HOEGH

Only the sky area was painted on the spot, in watercolour and gin, as the brushes froze quickly. The obvious reticulations and blobs were caused by the washes icing up. The blobs became lumps of ice that melted later. I finished the sketch back in the hut.

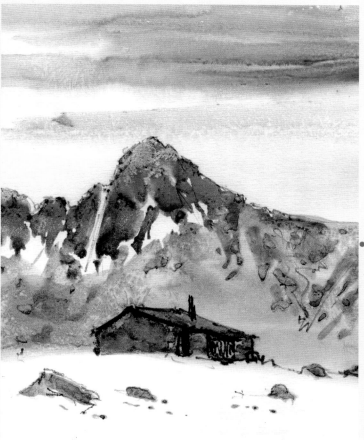

OLD HUT, KAP HOEGH

Sometimes the ambient temperature changes during a sketch, depending on the sun and wind and whether I am in or out of shelter. This watercolour sketch on cartridge paper started off with just mild indications of freezing in the sky area, but as I introduced more water, icy reticulations began to emerge, as seen on the background mountain. The wash on the brush developed a lumpiness, thus losing its flow and creating marks on the paper. I drew in the detail with a black watercolour pencil.

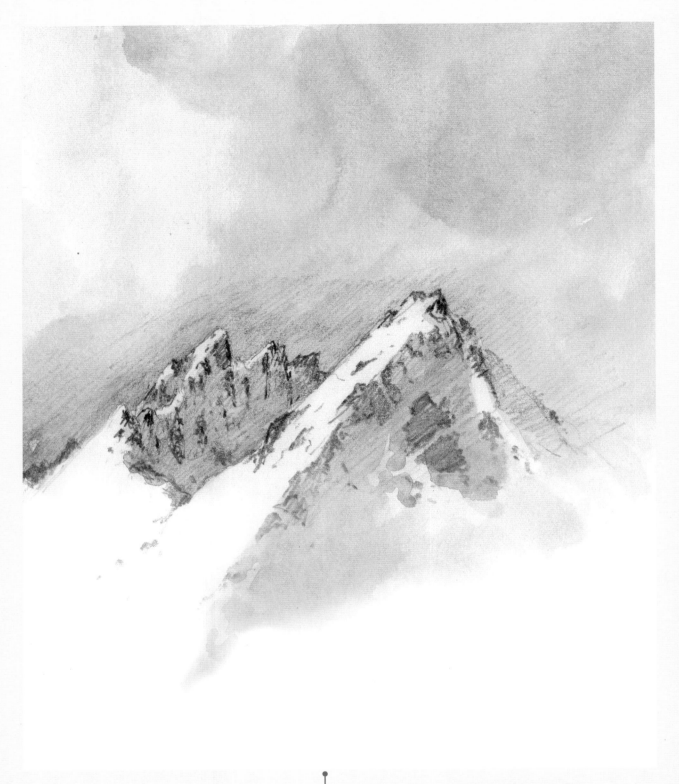

PEAKS ON THE YMERS BJERG RANGE

This sketch was drawn in pencil on location, applying hatching to suggest the darker areas in sky, mountain shadows and darker crags. Back at base I laid on basic watercolour washes over the hatched areas. This is a useful way of working in below-zero conditions and when colour is not critical.

Torben hadn't done any winter mountain work, so once we reached a suitable place for him to practise, we aimed to carry out a series of ice-axe arrests, which are designed to stop a potentially lethal fall down steep snow slopes. Flinging yourself head-first down a steep slope of hard-packed snow is not a natural activity, but I found a steep slope which had a gentle run-out at the bottom and was free from rocks. After I demonstrated the technique, Torben launched himself into it with gusto, and we spent some time enjoying the action, getting plastered with snow from top to bottom in the process.

Soon it was time to move on. Confident that we could both now use the ice axe to halt a fall, I stepped out onto an icy slope. The visibility had deteriorated and the flat lighting was so deceptive that I found it hard to read the slope and how far down it went. Without warning, I slipped and began to zoom off into oblivion. The slope was far steeper and higher than I had realised. Automatically my axe bit into the hardened snow surface and brought me to a halt. A brilliant example for Torben, but after all my guidance, I felt something of a buffoon. The temptation was to say, 'You see, that's how it's done,' but instead we fell about laughing at the irony of it. Still, it was a lesson that in this light, even a small mountain can be highly dangerous.

We continued upwards, the going getting really steep. Across the void, the Ymers Bjerg peaks were vague images merging into a grey overcast, with an impressive alpine look to them. Downwards, a precipitous face of hundreds of feet stared back at me, yet it looked perhaps 6 or 9m (20 or 30ft) at most. We couldn't be far from the summit now. At this point, Torben wisely decided not to go any further, but urged me on while he was happy to wait in the lee of some rocks. I hate splitting up on the

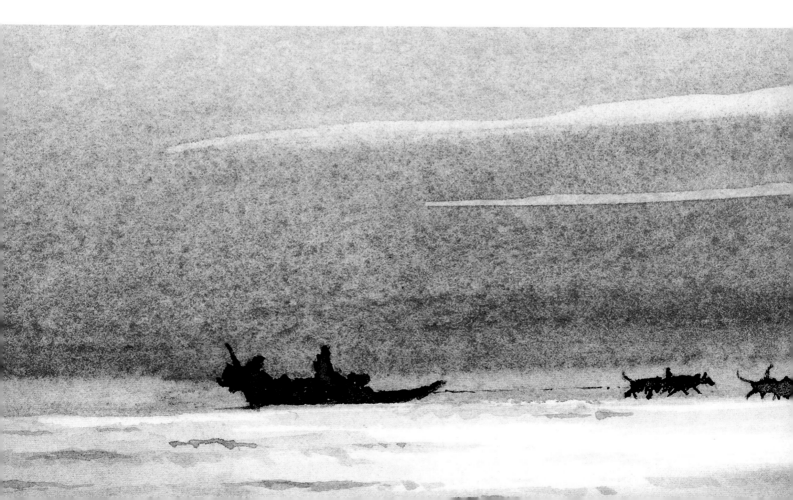

*At times we needed to
wrap up well against the
intense cold and wind,
which made sketching a
real struggle unless we
could find shelter.*

mountain as it can lead to all sorts of complications, but I decided to press on for twenty minutes
at the most, otherwise Torben would get cold and the longer I was away, the harder it would be to
locate him in this light. The slope was still unyieldingly steep and the light deteriorating. Not far to
the top now, I reasoned with myself, but each time it seemed to be approaching, it was inevitably
followed by yet more slope. I looked back down. Was that Torben's position, or just an illusion?
Even the brightest colours on an anorak merge into the drab grey of distance and atmosphere. The
exhilaration I had felt was evaporating into caution: what if I failed to find Torben on the way down?
He couldn't survive a night out on a mountain in the Arctic without shelter, and I'd never forgive
myself if anything happened.

I increased the pace, aware that in a few
minutes I would have to turn back. Still there
was no lessening of the angle of the slope,
and no sign of the summit. It must be close
now. This was becoming ridiculous – on
the one hand, this was a small mountain
which should be easy to climb, yet on the
other, this was a small mountain of no great
significance, so did it really matter if I didn't
reach the top? The twenty minutes were up.
For many, the summit is a sporting challenge,
the sole reason for climbing the mountain,
but in my case it is always secondary to the
visual and spiritual sensation of being in
such magnificent places, and living for such
moments. I would be totally irresponsible if I
didn't turn back. Reaching the summit was a
pointless exercise. So down I went, following
my tracks back to Torben, who was in good
spirits, and together we descended the peak
in the late afternoon gloom.

INTO THE
ICY WASTES

HUSKIES IN FULL CRY

The original pencil sketch holds a fleeting memory of hurtling down a steep slope while looking backwards at the following sledge, holding myself in position with legs straddling the sides, then bouncing off the sledge onto a snow bank and back on again, still with sketchbook in one hand and pencil in the other.

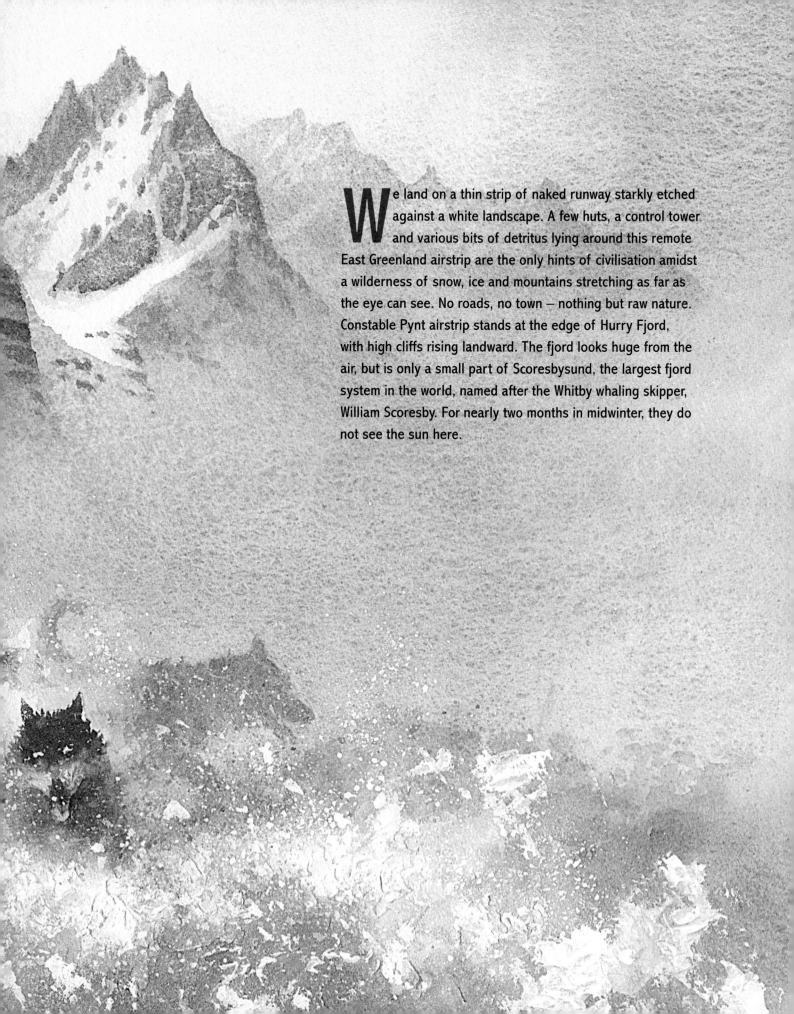

We land on a thin strip of naked runway starkly etched against a white landscape. A few huts, a control tower and various bits of detritus lying around this remote East Greenland airstrip are the only hints of civilisation amidst a wilderness of snow, ice and mountains stretching as far as the eye can see. No roads, no town — nothing but raw nature. Constable Pynt airstrip stands at the edge of Hurry Fjord, with high cliffs rising landward. The fjord looks huge from the air, but is only a small part of Scoresbysund, the largest fjord system in the world, named after the Whitby whaling skipper, William Scoresby. For nearly two months in midwinter, they do not see the sun here.

Torben and I were better organised for this more ambitious expedition to an even more remote part of Greenland. We disembarked and walked to the reception area, hurrying past two shifty-looking individuals standing watching the few disembarking passengers. They didn't bother with trivialities such as passports at the immigration post, and as we recovered our luggage, we were politely informed that we were wanted outside. By the shifty-looking pair, as it turned out. My English drew blank expressions. Torben tried some of the Greenlandic he had learnt at evening class, but was rewarded only with a look of confusion. He switched to Danish and fared better: Isak, the taller chap with the friendlier face, spoke a smattering of the language. His shorter companion, Jens Emil, looked the epitome of a Mongolian warrior, an image further enhanced by his explosive manner of speaking. These two would be our guides for the expedition across the mountains and sea ice north of Scoresbysund. They ushered us into a shabby tin shack labelled 'hotel' and produced an immense pile of Danish sausages while Torben and I changed into Arctic clothing and rearranged the contents of our rucksacks.

Two sledges awaited us outside, piled high with expedition gear and covered with musk-ox pelts. Huskies howled and danced about, straining at their traces in their eagerness to get going. One cannot help but compare these dogs to the desert camel, a beast that is rarely eager to get going, and has never been known to jump up and down in delighted anticipation of a session of purgatory hauling a massive load over rough terrain.

With a jerk, the sledges slithered away, hissing across deep snow down the slight slope to the fjord. On the far side, the snow-bound jagged peaks of the Roscoe Bjerge glowed pink as the sun sank in the sky. While the light remained, I sketched as we hurtled along behind eight or so dogs, to the familiar accompaniment of a foul smell. On the other sledge, Torben and Isak were etched darkly against the cold white fjord, Torben enjoying the company of a seal carcass on his sledge – part of our ration for the next few days, and adding significantly to the variety of smells.

Our evening sledge journey ran up Hurry Fjord for many miles to a hut near the bottom of Kalkdalen, a valley that we would be following up through the mountains in the morning. In the clear evening air, the hut appeared long before we reached it. The sheer silence of the place was overwhelming, something almost impossible to experience in 21st-century Britain, even in the mountains.

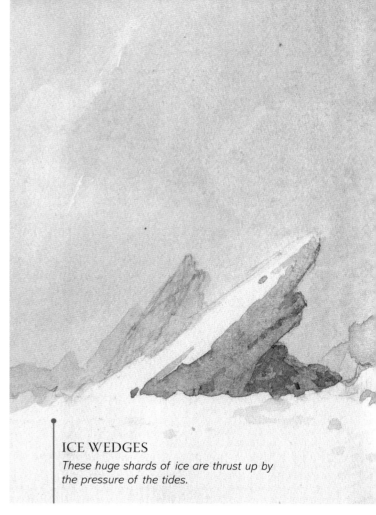

ICE WEDGES
These huge shards of ice are thrust up by the pressure of the tides.

Not a breath of wind stirred the atmosphere. The sense of freedom at such times is palpable and exhilarating, and one of the main reasons I love being in the Arctic. Even the intense cold seemed to pump a refreshing energy into my body.

The sun had gone down, yet the after-glow left sufficient light for me to carry out a brief sketch of the hut on arrival. A rich orange sunset, with limitless tints of lighter orange running up into an ever-deepening turquoise sky, slowly faded to the west, while a series of mauves, purples, blues and pinks coloured the eastern prospect. I attemped to lay watercolour washes, but instantly the brush turned into a solid frozen stump. What little pencil work I did quickly numbed my fingers, as the thin glove liners I use for sketching could not cope with the plummeting temperature. I ran into the hut, where Isak had the stove underway. As I thawed out, I lay on the washes over my sketch while I could still see by the Arctic twilight glowing through a steamed-up window.

SKETCH MAP OF LIVERPOOL
LAND AND SCORESBYSUND

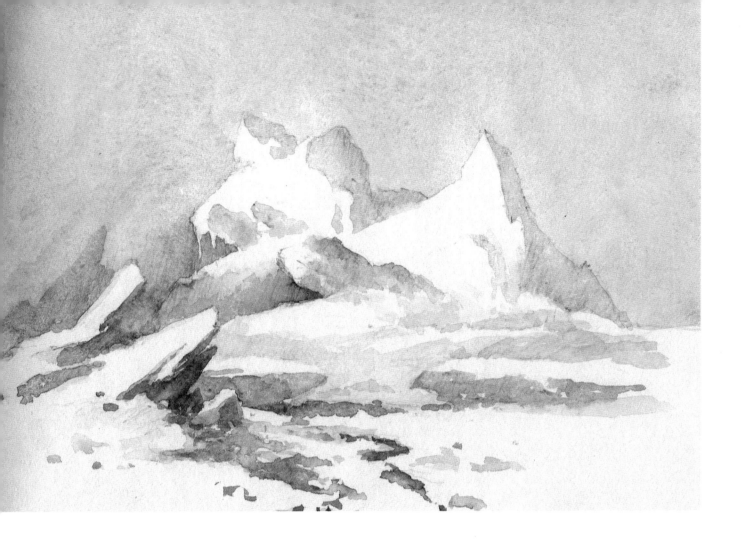

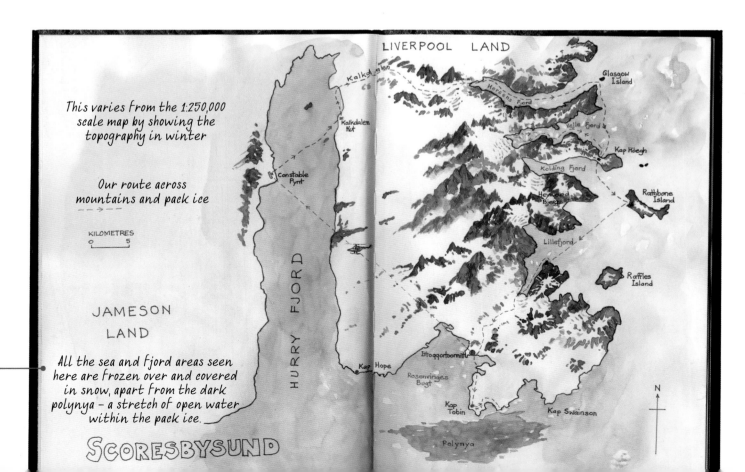

This varies from the 1:250,000 scale map by showing the topography in winter

Our route across mountains and pack ice
– – – →

KILOMETRES
0 5

JAMESON
LAND

All the sea and fjord areas seen here are frozen over and covered in snow, apart from the dark polynya – a stretch of open water within the pack ice.

SCORESBYSUND

LIVERPOOL LAND

Kalkdalen

Kalkdalen Hut

Constable Pynt

HURRY FJORD

Kap Hope

Ittoqqortoormiit

Rosenvinges Bugt

Kap Tobin

Kap Swainson

Polynya

Herceflus Fjord

Glasgow Island

Vejle Fjord

Kap Höegh

Kolding Fjord

Heyward Bjerg

Rathbone Island

Lillefjord

Raffles Island

N

The hut was a simple box of two rooms joined together by a doorless doorway. As expected, its furnishings were hardly in the luxury class: one dismal bunk, a small wooden table, desperately uncomfortable trestles to sit on, a stove and a sink area. There was no running water, of course. This had to be produced by melting snow and ice on the two primus stoves. The main stove for heating was oil-fired, and soon made the place cosy. After a meal of Danish luncheon meat and bread, I snuggled into my sleeping bag. It was good to be back in the Arctic, and I could hardly stifle my sense of excitement in anticipation of a full day's sledging and sketching across the mountains tomorrow.

Next day, after a breakfast of muesli, I reluctantly had to face the toilet, which ranks among my most memorable. It stood in the first small room by the entrance, in a grand position to welcome everyone entering the hut, where they could view the incumbent in action. To preserve my dignity in this situation, I generated a lot of fulsome noises to indicate both my presence on the loo and the general activity taking place, if somewhat exaggerated. All this was further enlivened by the obligatory curses associated with the complications of wearing a one-piece undersuit.

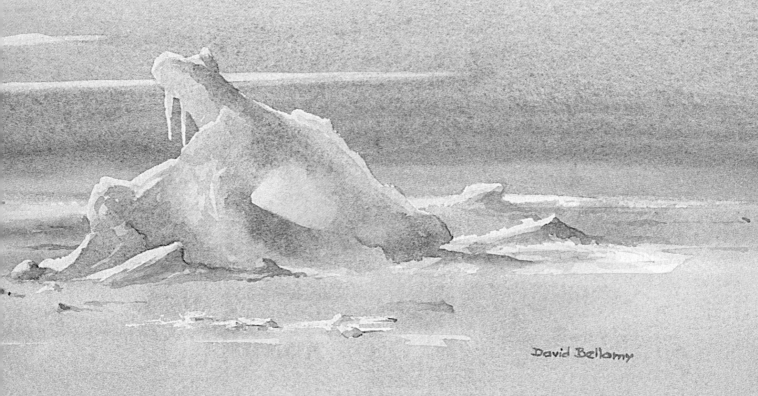

SLEDGING OVER THE PACK ICE

A hint of light breaks through the cold Arctic sky, creating a gleam of yellow in the small iceberg. In poor weather, the pack ice can be a lonely, threatening place.

David Bellamy

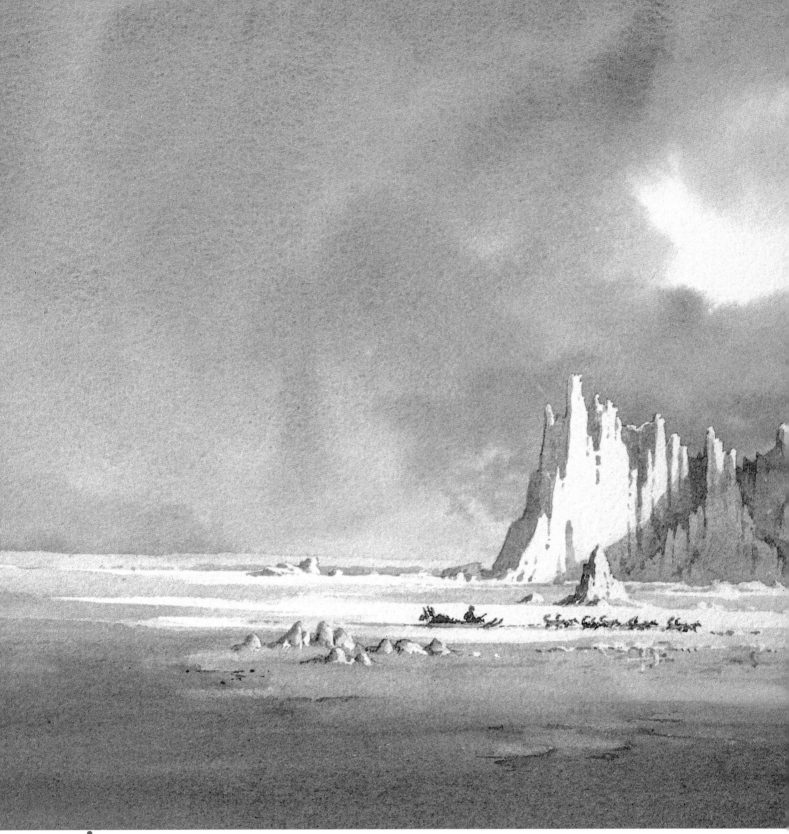

ICE CASTLE

The sledge gives a sense of grandeur to this castle-like iceberg stuck in the pack ice until the summer warmth releases it.

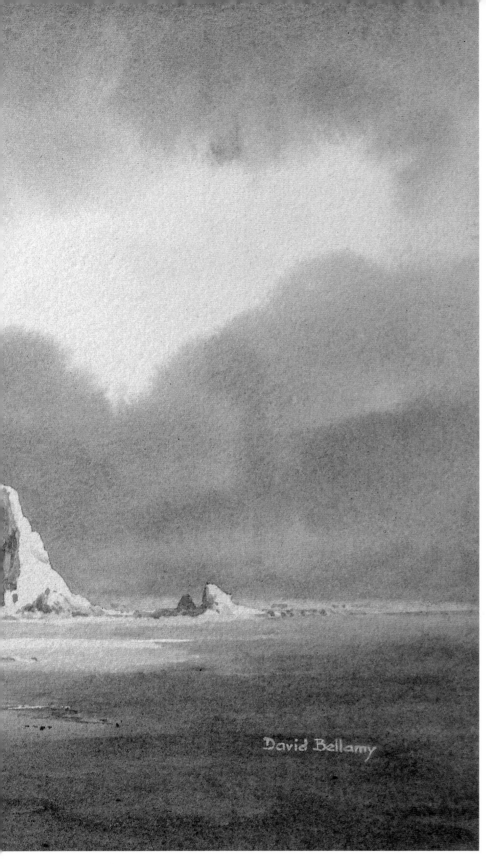

David Bellamy

Outside, even if you are wrapped up in a down-feather cocoon, the cold hits you like a wall of solid ice. I moved around quickly to get heat, admiring the fjord scene, while the dogs once more jumped around, eager to leave. They had to be anchored down to stop them rushing off. Nearby a musk-ox skull lay in the snow. The rising sun warmed us up, and beneath cloudless skies, we got underway over the fjord ice, initially heading northwards. Just short of the head of the fjord, we turned east and climbed through deep snow up Kalkdalen, which means 'limestone valley'. The going soon became so steep that we dismounted to ease the weight for the dogs, and walked through deep, energy-sapping soft snow behind the sledges, though 'floundering around' might be a better description. This made me realise the value of the dogs. They all hauled heroically, tongues hanging out most of the time, through deep snow that had me struggling even though I wasn't pulling anything. My favourite was a young bitch called Migichuchu, and although huskies are savage animals compared with a normal pet dog, she seemed affectionate and greeted me enthusiastically each morning. She had a lovely reddish coat with two symmetrical spots by her eyes. Huskies stay part of a team for seven or eight years.

When the Royal Navy sent expeditions in search of the North-West Passage in the 19th century, their cumbersome sledges were of heavy oak with iron runners, hauled by sailors. In true RN tradition, each sledge bore an inspirational name and a pennant, was often equipped with a sail, and commanded by an officer, rather in the manner of a warship. On occasion they were

even accompanied by a band, all of which did little to impress the Eskimos, whose dog-hauled lightweight sledges could move so much faster. Naturally the sailors could not survive on dog rations, so even more provisions had to be carried. Unlike the Navy, Eskimos did not feel the need for a full complement of silverware to accompany their meals.

Eventually the ground dropped away and we hurtled downwards on the sledges at breakneck speed. I tried to capture this wild action in sketches, but fell off the sledge, bounced off a snowbank and landed back on the sledge, still gripping pencil and sketchbook. Our route crossed frozen lakes, gradually climbing to a low saddle, and for much of the time I sketched as we moved along, mainly working with water-soluble pencils. To lay out a full watercolour kit would have been pushing my luck, for if the sledge suddenly took off at pace and rolled from side to side as they often do, the mountainside would be littered with paints and brushes.

After some time, we reached the snout of a glacier with a handsome peak rising above it. We stopped for lunch, but my priority was to sketch the dramatic ice formations. This caused some comments from the guides, who were both aware that I'd hardly stopped drawing all morning, a most peculiar habit which

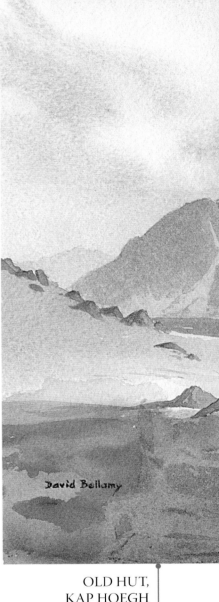

OLD HUT,
KAP HOEGH

Inside, this was a dark hole compared with the newer hut where we stayed, but it had a more pleasing profile for the artist.

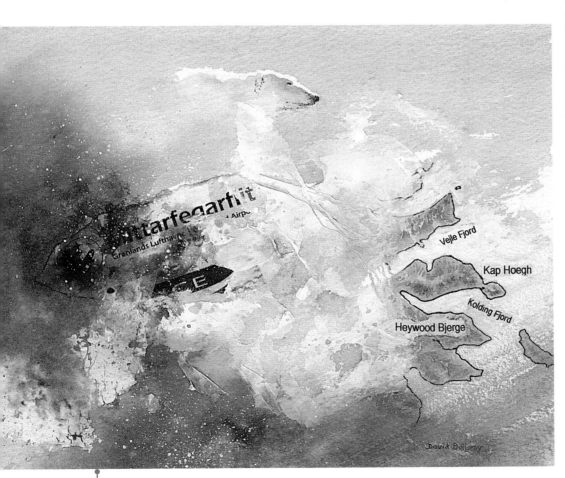

POLAR BEAR AND MAP OF KAP HOEGH, GREENLAND

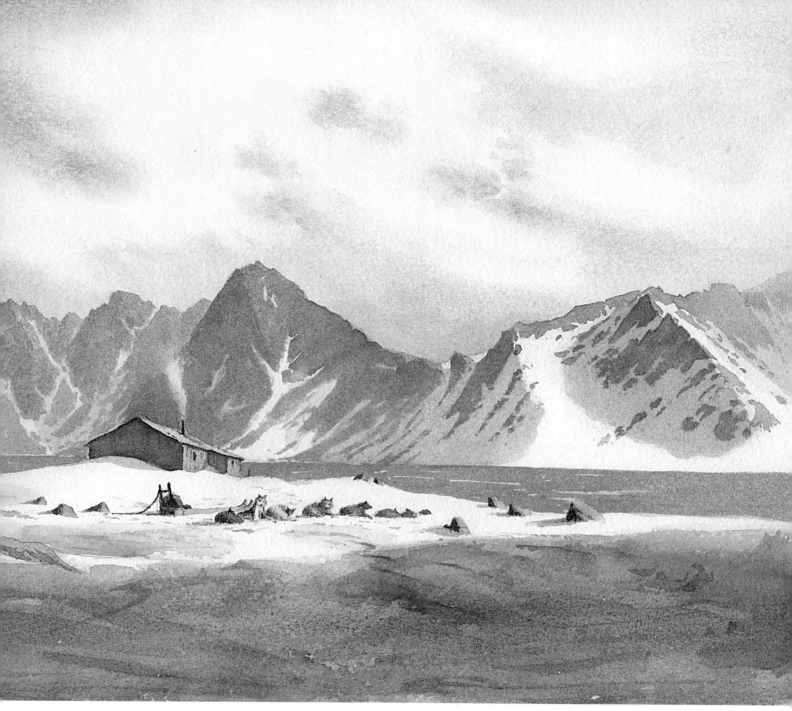

they couldn't understand. Torben enlightened them in Danish, causing howls of laughter. I managed two watercolour sketches of the scene from slightly different angles, though one had to be completed in the hut later. The midday sun kept the temperature just above freezing, so painting was relatively straightforward, without any icing problems.

Our route wound past impressive peaks through virgin snow. At times deep, sloping snow brought our speed down to a snail's pace. Gradually we descended to the head of Horsens Fjord. Here, on snow-covered flat ice, the sledges sped up. Steep cliffs hemmed us in

on both sides. Ahead the view looked promising for a good composition, so I prepared the sketching gear. Half an hour later the view still seemed to be no closer. It took at least an hour to reach the point I had picked out, and by then the scene had changed completely. In this clear atmosphere, the sense of scale was unbelievably deceptive. There was absolutely nothing to give you any idea of distance or scale. No familiar trees, houses, cars, people – nothing.

We passed huge icebergs, trapped in pack ice until the summer thaw. It was ages before we reached the end of the long wall that bound us on the south side,

THE EAST GREENLAND SLEDGE

Even within one region of Greenland, the sledge design varies, and in these two drawings, the sledge runners are quite different. The Scoresbysund sledge is fitted out for an expedition, while the other is for a day trip. Although snowmobiles are more in evidence these days, sledging is still often the preferred mode of transport during the winter months for hunting and visiting neighbouring settlements. With the sea ice thinning in places, sledging is becoming more restricted and hazardous during the warmer months. Sledges are normally pulled by 8 to 12 dogs, always eager to get going.

EAST GREENLAND SLEDGE,
SCORESBYSUND

Pulled by 8 to 12 huskies in fan formation, it is still the best way of crossing the show fields and pack ice. Inevitably there are times when the traces become hopelessly tangled, or dogs fight, but it is truly amazing how much the huskies can pull on the sledge.

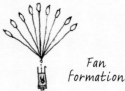

Fan Formation

Many sledges have a brake at the rear which the driver stands on, though it has limited effectiveness on extremely steep slopes. Like many, Jens uses a coiled and intertwined series of rope lengths which he throws over the sledge runners at the front. This will gradually slow and then stop the sledge.

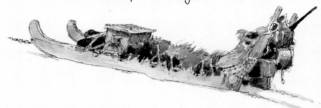

Here the sledge is heavily laden for an expedition with musk-ox skins covering the equipment. At the rear, pots and pans dangle and there is always a large bag and a rifle. The metal box at the front held our food.

Because of the constant stresses from various directions as the sledge crashes over ice ridges, sastrugi and at times rocks, it is held together by cord, as nails would simply pop out. Sometimes runners are splayed out; sometimes they are vertical.

Much of the time, riding on a dog-sledge is easy going, even serene, but a long day of manoeuvring and sliding into deep snow uses muscles that are not often needed, so the next day you find aches where you don't normally get them!

Bent's sledge is light-coloured natural wood, but some are painted, typically a very light blue.

9 April 2004

The whip is a sturdy tool, the handle similar to a traditional wooden ice axe. It is also used as a brake when in the sitting position.

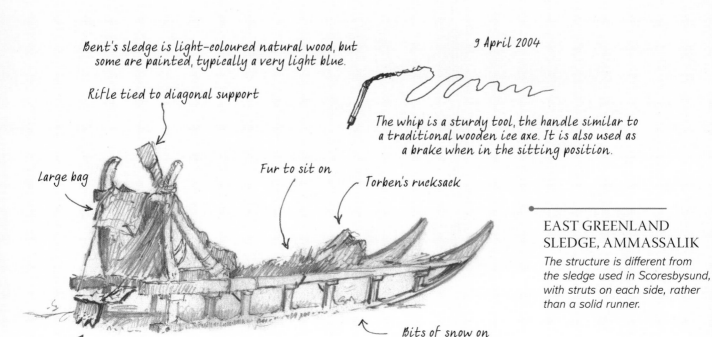

Rifle tied to diagonal support

Large bag

Fur to sit on

Torben's rucksack

Brake

There are 7 uprights on each side

Bits of snow on topside of runner

EAST GREENLAND SLEDGE, AMMASSALIK

The structure is different from the sledge used in Scoresbysund, with struts on each side, rather than a solid runner.

and Glasgow Island, a massive red crag rearing out of the frozen sea. At this juncture, we paused to indulge in afternoon tea on the sea ice and to take photographs of the occasion. I celebrated with yet another sketch. The dogs then plunged on with renewed vigour as we turned south along the coastline, where rugged ice-bound mountains dropped straight into the sea, although at this time of year there was no sign of any sea, of course. We headed for the trapper's hut at Kap Hoegh. The going across the pack ice varied, sometimes smooth, sometimes a bone-jarring succession of crashes over a series of seemingly never-ending sastrugis. Occasionally we hit an icy mound or rammed into a pressure ridge and almost came off the sledge. To our right, Pedersen's Glacier sparkled invitingly in the sunshine, but it would have to wait for another day. We passed a massive ice castle rearing out of the surface like something out of the Tales of Narnia, its impressive scale amplified by the sight of Torben's sledge running across the ice in front of it.

After much jarring, it was a relief to arrive at Kap Hoegh and stretch our legs. The hut was set on a wind-battered isthmus between the mainland and a bare, rocky peak. There were in fact two huts, the older one being the

ARCTIC SUNRISE: ISAK WITH HIS DOGS

Isak was always kind to his dogs, hugging each one in turn.

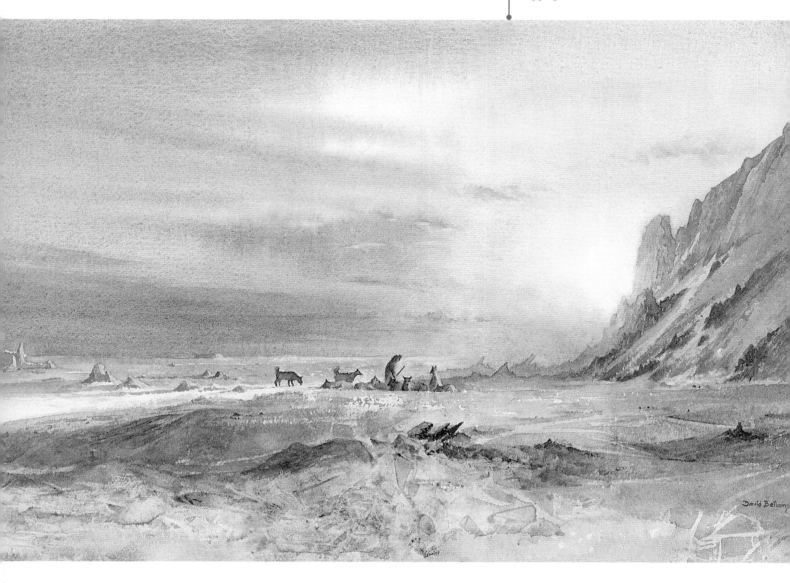

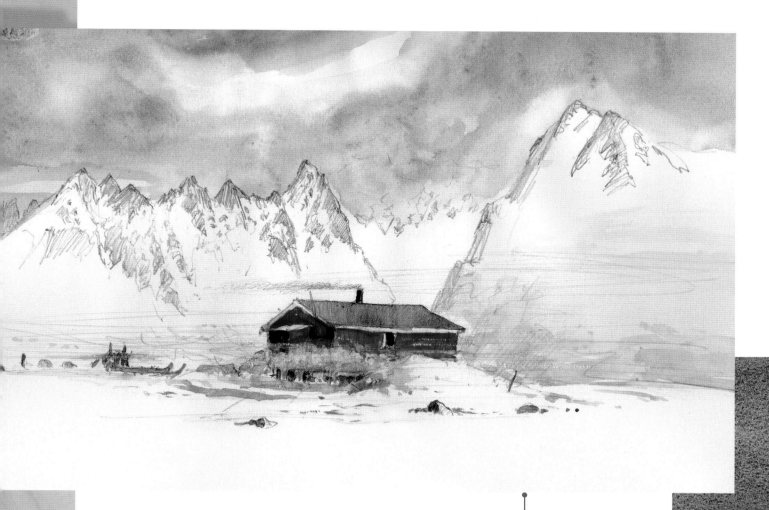

more aesthetically pleasing as a subject for the artist. 'Hoegh' means 'there are hares' and we saw many Arctic hares in their white winter coats over the next few days, bounding in between rocks. We made our home in the more modern hut, which was a lot larger than that at Kalkdalen, but with the same charmingly exposed toilet arrangement in the 'entrance hall'. The sledges were unloaded, the dogs anchored and tea made. From the window I saw Isak going round each of his dogs in turn, giving them a hug and a few pats in a fatherly way. They responded well to this display of affection. Jens, by contrast, simply scowled at his team.

In the evening we were treated to a meal of polar bear steak accompanied by a strange mixture of rice and pasta. The meat proved to be as tough as a discarded mountain boot, and even when liberally plastered with tomato sauce, it was hardly memorable. While on the subject of polar bears, I wondered what would happen if one knocked on the door, as Jens left his rifle outside on the sledge at night.

I awoke at 5 am, in time to witness the first flush of sunlight across the pack ice. Sunbursts glanced off the wind-sculpted icebergs trapped offshore. Viewing it from a window, I rendered a simple watercolour before breakfast. For washing and drinking, snow was dug some distance from the hut, to

RISING STORM, KAP HOEGH

I abandoned this sketch as the temperature plummeted and my hands went numb. As the drawing was complete and the first watercolour washes laid, I decided to leave it as it was rather than finish it off.

avoid contamination, but it took some time to create water this way. I used wet wipes at times of water shortage, but the great Greenlandic explorer, Knud Rasmussen, swore by a vigorous rub-down with walrus blubber as an alternative to washing properly. Knud was an ever-cheerful and inspiring expedition leader, even leading the singing when things began to look dire, and he was greatly loved by the Greenlanders.

Kap Hoegh hut had superb views of the mountains on the far side of Kolding Fjord, and there were many subjects to sketch close by, without travelling far. In the sunshine I managed to work up several watercolours, while Torben did some drawing. Colour is vital when sketching ice formations, for it is the play of light and the intricate subtleties of the various colours in the ice that make the subject so attractive. At times, colours seem to change and burst into coruscating life as you gaze at an object. With such subtle nuances, simply writing colour notes on a pencil drawing is totally inadequate. Pencil or charcoal, though superb sketching tools, will only provide shapes and tones. Laying washes was no problem while the sun beat down on the paper, but in shadows I struggled, as they immediately froze over. This often created fascinating patterns and reticulations, sometimes improving the sketch,

WEATHERING THE STORM

The huskies hunker down for the stormy night, well wrapped in fur, as spindrift blows over them.

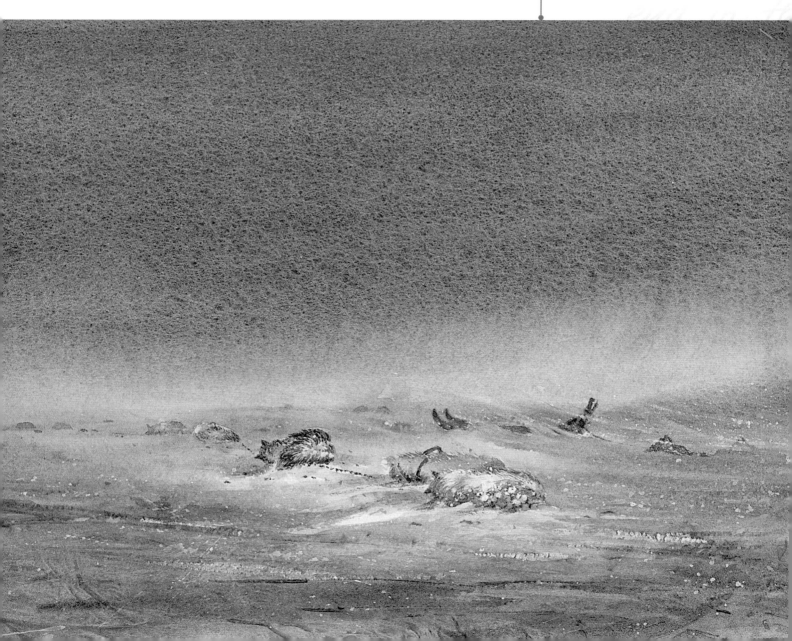

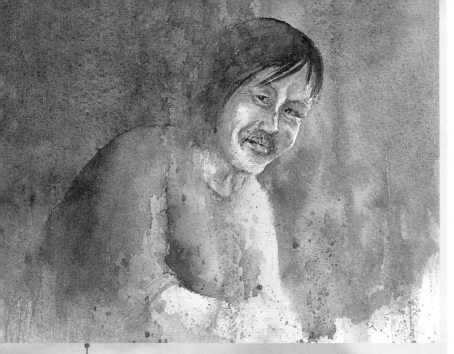

atmosphere – it was too exciting to leave, too dangerous to stay. Stinging snow buried my scattered sketching equipment. I abandoned the sketch and dived into the hut. Still, I got the image I sought, however primitive, and so often the unfinished ones are the best.

A hot drink revived me. By now the storm was battering everything mercilessly, with clouds of spindrift at times blotting everything out. The dogs lay hunkered down in the snow, looking like frozen rocks in a desolate landscape. I tried to sketch them from the window, but it was difficult, so again I put on

JENS IN A RARE HAPPY MOOD

KORSBJERG PEAKS FROM VEJLE FJORD
Vejle Fjord is surrounded by a cirque of magnificent peaks on all but the seaward side, with massive tabular icebergs the size of cathedrals frozen into the snow-covered pack ice.

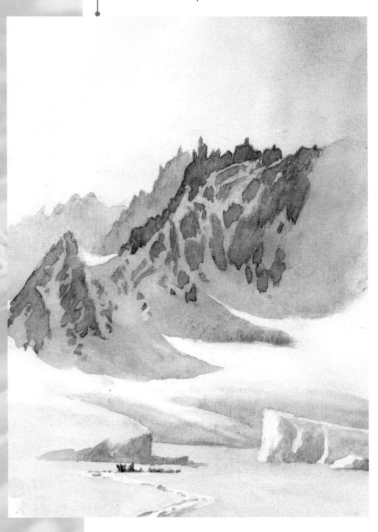

but much of the time it left blotches and marks that could ruin the image. At one point when the temperature dropped below zero, I coloured the scene with watercolour pencils on dry paper, then rubbed soft snow across the paper to blend in the colours. This naturally produced a crude image, but I was able to draw on top of it and produce a worthwhile colour sketch.

Come late evening, I sat on a rock sketching the main hut, shivering even though clad in warm clothing. Finishing the pencil stage, I got up and danced several times around a rock to get some heat going, then attempted to lay watercolours over the drawing. It froze straight away, and even adding gin to the painting water had only limited effect in such temperatures. The wind increased, blasting spindrift across the isthmus. I fought to capture the sense of the violent wind hurling the spindrift, scratching and scoring across the paper with whatever came to hand. Watercolour became hopeless – the brushes instantly turned to solid ice and washes into ridged patterns with dark blobs as fine snow hit the paper where I tried to lay colour. The temperature took a sudden, massive drop, making me gasp, my face stinging to the blast of a thousand ice needles in this tumultuous

all my outer gear. The guides looked disapproving as they saw that I was going back outside with a sketchbook. Jens clearly thought I was barmy. In the lee of the porch, it was bearable, but stepping beyond that, the storm hit me like a brick wall. I staggered back into shelter, recovered my breath, then slipped quickly round the corner, still in the lee of the hut, and from there I could sketch the dogs and sledges. Even working with a bottle of gin instead of painting water, I doubted that I'd be able to use watercolour, but I managed reasonably well with a pencil, as there was little colour to record. Eddies of blinding, stinging spindrift swirled around me, and most of the time I could not see anything beyond the dogs. I hoped there were no polar bears around, as I would have little warning, unless the dogs scented them in time. Kap Hoegh caught the full force of the northerlies that streamed down the coast, and the fury of an Arctic storm was all too apparent from inside the hut. In really bad weather, one can get trapped for a week or longer. Caught in a bad storm, you can't even see your feet. Further up the coast at Ella Island, the base of the Sirius Patrol, ropes link each building as people have become hopelessly lost even just a short distance from a building.

The guides called me in for dinner and I wondered what delights awaited. When you are bursting with hunger and anticipating a delicious hot meal, it can be a dreadful blow if the offering falls far short of what you expect. Early Arctic explorers often ate meat raw, Eskimo-style, a subject that the American explorer, Elisha Kent Kane, described with singular relish:

HEYWOOD BJERGE SUMMITS

I climbed the south-east face of Sandbach Halvo to get an elevated view of the Heywood Bjerge summits while Torben stayed at sea level. The reward was a truly exciting prospect of this really craggy range.

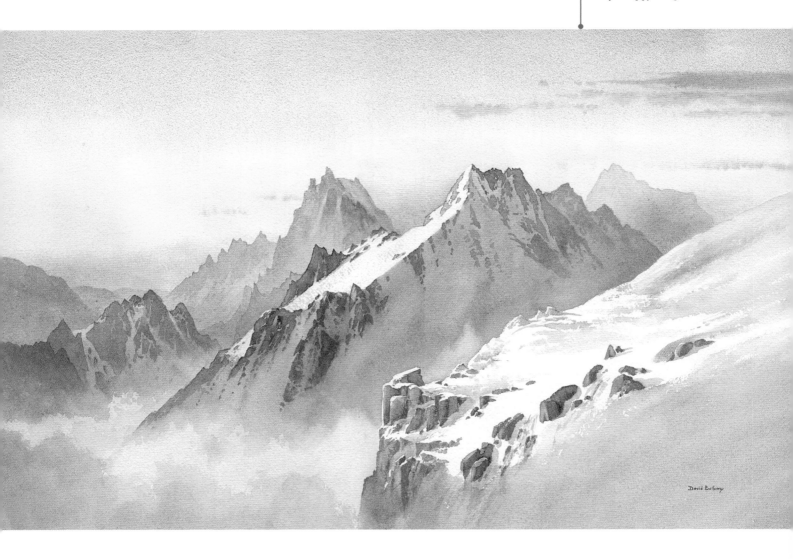

'The liver of a walrus eaten with little slices of his fat – of a verity it is a delicious morsel.' I was spared such raw delights, however, with a pleasant surprise. A plate of steaming musk-ox mince accompanied by mashed potatoes greeted me; a really delicious meal that quickly thawed me out.

The storm raged through the night, at times shaking the hut to its foundations and making us wonder if it would survive such an onslaught. By morning it had only slightly abated, so we stayed indoors. I worked on portraits of the guides. Jens with his wild countenance fascinated me. His occasional head-jerks made it a challenge to create a likeness. The tragic story of his family life gradually unfolded as we met various people later in Ittoqqortoormiit. He came from a family of twenty-four brothers and sisters, twenty-one of whom have died. These statistics made us curious, and when Jens was reluctant to talk about it through Isak, we suspected a grim tale. Apparently the twenty-four siblings, only two of whom were female, were from three mothers. One of his brothers committed suicide and was given a funeral in Ittoqqortoormiit, and afterwards the family drank themselves legless. Most of them lived at Kap Hope, a small settlement several kilometres to the south-west of Ittoqqortoormiit, and as many of them made their way across the sea

HEYWOOD BJERGE PEAKS FROM SLEDGE

I sketched this with a sort of 'jerk and stab' method while bouncing across massed sastrugi ridges on the sea ice. We were trying to race the storm, hence the reluctance to stop the sledge to do a proper drawing. Later I improved the sketch, which was rather like joining the dots.

WIND AND SPINDRIFT IN ITTOQQORTOORMIIT

The storm hit us on arrival at Ittoqqortoormiit, and for the next twenty-four hours, we could see little of the town.

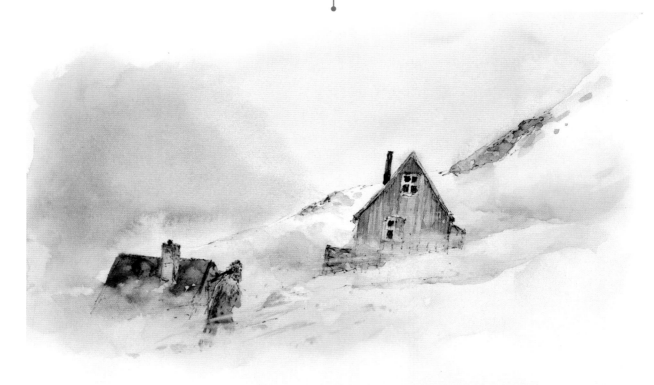

ice, a severe storm blew up. In their drunken state, they didn't stand a chance. They all perished at one stroke. Jens now had only one brother and one sister living, and he was generally an alcoholic himself when not working. As a guide and hunter he was a true professional, though excessively hard on his dogs. He had to maintain discipline and show them who was boss, but at times they were so frightened of him and his whip that they charged off into the blue yonder and he had an unwanted chase on his hands. I only wished I could converse with him directly, as I was sure he has much to tell, but I had to ask Torben questions, which were relayed to Isak, who then asked Jens: a rather cumbersome manner of working!

On the morning of our departure for the journey to Ittoqqortoormiit, Jens took exception to one of the dogs and charged at it, whip flailing, accompanied by what sounded like the most unseemly imprecations in Greenlandic. The dogs shot off, taking the sledge with them. Jens completely lost his rag and waded in with the whip, then fell over into deep snow. The sledge came to a stop, but one dog broke free from its trace, and there began a chase round the isthmus, taking Jens some time to catch the dog, administer a thorough beating and then attach the poor creature to the sledge.

Once we were on our way, we bounced splendidly across an uneven Kolding Fjord, followed by extremely rough going at Lillefjord over acres of prominent ice ridges. The jarring became so bad, it was like crossing miles of railway lines strewn across the path. To the right the jagged peaks of Heywood Bjerge reared up sharply. Being behind schedule, partly because of the morning's antics with the dogs, I decided to sketch on the move. The guides were not keen to do the last stretch in the dark and were concerned that another storm threatened to catch us out in the open. The sketching became quite ludicrous, but I was up for the challenge. For simplicity I worked in pencil, which, because of the buffeting, refused to go in the desired direction. Jabbed pencil marks appeared all over the paper, rarely in the right place. The look of astonishment on Jens' face when he glanced back left no doubt that he thought I was a few pencils short of a full box.

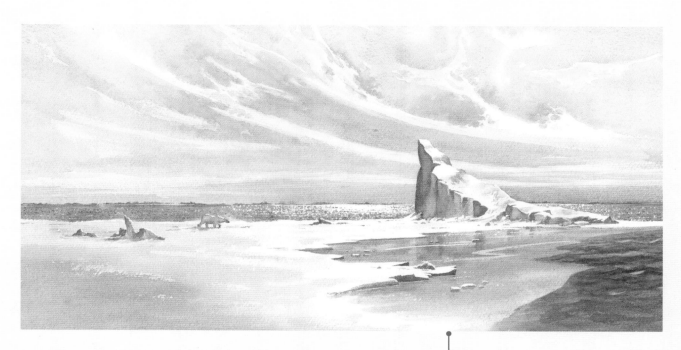

THIN ICE

The handsome iceberg was fixed into the pack ice right at the edge of the polynya, with newly formed thin ice visible on the right. I watched the new ice undulating like a sheet of thin plastic with the motion of the sea, without cracking. The polar bear was not too far away according to the locals, but it gave us the slip and I had to add one in from elsewhere.

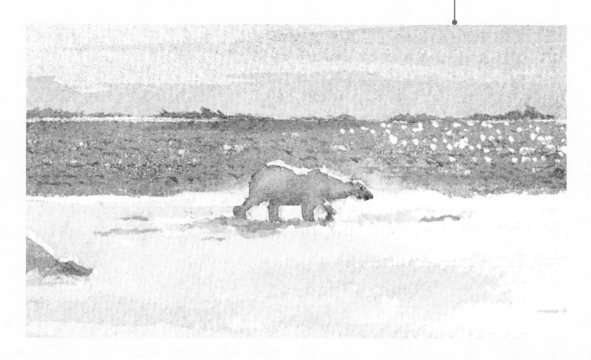

THE SCORESBYSUND POLYNYA

A polynya is a large area of open water that remains ice-free for the whole year, and is thought to be created by strong tidal currents and winds blowing in a persistent direction. On the coast round Kap Tobin, many hot springs are clearly visible, and these must affect the temperature of the seawater to keep it ice-free. The polynya enables ice-edge hunting of ringed seals and walruses, and narwhals in the spring. Most of the population of Ittoqqortoormiit, which is around 550 souls, still rely on hunting. Large colonies of Brunnich's guillemot and little auks breed here, and many other bird species visit. Polar bears are attracted by the abundance of seals. The sky over the water was alive with seabirds every day while we wandered around looking for the ice bear, which sadly eluded us yet again on our Arctic travels.

 After our sledging expedition, Torben and I stayed several days in Kap Tobin and explored part of the coastline on foot. As the snow lay deep, it required some effort, and we took turns to break trail. At one point we took a shortcut across a small bay covered in ice and snow, but soon found ourselves sinking really deep into the mushy snow. Heavily laden with packs and rifles, it would have been no joke to sink through the treacherous snow and ice into deep water, so we quickly headed back towards firm land. We came across several hot springs and realised this could well be the cause of the mushy snow.

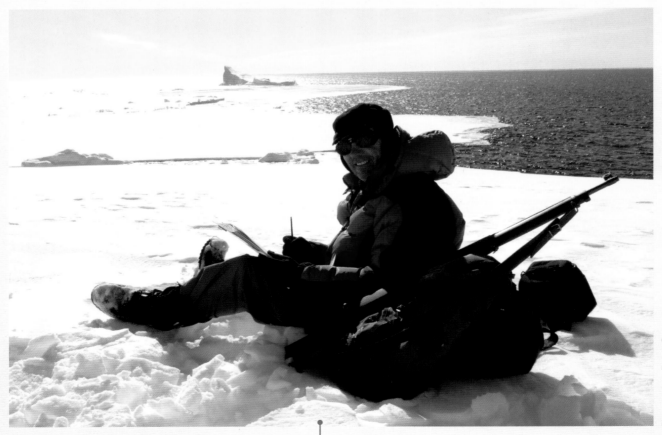

Photograph by Torben Sorensen

THE AUTHOR SKETCHING BY THE POLYNYA

I could only manage short stabs, trying to render the dramatic red pinnacles rising out of the steep mountainsides. It was like trying to sketch with someone punching and shaking you at the same time. Later I managed to turn some of the stabs into convincing crags, add some tone for the dark rocks (which also obliterated many rogue stabs) and generally give the scene more shape. The result was surprisingly pleasing.

Seemingly endless, Lillefjord eventually narrowed, and at the head of the fjord, we climbed a gentle slope across the Hvidefjeld Glacier. A wall of massive grey ice cliffs, dripping with a heavy layer of fresh snow, stood to our left. Sunlight danced on the many ledges, and how I wished there was more time to explore this wonderland of centuries-old ice. The sledges moved to the right-hand end of the wall of ice, where deep snow conveniently covered the vertical sections and provided an easy ramp for us to negotiate. It became so steep that we all got off the sledges to hike up the side of a hill through deep snow. After a few minutes, the exertion of climbing in a padded down jacket began to take effect. It took me some time to catch up with the sledges at the top of the slope.

Ahead, the view revealed miles of cold, bare, rounded hills. We were leaving the more interesting jagged peaks and heading across open, featureless terrain. Here the going seemed even slower, but this was simply in the mind. The strident line of a weather front crossed the sky directly above us, drawn like a gigantic curtain to obliterate the blue skies behind us. Lenticular clouds with strange spindly 'legs' dangling below them appeared stark against the threatening dark sky, like a fleet of alien ships from another planet. They presaged drastic weather. When I tried to sketch them, they looked like a mass of badly drawn insects hovering in the sky. Ahead lay an atmospheric haze through which the sun glowed weakly, creating a distinct shimmer on the ice and hard-packed snow – raw beauty before an impending storm. Torben and Isak stopped on the summit of

FIERY PACK ICE NEAR KAP TOBIN

As the sun lowers in the sky, the light shimmers and dances on the ice floes, creating the most lovely effects. I sketched this scene from the window of the house we stayed in at Kap Tobin. Shortly afterwards the whole area of ice floes seemed to be moving rapidly. The phenomenon electrified us, and it took some time to realise that it was the effect of massed spindrift being blown by strong winds just above the surface of the sea ice.

David Bellamy 79

a hill, and as we caught up with them, Jens got off and strode over to the dogs, whip in hand. Suddenly they shot off downhill. I didn't have time to get off the sledge. Jens again yelled obscenities (I assumed), ran after the sledge and leaped on at the last moment. Off we went at a cracking pace, hurtling round in a huge circle.

As we returned to where Torben and Isak stood for the second time, Jens stopped the sledge and I leaped off, not wanting to go round in any more circles. Once more, Jens approached his dog team, but again they took to their heels, careering madly down the slope. Roaring another fusillade of invective like some Mongol warlord, Jens leaped back on the sledge, and wielding his whip, rampaged once more across the frozen tundra. While he was going round in circles, I desperately tried to change batteries in my video

HOUSE AT ITTOQQORTOORMIIT WITH SLEDGE

camera, but I was helpless with laughter. The guttural curses and cracking of the whip faded as the sledge disappeared into the distance. Some time later it hove into view again. On arrival, Jens anchored the sledge, then set about the dogs with his whip, to the accompaniment of much yelping.

The remainder of our route was chiefly a descent southwards. At times we built up incredible speed, roaring downhill. Even though there were acres of space, the two sledges crashed into each other once, but luckily

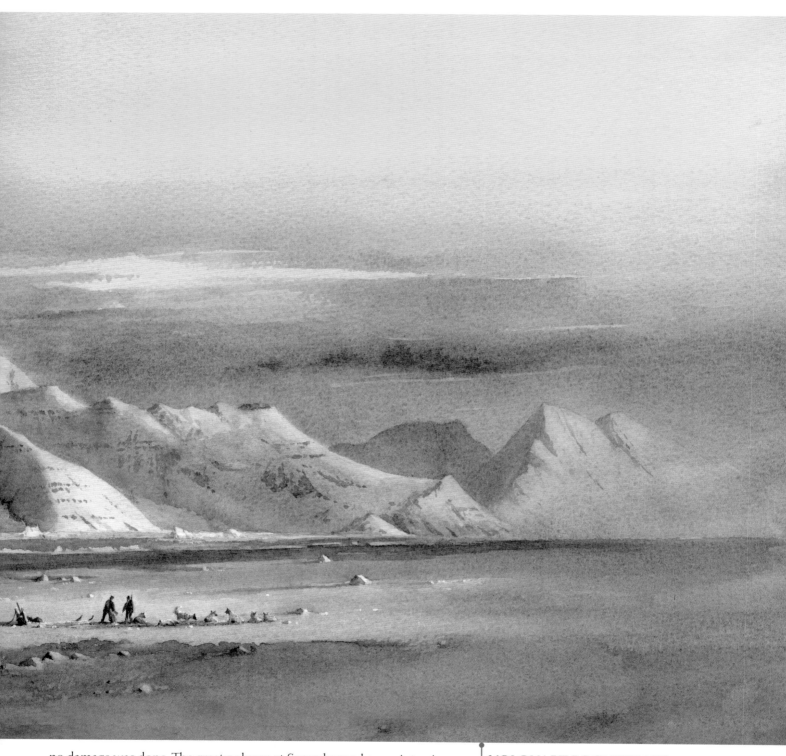

no damage was done. The great polynya at Scoresbysund came into view, a large expanse of deep blue water trapped within the greater mass of pack ice. Beyond lay the shapely white peaks of Kap Brewster to the south-west. Shortly after, the first cheerily coloured houses of Ittoqqortoormiit appeared a long way below us, and as we entered town, just about every canine inhabitant gave us a rousing welcome. The human population was somewhat less forthcoming. We had beaten the storm back.

VOLQUART BOONS PEAKS

Shapely mountains caught just before twilight, with hunters on the ice.

THROUGH ARCTIC SEAS

The Arctic archipelago of the Svalbard Islands, with its outstanding wildlife and magnificent Arctic scenery, holds a fascination for a great many, even those not especially interested in the Arctic. With its northernmost point less than 965km (600 miles) from the North Pole, most of it is permanently covered in snow and ice. A land on the extreme edge of civilisation, it is littered with the physical remains of man's endeavours to eke out an existence here. Svalbard was first discovered by the Dutch seafarer, Willem Barentsz, in 1596 while searching for the Northeast Passage, and he was followed by whalers from many European countries. The Pomors, Russian hunters, may well have seen Svalbard earlier as they went there to hunt, but their last stations there were abandoned during the 19th century.

EVENING STROLL BELOW GEOLOGRYGGEN

The glacier stream breathes and sparkles once more as it emerges from its underground passage through Kjerulfbreen Glacier.

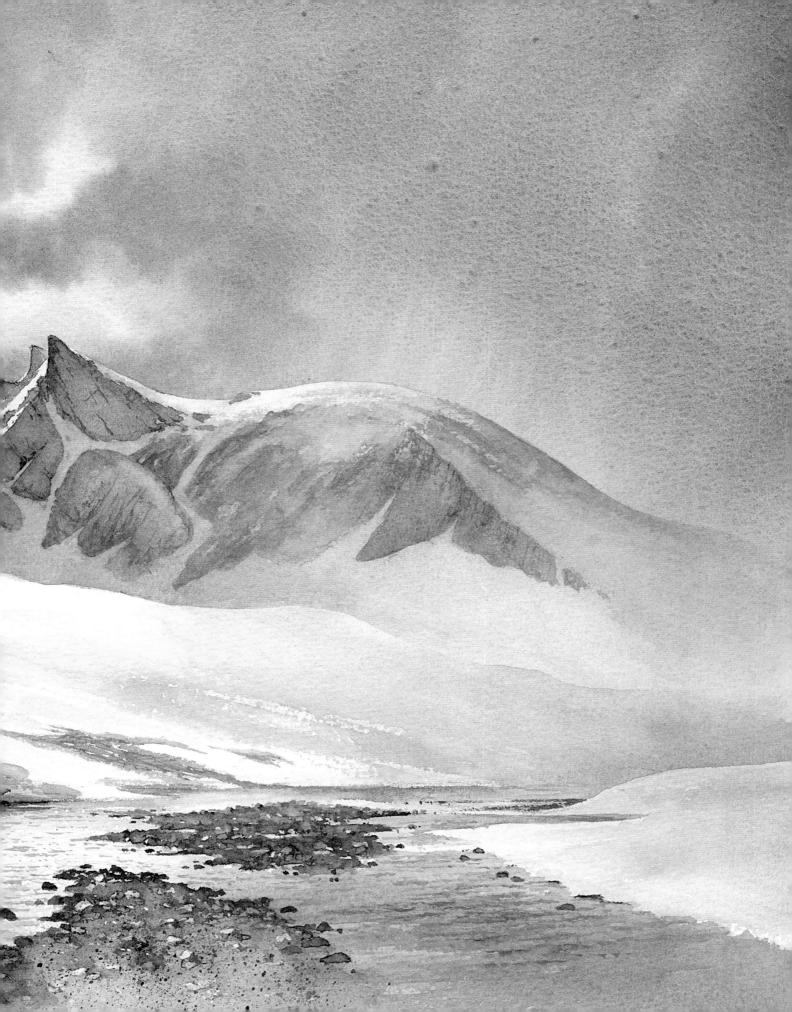

They were followed by Norwegian trappers, scientists and companies keen to extract minerals. Many of these failed, but exploitation of the natural resources of the archipelago has taken place ever since. In 1920 it came under Norwegian administration when the Spitsbergen Treaty was signed.

The combination of wild, stunningly beautiful raw mountain and fjord scenery with exciting wildlife possibilities drew me like a moth to a flame. However, I soon realised that it would be extremely difficult to access the north-west region, where the prospects of accomplishing my dream targets were highest. There are no roads outside the few settlements. We couldn't fly into the northern wastes, and no cruise ship would provide me with the opportunity to carry out detailed sketches and studies of the wildlife and topography I needed. The cost of hiring a vessel for the purpose for just two of us was prohibitively high. In the end, I decided to ask three friends who had been on an expedition with me before to join Torben and myself. To my delight they all accepted with instant enthusiasm.

Our main objective was to sail to Mushamna in Woodfjorden, on the north coast of Spitsbergen, the largest island of the Svalbard Archipelago, and to camp where we were likely to find polar bears and other wildlife: in other words to 'stick our heads in the beast's jaws'. Six of us flew into Longyearbyen, the capital of Svalbard, on an overcast day, all eager to explore this mind-blowing wilderness: Tony Brown, a Yorkshireman who had been to the Andes with me, who prefers to 'sketch' with his camera, although he also does some interesting sketches; Dr Will Williams, a geologist with English Heritage, who had joined me on several expeditions and enjoys sketching and painting a wide variety of subjects; Rosemary Hale, who is never happier than when observing wildlife and who was at that time on the point of starting her own art career; and her husband Richard who, although not an artist, was fascinated by the prospects ahead. Rosemary has

SKETCH MAP OF NORTH-WEST SPITSBERGEN

medical experience and I had valued her help on several group trips. Torben, of course, would be sketching, though like Tony, he did more with his camera than his pencil.

Our vessel was the 15m (59ft) *Jonathan*, a yacht with a reinforced hull for use in the Arctic, owned by Mark van de Weg, a tall, bearded Dutchman who thankfully had a bizarre sense of humour to match the rest of us. After filling up every conceivable storage space with food, cold-weather gear and sketchbooks, we sailed down the vast Isfjord under engine power, marvelling at the impressive cliffs that dropped vertically into the sea along the southern shore. Blessed with good weather, we made reasonable progress, and after a comfortable night aboard the craft in Trygghamna Fjord, where the handsome schooner *Noorderlicht* joined us for the night, we continued up the west coast under sullen skies. The cold grey Arctic sea did not look at all inviting, especially to a non-sailor like me, but I concentrated on sketching and our objectives. Even though it was July, the snow-clad mountains and barren coastline intensified the feeling of a cold midwinter, for the snow had fallen especially heavily that year. For me, this was a bonus, as it enhanced the sketching and photography.

The sea noticeably slackened its swell when we came within the lee of Prins Karls Forland, a long, thin island a few miles off the west coast of Spitsbergen. As we closed in to Poolepynten, a sandy promontory jutting out towards the mainland, we found a walrus colony, with masses of the beasts sunning themselves on the shore. Those in the water welcomed us with an endearing

WALRUS COLONY, POOLEPYNTEN

Most of the walruses lay on the beach, sleeping, belching and breaking wind, though some sat up as though discussing the arrival of noisy tourists. The few in the water showed their distaste for us by pointedly emitting the most revolting smells. When attacked from a kayak or small boat, walruses will counter-attack violently, and there were many incidents of early hunters having their boats smashed up or sunk.

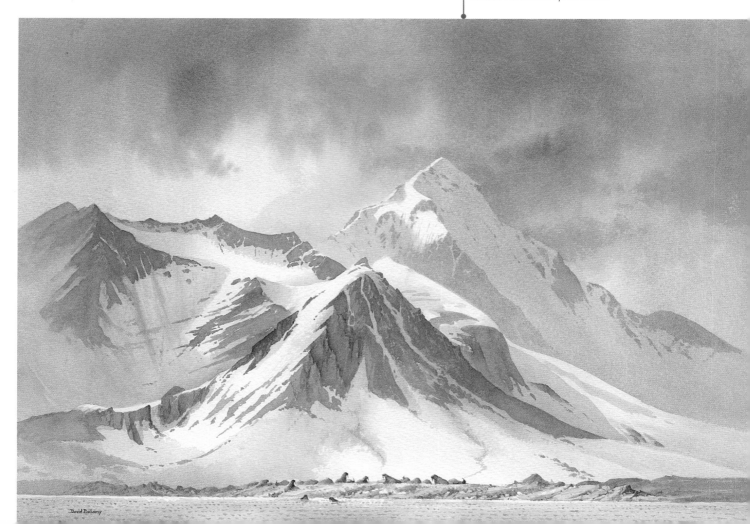

SIESTA TIME: WALRUS MONTAGE

The walrus (Odobenus rosmarus) is a splendid fellow who is quite content to pose for long periods, especially if the sun is out, and is not given to much leaping around. These didn't seem to mind a gaggle of artists turning up to paint them, and we had a field day.

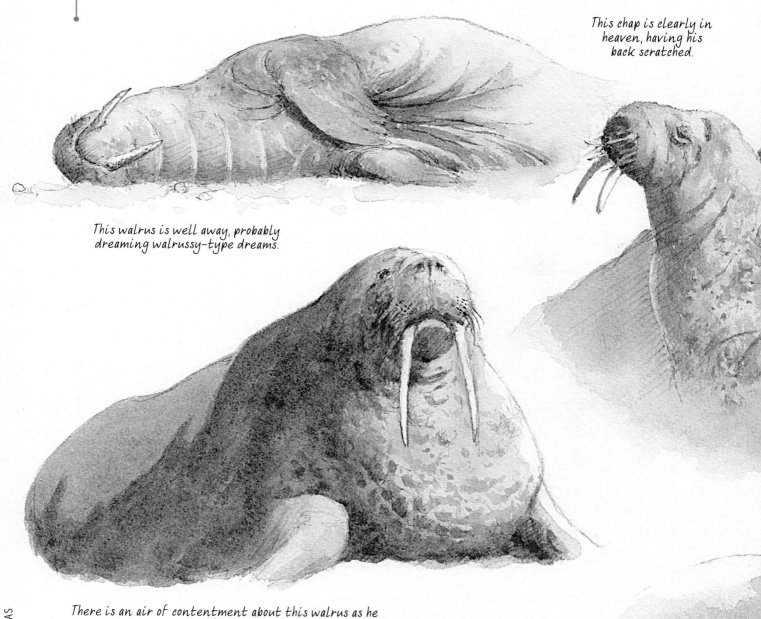

This chap is clearly in heaven, having his back scratched.

This walrus is well away, probably dreaming walrussy-type dreams.

There is an air of contentment about this walrus as he makes his ungainly, shuffling way up the beach with the poise of an overweight sergeant major, his rear end still damp after a dip in the sea.

David Bellamy

blast from their extensive rear quarters – the smell, even in the open air, was revolting.

Our yacht had a Zodiac – a semi-rigid inflatable boat – for reaching shore in difficult, exposed places. We heaved to and lowered it well away from the walruses. They will surround and attack small boats en masse if they take a dislike to you, and can easily smash them up with their enormous tusks, as depicted in many illustrations and accounts of early exploits in the Arctic. Thankfully we reached the shore in one piece, only to be set upon by angry, diving Arctic terns. The antidote to aggressive terns is to hold your stick, easel, ice axe, umbrella, no. 10 sable watercolour brush, or whatever comes to hand, high above your head and they will happily attack it rather than your head.

Once we came close to the basking walruses, the terns abandoned us, and we were able to sketch in comfort, sitting on logs that had drifted down the Arctic current from the forests of northern Siberia. By now, nature

smiled on us with the great bonus of warm sunshine. The bull walruses made excellent models, generally refraining from leaping around, or indeed expending any energy at all. Every so often they would turn over, fart, grunt and poke a neighbour in a friendly way. Their rippling rolls of rough-textured blubber came in a variety of colours, changing as they dried out after a dip in the water, each with its pattern of scars from battles with other walruses. The highlight of the fellow, though, was its be-whiskered face, with its weathered, often broken tusks, and a look that ranged from sheer contentment to puzzlement, botheration and annoyance. They didn't seem to mind our presence, although I was sure one was taking more than a passing interest in Will's beard. In my drawing it was tempting to imbue them with human characteristics, and indeed I recalled several folk who remind me of a walrus both in habit and looks.

We spent ages with our walrus friends, doing several sketches of the various characters, well aware of the great privilege of witnessing this iconic Arctic scene. Eventually we ran the gauntlet of the terns again and returned to the boat to resume our northward passage.

This old fellow appears to be contemplating life.

These two are enjoying getting a tan – walruses seem to love a bit of sun.

POLAR BEARS

The polar bear, *Ursus maritimus*, is the world's largest land predator and can be extremely dangerous, yet it is one of the most well-loved of animals. In Svalbard the numbers are happily increasing, mainly due to the ban on excessive hunting in 1973. The WWF confirm that they have returned to healthy numbers in many of the world's populations, but are concerned about how the thinning ice will affect their habitats. The bears' menu consists primarily of seals, though they are not averse to the occasional human, especially if desperately hungry, so it is essential to remain alert all the time you are in their fiefdom. This means erecting trip-wires linked to flares around the camping area, both to scare the bear and alert the sleeping campers.

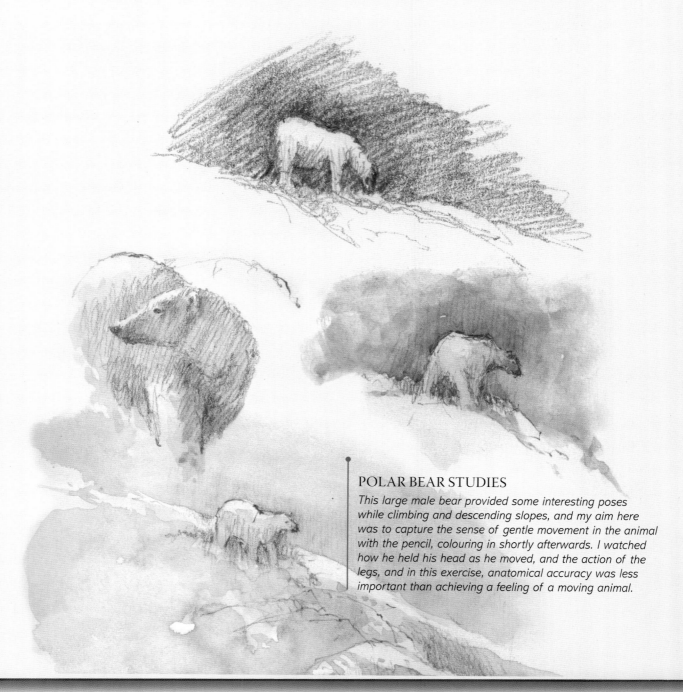

POLAR BEAR STUDIES
This large male bear provided some interesting poses while climbing and descending slopes, and my aim here was to capture the sense of gentle movement in the animal with the pencil, colouring in shortly afterwards. I watched how he held his head as he moved, and the action of the legs, and in this exercise, anatomical accuracy was less important than achieving a feeling of a moving animal.

As artists engrossed in the scenery, we were especially vulnerable, so we employed a guide to keep watch while we painted. Mark always stayed on the boat, 'to overhaul the engine,' but no doubt he was really having a siesta. We carried several .303 rifles with expandable ammunition, and Richard had a shotgun with rifled slugs, as well as flare pistols.

The last thing we wanted to do was shoot a polar bear – the idea was to frighten it away. Only as a last resort would we fire at it. Even if you hit it, you may well not kill the beast, as the vulnerable area is quite small, and a wounded bear becomes even more dangerous, gaining strength through high adrenalin.

There are hardly any predators that can take a polar bear, though while swimming it is more vulnerable, and they have been killed by the much-feared Greenland shark. In Ny Alesund, we learned that to the diving scientists' discomfiture, these sharks were known to be in the vicinity, and when one was caught, its stomach contained part of a polar bear. According to Inuit legend, these sharks, that can live over 400 years, live in the urine pot of Sedna, the goddess of sea and marine life.

ON THE PROWL
There is nothing like seeing this iconic beast in its natural environment, especially when it is this spectacular.

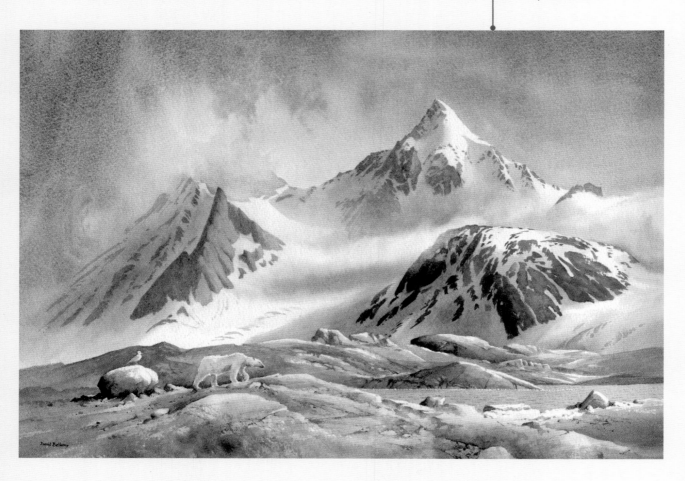

OLD TRAPPERS' HUT AT BJORNHAMNA
The hut is now used by the staff of the Sysselmann, the Governor of Svalbard.

As 'night' approached (at this time of year in Svalbard, it is twenty-four-hour daylight), the weather closed in. I retired to my bunk early as we sailed through the gloom. When I rose in the early hours for a spell of watch, the poor, misty weather was still with us, but it did give the sensation of a more normal night-time. As the early morning weather improved, we sailed up to the old trappers' hut at Bjornhamna, a place now used by the employees of the Sysselmann, the Governor of Svalbard.

Over the next few days, we basked in sunshine and calm seas, sketching the awesome mountains that rise high above a coastline indented with endless fjords. We landed on the small island of Ytre Norskoya and climbed to the summit peak, doing the obligatory searching gaze, with set jaw and heroic pose, in the direction of the North Pole, a mere 965km (600 miles) away. Now our route turned eastwards along the north coast of Spitsbergen, and not too far from where we intended to set up the tents at Mushamna in Woodfjorden, hoping to find a few polar bears to sketch. Lower down on the island, the graves of many ancient Dutch whalers were clustered together on the brow of a low ridge. Lines of stones outlined the graves. Apart from the glaciers, Svalbard is entirely covered in permafrost,

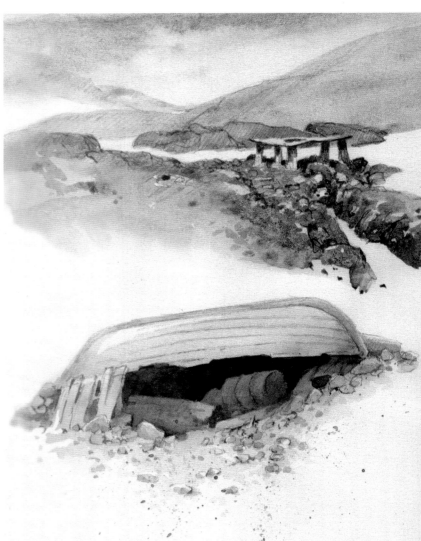

LONELY TOILET SEAT AND OLD WHALER
Tough times, when you have to sit on the loo in the teeth of a force 10 gale and bare your bottom to the elements. This seat is used by the folk manning the Sysselmann station.

which tends to push up anything buried, and this is one reason it is against regulations to die on the archipelago.

We called up Mark on the radio and he picked us up in the Zodiac. Soon the *Jonathan* was ploughing north-eastwards, the sea sparkling in strong sunlight. After a while we encountered ice floes. These increased, and soon we could make out a wall of white ahead of us, a mass of broken drift ice. Mark reduced speed to a crawl to edge our way through the ice blocks, some with fantastic shapes. Every now and then the hull bumped against one, or scraped past. The skipper kept a watchful eye to make sure we didn't get wedged in between the larger moving blocks of ice, and all the time we searched the icy horizon for bears. The drift ice became thicker, and safe passage more precarious, until Mark decided it was not safe to continue further into this ice jungle that could easily trap and crush the boat. We backed off, still watching for bears, but without luck.

BEARDED SEAL POSING
ON AN ICE FLOE

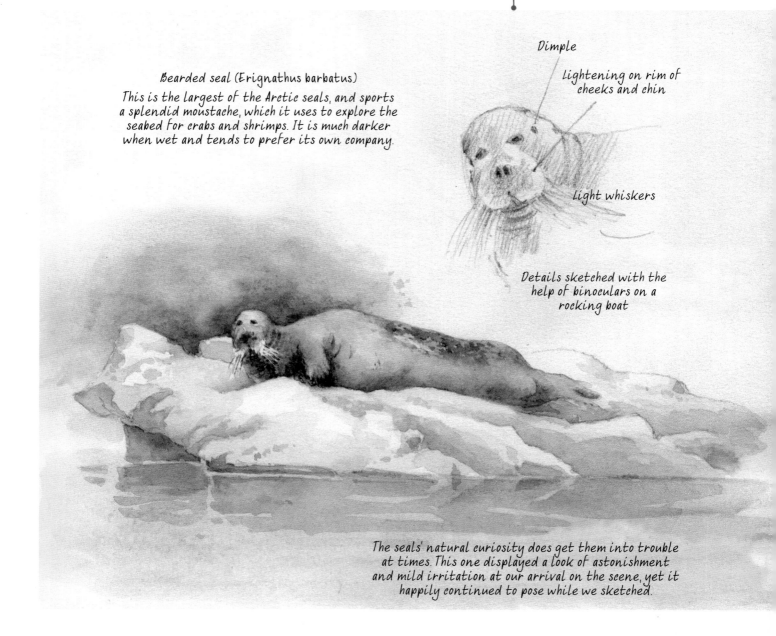

Bearded seal (Erignathus barbatus)
This is the largest of the Arctic seals, and sports a splendid moustache, which it uses to explore the seabed for crabs and shrimps. It is much darker when wet and tends to prefer its own company.

Dimple

Lightening on rim of cheeks and chin

Light whiskers

Details sketched with the help of binoculars on a rocking boat

The seals' natural curiosity does get them into trouble at times. This one displayed a look of astonishment and mild irritation at our arrival on the scene, yet it happily continued to pose while we sketched.

We discussed the options. Getting to Mushamna would be extremely hazardous, if not impossible, and naturally Mark did not want to risk the boat. Even if we did get into the fjord, we could easily find ourselves trapped in there by drift ice for the rest of the summer.

We headed for nearby Raudfjorden, while we considered new plans. The boat glided serenely up the fjord, while a line of shapely snow-clad peaks on the starboard side increasingly drew gasps of wonderment from the group. A high sun made the water dance and sparkle with light and with hardly a breeze, our passage became dream-like in this Arctic jewel of a fjord. Ethereal ribbons of cloud drifted across great glaciered corries, adding to the sense of overwhelming grandeur. The scale was jaw-dropping. For some time, we were all struck dumb, simply gazing in awe at this unfolding panorama of matchless icy beauty. Within minutes, our despair at failing to reach our planned campsite had turned to ecstatic admiration for one of the most sublime scenes I had ever witnessed on earth.

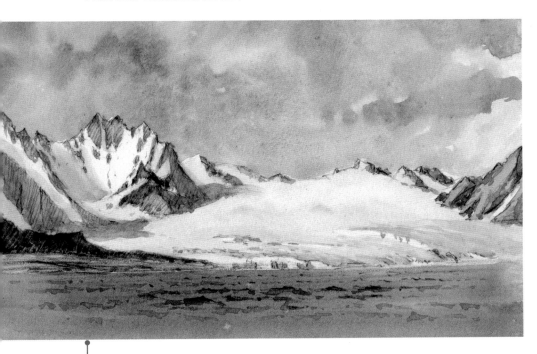

AAVATSMARKBREEN GLACIER
One of a succession of impressive glaciers in North-West Spitsbergen.

Our mesmeric trances were suddenly shattered by a yell as a minke whale surfaced off the port bow, and we all rushed to see. For some time, the boat moved around at crazy angles as we tried to get shots of the whales, but they proved elusive. My photography was wretched, capturing only indefinite rippled water, sometimes with the addition of a piece of broken ice, but no whale anywhere to be seen, so I resorted to a sketch. Caught unawares, I had only the rear side of a map and a fibre-tip pen to hand, so this was not going to be a major piece of artwork. I managed a half-sketch before we gave up as the whales stopped performing.

SV *NOODERLICHT* EDGING THROUGH THE ICE
The Noorderlicht *stayed with us for a few days, a handsome ship that made a fine focal point in a painting, with an endless backdrop of magnificent mountain and glacial scenery.*

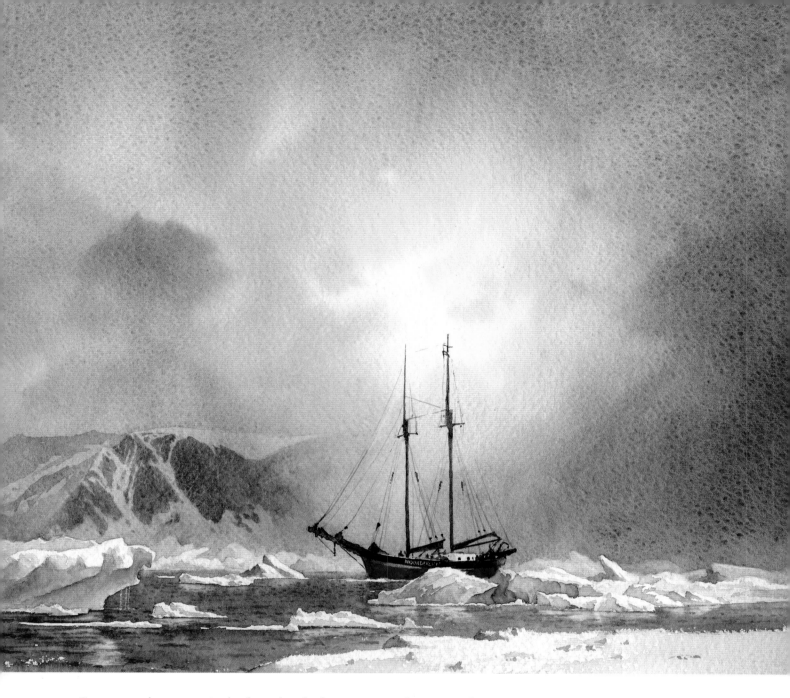

Once more the mountains beckoned and calm was restored. Never-to-be-forgotten scenes slid by while we sketched and photographed. As we approached Hamiltonbreen with its great broken wall of shattered ice cliffs, spectacularly sculpted by nature's forces, one cliff, set a short way back from the shoreline, rose sheer, some thousands of feet, while Brunnich guillemots wheeled in the sky above us with a raucous noise. The fledglings are encouraged to fly by their parents by the simple process of shoving them off the cliff. Some manage to flutter ungainly down to the sea, others fall on the tundra below. Small dots moved nimbly across the lower snow slopes and binoculars revealed them to be Arctic foxes. They moved rapidly across difficult terrain to catch the chicks that plunged off the cliffs above. The foxes were clearly having a field day. Up to seventy percent of the chicks are lost to foxes, glaucous gulls or injuries when hitting the ground.

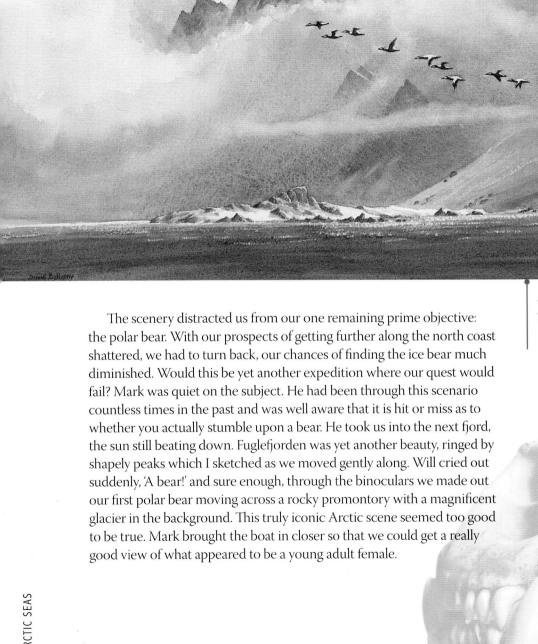

The scenery distracted us from our one remaining prime objective: the polar bear. With our prospects of getting further along the north coast shattered, we had to turn back, our chances of finding the ice bear much diminished. Would this be yet another expedition where our quest would fail? Mark was quiet on the subject. He had been through this scenario countless times in the past and was well aware that it is hit or miss as to whether you actually stumble upon a bear. He took us into the next fjord, the sun still beating down. Fuglefjorden was yet another beauty, ringed by shapely peaks which I sketched as we moved gently along. Will cried out suddenly, 'A bear!' and sure enough, through the binoculars we made out our first polar bear moving across a rocky promontory with a magnificent glacier in the background. This truly iconic Arctic scene seemed too good to be true. Mark brought the boat in closer so that we could get a really good view of what appeared to be a young adult female.

Looks a bit too cold...

Ah, it's quite nice now I'm in.

I'll just get out and see what's going on here.

I'll just give myself a shake ...

Nothing quite like a roll in the snow and a rub on the back.

I'll just rub my chin a bit to dry off.

Hmm, think I'll have a snooze before I chase those birds.

AFTERNOON DIP – POLAR BEAR MONTAGE

This bear decided to go for a swim across to a small rocky island, whether to chase birds, grab their eggs or just enjoy a dip is uncertain, but this shows the sequence of her actions as she progressed. She left us all astonished with her antics.

POLAR BEAR BENEATH GLACIER CLIFFS

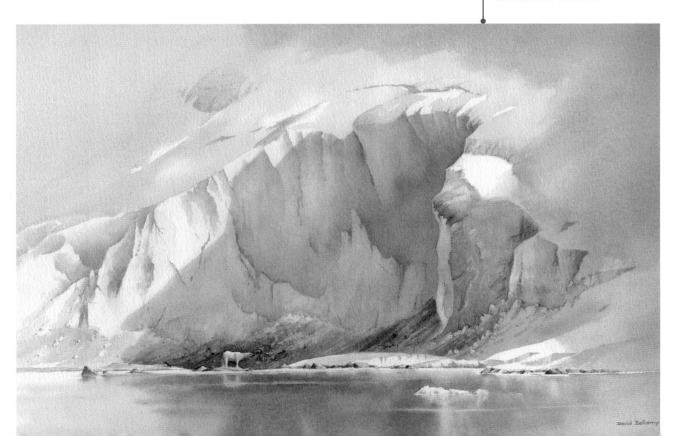

WINTER HUNTERS OF SVALBARD

There are many abandoned *fangsthutte*, or hunters' cabins on Svalbard, built from logs that float down the Arctic currents from Siberia. In the past, hunters, including some lone females, would over-winter, staying in these huts month after month, when you can't tell night from day, and some of their provisions still lay scattered around the hut in rusting tins. Some went quite mad. The most famous female hunter was Wanny Wolstad, who over-wintered in Svalbard over several years. Born in 1893, she was an expert shot and trapper from Tromso in Norway, and she even pioneered the town's taxi service in the 1920s.

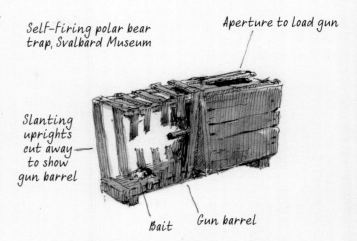

Self-Firing polar bear trap, Svalbard Museum

Aperture to load gun

Slanting uprights cut away to show gun barrel

Bait

Gun barrel

When the bear stuck its head inside and grabbed the bait, it pulled a cord that fired the trigger. Sadly, many bears were simply wounded or died a slow death.

POLAR BEAR TRAP

REMAINS OF A TRAPPERS' CABIN

Foxes and bears were hunted in winter when their fur is at its best, and seals in the spring. During summer, bird hunting and egg-collecting took place, while in the autumn, ptarmigan and reindeer were the prey. One especially nasty trap was used to kill polar bears: it involved a wooden box with one end open while the opposite end held a rifle aimed at the open end. When a bear stuck its head inside to grab the bait, the rifle would be triggered by a cord. Many bears did not die immediately, but suffered a lingering death, and as some of them had cubs, these also suffered drastically before dying of starvation. If they found live cubs, hunters would sometimes try to keep them alive, but this type of trapping was a foul business that drastically reduced the polar bear population. Eventually it was outlawed. Incidentally, it is against the law to interfere with, tidy up or remove the 'cultural litter' such as rusting tins of margarine, old pots and general detritus from hunters' sites, mines, and so on, in Svalbard.

At first the bear seemed quite dour. Our presence certainly didn't bother her. Without warning, she exploded into action, chasing the gulls and ducks and grabbing their eggs. She adopted many poses for us as we sketched, photographed or simply gazed in admiration at this beautiful but deadly beast. After a while, like some coy young lady kitted out in her bikini for the first time in public, she looked all round, then gently slid into the sea and swam to the next rocky islet, where she shook herself vigorously as she emerged from the water. She rolled over, cavorting in the snow, rubbing her chest and nose into it, using the snow like a towel to dry her fur. She rolled onto her back and kicked her legs in the air in a spectacular performance, and all this against the stunning backdrop of the glacier and high snow-clad peaks. It was almost as though she was putting on a performance for us. Many of my drawings of her were left unfinished as she adopted yet another pose. I filled several pages with half-done sketches. None of us had expected this: nature in its raw magic, a combination ranging from beauty, sudden bursts of wild energy, to unbridled movement and comic chases over the rocks. It was truly humbling witnessing such a beautiful and awesome creature perform in this way, in such magnificent surroundings.

POLAR BEAR CLAW

LONELY HUNTERS' HUT

The hut can be seen to the left of the birds in flight, and is slowly disintegrating in its exposed position. The beach is strewn with logs brought down from northern Russia on the Arctic current.

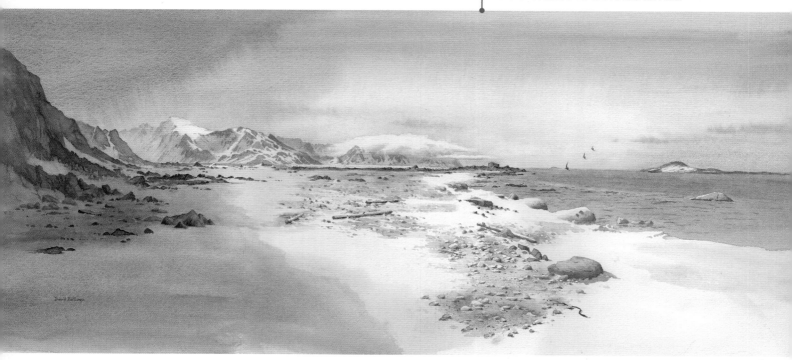

After spending hours observing the bear, we left in euphoric mood with the last of our main expedition objectives achieved. It is hard to visualise anything that could surpass the amazing scenes that we had all witnessed.

The next day we landed near the old whaling hut at Sallyhamna and set off along the shoreline, glad to stretch our legs, even over rough and snow-covered terrain. Here the shore lay flat for about half a mile inland where it rose almost sheer to a series of shapely peaks, mostly covered in cloud formations. By a frozen tarn, we paused to admire masses of thick cloud rolling dramatically at high speed down a ragged mountain crest, driven by ferocious katabatic (descending) winds in a seemingly never-ending belt, a great dark vortex of boiling, swirling vapour which was challenging to capture in a sketch. Strangely enough, the wind did not reach us in any strength. We stumbled upon a ruined log cabin once used by hunters, and tried to imagine its former occupants and their harsh way of life.

KATABATIC WINDS COMING OFF TESSINFJELLET

Clouds hurtled down the mountainsides with a ferocity I had never witnessed before, swirling and boiling up like some aerial maelstrom. The phenomenon was not easy to capture in watercolour, but I had a go and ended up with a delightful mishmash of incoherent splodges, from which I painted this watercolour.

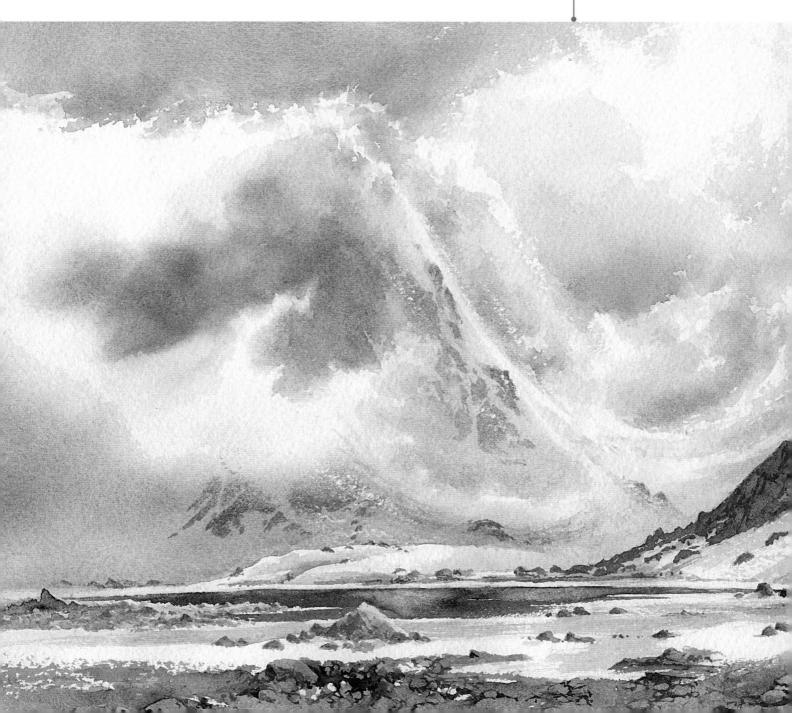

BIRD ROCK, HAMILTONBREEN

Sunlight gleams on the water while thousands of birds fill the sky around the left-hand cliff, hardly discernible beneath the layer of cloud.

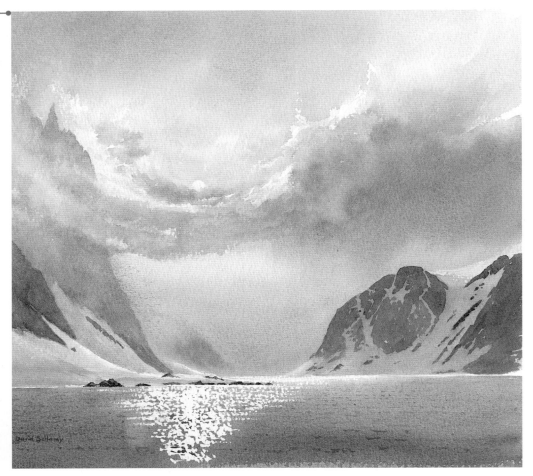

GOING ASHORE IN THE ZODIAC

Arctic skuas allow you to get quite close to them on the ground, provided they are not on a nest ...

Take-off - a good time to sketch, as they are much slower then.

The skuas attacked from a variety of angles and directions. It was quite a spectacle and I didn't think the fox could survive long against such a determined and coordinated assault. It simply had no answer to the speed and violence of these birds.

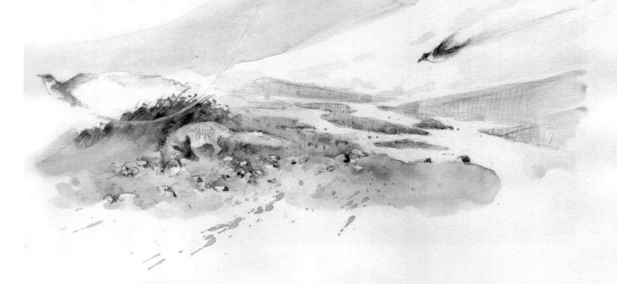

Arctic fox being dive-bombed by skuas, Blomstrandhalvoya. The fox looked petrified as the pair of skuas attacked, but they ceased when the fox moved away – no doubt it had wandered too close to their nest.

ARCTIC FOX ATTACKED BY SKUAS

The young fox strayed across the braided stream, but it was too close to the nesting site for the skuas, which set upon him with a vengeance. As we watched, they dive-bombed the fox mercilessly, each bird from a different angle. The Arctic skua has been known to break open a man's skull, so we doubted that the fox would survive such a ferocious attack. After a few moments, totally bewildered and terrified, the fox retreated across the stream and the birds left him alone.

After a few days, the weather began to deteriorate, so that at times we had difficulty landing the Zodiac. We stayed overnight at Ny Alesund, originally a coal-mining settlement, but since the 1960s developed as a place for international scientific research, and the most northerly settlement in the world. I did several sketches, including a rough pencil sketch, done in atrocious weather conditions, of the airship mast built for Umberto Nobile's airship, the *Norge*, in which he was intending to fly Norwegian explorer Roald Amundsen (1872–1928) over the North Pole in 1926. They flew across the pole and ended up in Alaska. Amundsen's statue stands in Ny Alesund. One of the greatest polar explorers, he perished in an aircraft on a rescue mission to locate the the airship *Italia* in the Arctic in 1928. A taciturn, poker-faced giant of a man, he was once given an Inuit jacket and commented that he wouldn't mind some Inuit underwear as well. To his astonishment, the Inuit fellow who had provided the jacket took off his own underpants and Amundsen was obliged to change into them in front of the man and his wife.

RAGING ARCTIC SEAS
The non-sailor's nightmare as we headed south through stormy seas, chilled to the bone despite many layers of clothing.

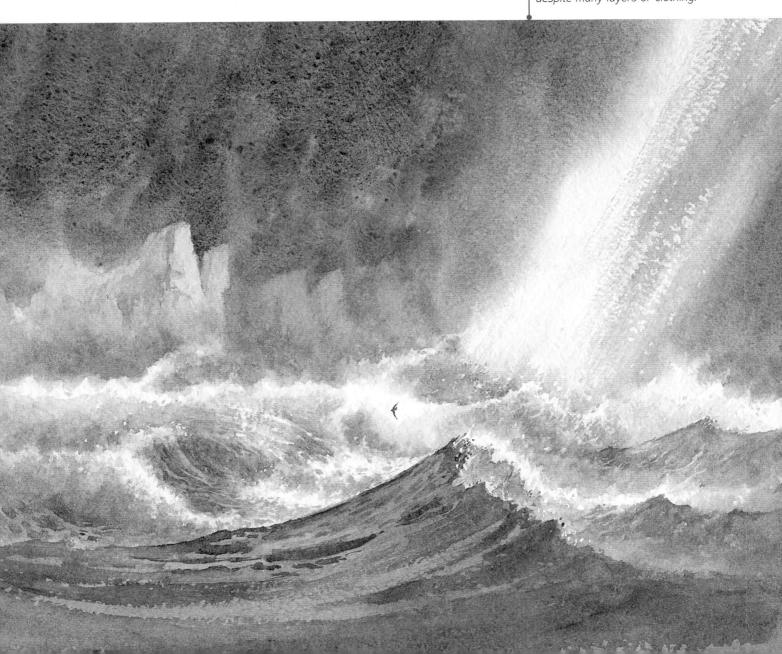

It was time to head back south to Longyearbyen, but once we cleared harbour, the monstrous seas hit us, pitching our little craft around violently. Massive waves dwarfed the boat. The sea seemed to be above us, a raging, threatening wall of cold, grey water. The temperature plummeted and flurries of snow and sleet increased the tempo. We glimpsed occasional points of land and ice, and sketching became a challenge while being tossed around like a pea in a cauldron. Even the seabirds seemed to have deserted us. The boat took a real pounding as we headed directly into the full fury of the storm, and although we all remained cheerful, there was a nagging feeling that these stormy Arctic seas were not the place to experience capsizing!

THREE MEN IN A ZODIAC
Torben, Mark, the skipper and Thorbjon, the Norwegian guide, returning to the boat.

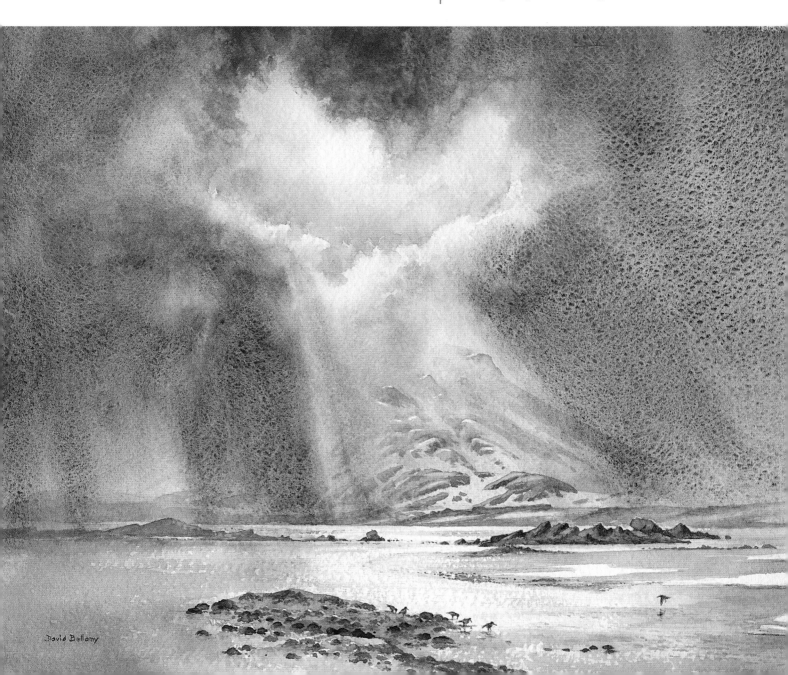

David Bellamy

For hours the engine drove us into severe headwinds through the storm. The cold penetrated the thick layers of my Arctic gear. Descending into the cabin to find more clothes would probably bring on sickness, so like the others, I stayed on deck as the sky darkened. Even though this was twenty-four-hour daylight, it felt like the Arctic night. Torben kindly distributed some chocolate while bemoaning the lack of Danish pastries to boost morale. Afternoon tea or coffee was absolutely out of the question, as even with the combined skills of a gymnast, contortionist and juggler, it would be hazardous, and I don't think any of us was suitably qualified. It seemed ages before we eventually came within the lee of Prins Karls Forland and the sea abated sufficiently to make our going easier. We could now venture below deck without that desperate feeling of intense nausea about to overwhelm us.

CHASM OF LIGHT, TRYGGHAMNA

Purple sandpipers find sustenance in the braided stream that flows out from under the Harrietbreen Glacier, while sunlight cascades through a break in the clouds.

SVALBARD EXPEDITION GROUP

Here the group stands beside the walrus colony on Poolepynten beach. From left to right: Torbjon, the Norwegian guide; Torben Sorensen; Rosemary Hale; Richard Hale; Tony Brown; the author; Will Williams.

CANYONS
OF ICE

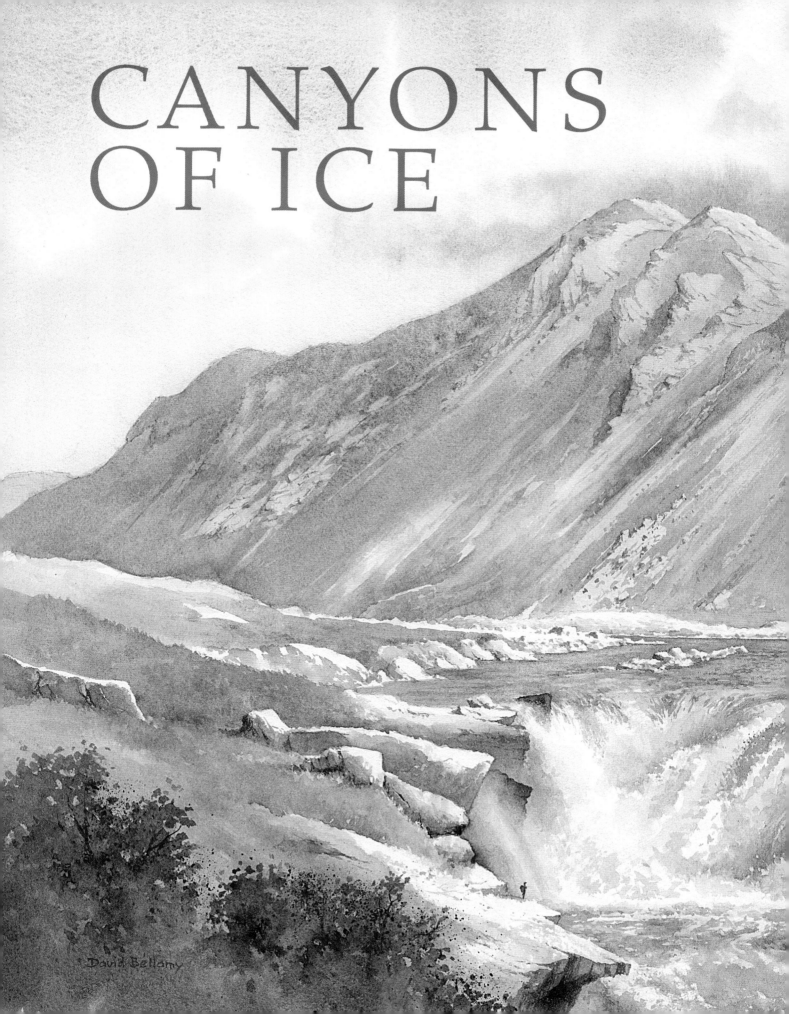

David Bellamy

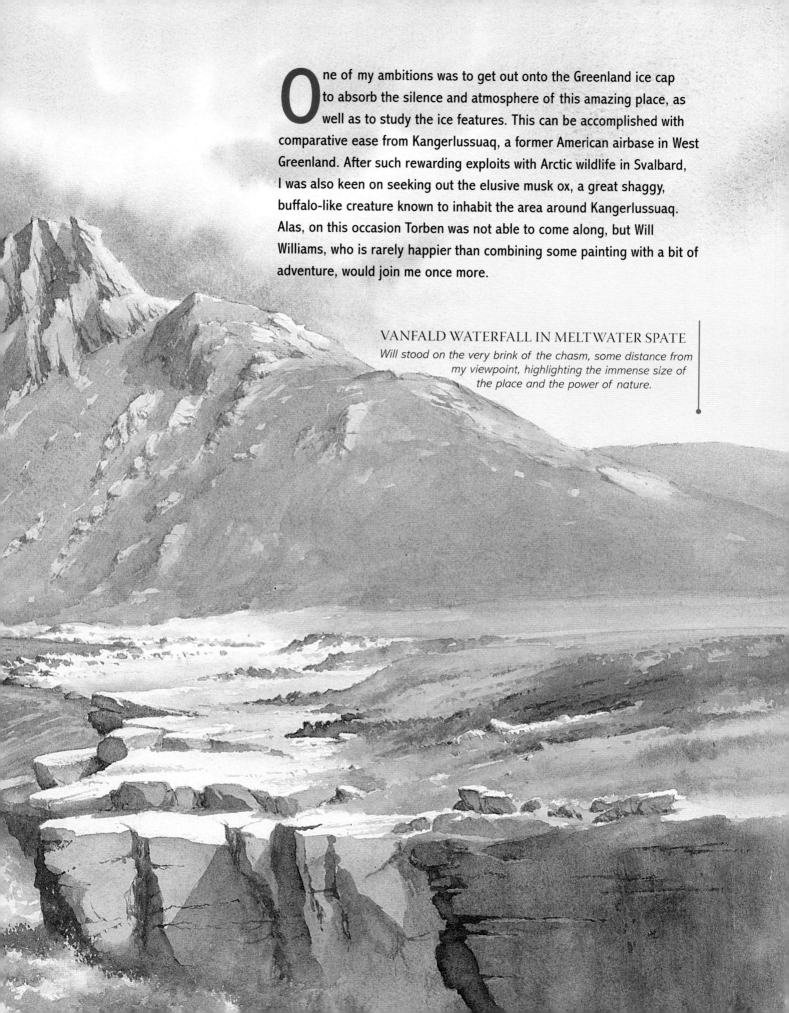

One of my ambitions was to get out onto the Greenland ice cap to absorb the silence and atmosphere of this amazing place, as well as to study the ice features. This can be accomplished with comparative ease from Kangerlussuaq, a former American airbase in West Greenland. After such rewarding exploits with Arctic wildlife in Svalbard, I was also keen on seeking out the elusive musk ox, a great shaggy, buffalo-like creature known to inhabit the area around Kangerlussuaq. Alas, on this occasion Torben was not able to come along, but Will Williams, who is rarely happier than combining some painting with a bit of adventure, would join me once more.

VANFALD WATERFALL IN MELTWATER SPATE

Will stood on the very brink of the chasm, some distance from my viewpoint, highlighting the immense size of the place and the power of nature.

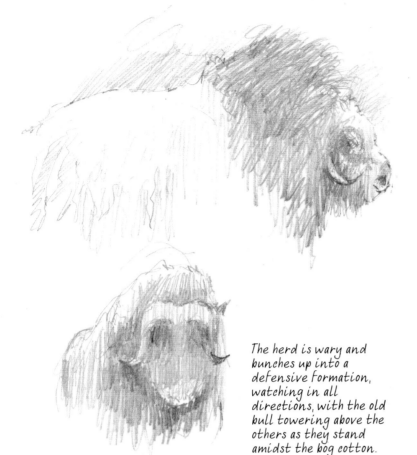

The herd is wary and bunches up into a defensive formation, watching in all directions, with the old bull towering above the others as they stand amidst the bog cotton.

Kangerlussuaq is a dreary spot, set in a shallow valley at the head of Kangerlussuaq Fjord, some 185km (115 miles) long. When we visited, the exuberant July glacial meltwater of the Watson River ran in torrents into the fjord. To the north rose a landscape peppered with thousands of small lakes, while to the south a more mountainous landscape also contained a vast quantity of lakes.

Will and I began the hunt for the elusive musk ox by exploring the immediate area on mountain bikes, and it was not long before we were seeing them everywhere in the distance. Unfortunately, getting out the binoculars always revealed that we had spotted nothing more than large boulders. How easy it is to see boulders moving across the landscape when you are firmly convinced they are wild animals. We sketched and climbed the hills, still on bikes, romping over large slabs of flattish grey rock. The best views were glimpses of the distant ice cap, stark-white between gaps in the peaks. What really caught the eye, though, was the intense reds and oranges of the low-lying vegetation. They provided striking foregrounds to a number of colour sketches throughout the trip.

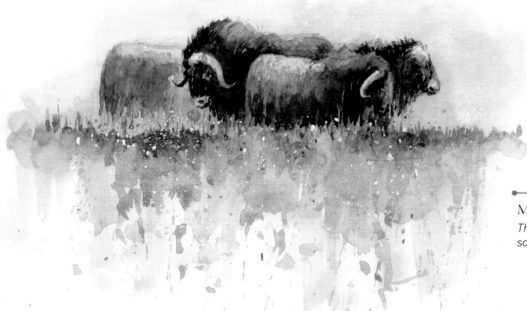

Musk ox bull guarding the rear of the herd

MUSK OX IN BOG COTTON
This group stayed statuesque for some time while I sketched.

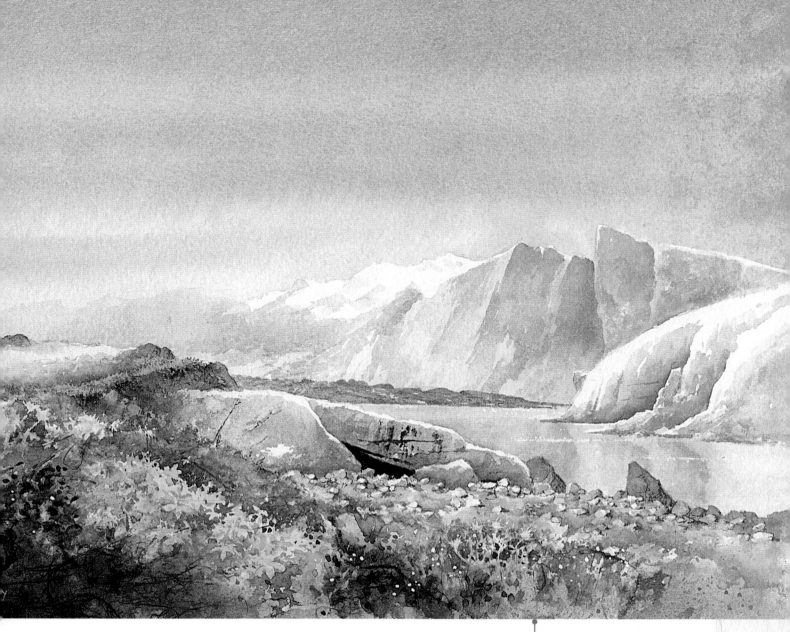

*The vivid colours of flowers
and vegetation are an
absolute delight, especially
for the artist seeking
colour to brighten up an
otherwise austere scene. It is
astonishing that such delicate
beauty survives in such a
hostile location.*

One of our targets up the main valley was the Vanfald Waterfall, especially with
the glacial spate roaring down. Again, we rode off on bikes, this time up the wide,
stony Land Rover track which eventually led to the ice cap. In places the going was
fairly easy, but here and there ruts and large stones by the truckload make cycling
purgatory, especially with my lack of cycling preparation. Several vehicles passed us,
carrying tourists on a day visit to see the ice cap. Each time, they were accompanied
by a cloud of dust which totally engulfed us, as the climate here was surprisingly dry.

After a mile or so, I went into a wobble when I spotted some genuine non-
boulder musk ox moving amidst low willows on the opposite side of the river. I
studied them for some time before starting to draw. Sketching wildlife demands
extreme patience, and this was no exception. Although these beasts were the size
of a bull, not much was visible among the willows, and they became totally lost
when they sat down. I began by drawing all that I could see – a bit of dark fur and
the end of a horn – then waited in the hope that a bit more might be revealed. The
back end of one appeared, so I fitted it into the sketch, trusting it belonged to the
same animal and praying the bit in between would match up in the finished sketch.

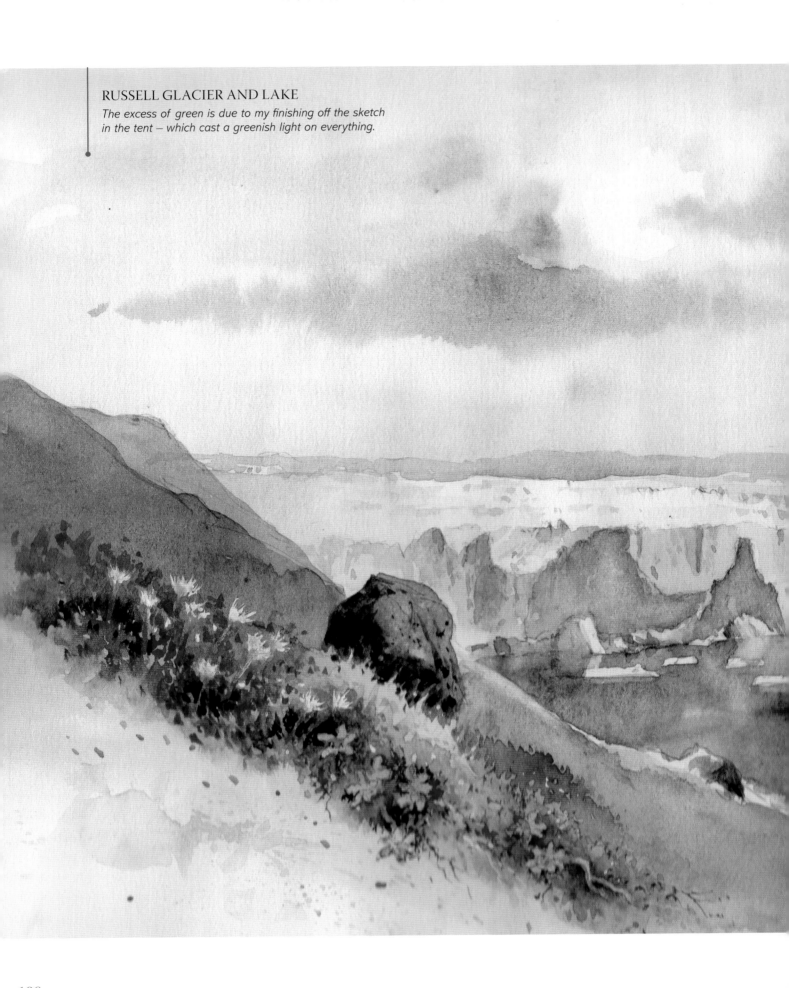

RUSSELL GLACIER AND LAKE

The excess of green is due to my finishing off the sketch in the tent – which cast a greenish light on everything.

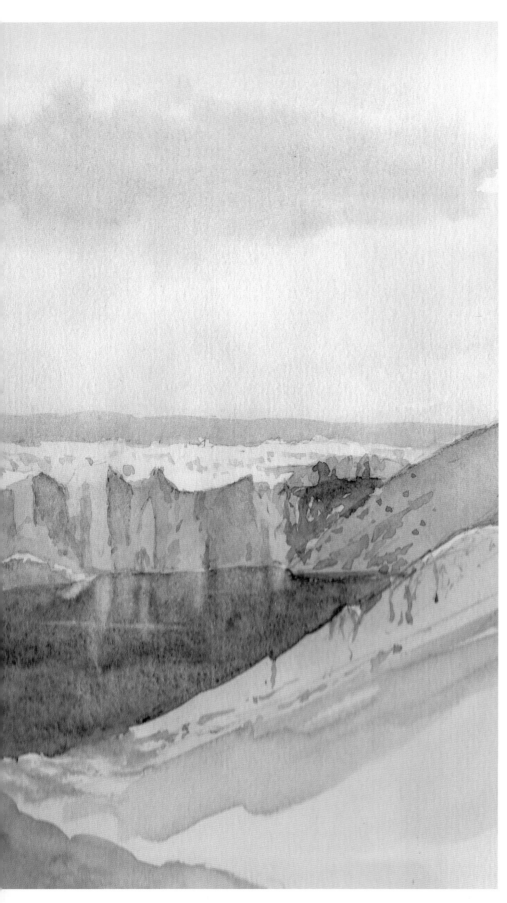

Having to observe them through binoculars made it more than doubly difficult. The process was further complicated by the fact that some of the musk ox were shedding their fur, so they looked as though they were wearing extraordinarily badly fitting, ill-matched toupees, and the fact that these were a much lighter colour than their bodies added to the confusion when they were seen from a distance. We had to wait for them to appear in a gap, then painstakingly try to draw them. I attached the binoculars to a tripod, which made it easier to keep tabs on them, but it was a long-winded effort. The resulting sketches were incoherent dabbles. Eventually the animals moved further away into the willow, and became lost from sight.

Our route continued up the track, then struck off on a more pleasant footpath, which for much of the time was delightfully mossy. Will was leading, revelling in the slightly downward slope, when without warning his bike stopped with a jerk and he flew over the handlebars, happily landing in a patch of vegetation. The experience didn't seem to affect his enthusiasm, and we soon rejoined the river.

Here it was much more rocky, and before long we came upon a savage gorge where the river was at its wildest. We abandoned the bikes, as there were many obstructions and in places the track was only inches wide and poised precariously above a sheer 18m (60ft) cliff. Ahead lay the highest peaks we had seen so far.

TENT ON THE ICE

We continued on foot, climbing up the side of the gorge with the grey glacial water roaring and churning below us in absolute fury. I had only seen water this violent in the Urubamba River in Peru. The river twisted in wild contortions yet again as it was forced between the sides of the huge cleft. Water exploded high into the air where it hit a rock.

We climbed up enormous slabs of rock that sloped precipitously over the maelstrom, and the waterfall came into view ahead. The whole scene resembled a giants' playground, with the immense grey mass of glacial water crashing over the falls, throwing up clouds of mist, with the gleam of a rainbow rising out of the spray, in the wildest juxtaposition of chaotic rock and crashing water. Above and beyond rose a ridge of handsome peaks to cap a truly stunning vista – a fitting backcloth to some epic Norse myth.

SUNSET OVER THE ICE CAP

I achieved this by using watercolour pencils, then laying on water with a brush, while working just inside the tent.

Opposite

MOULIN ON THE ICE CAP

We found several moulins, where the surface meltwater streams drop down into the bowels of the ice cap.

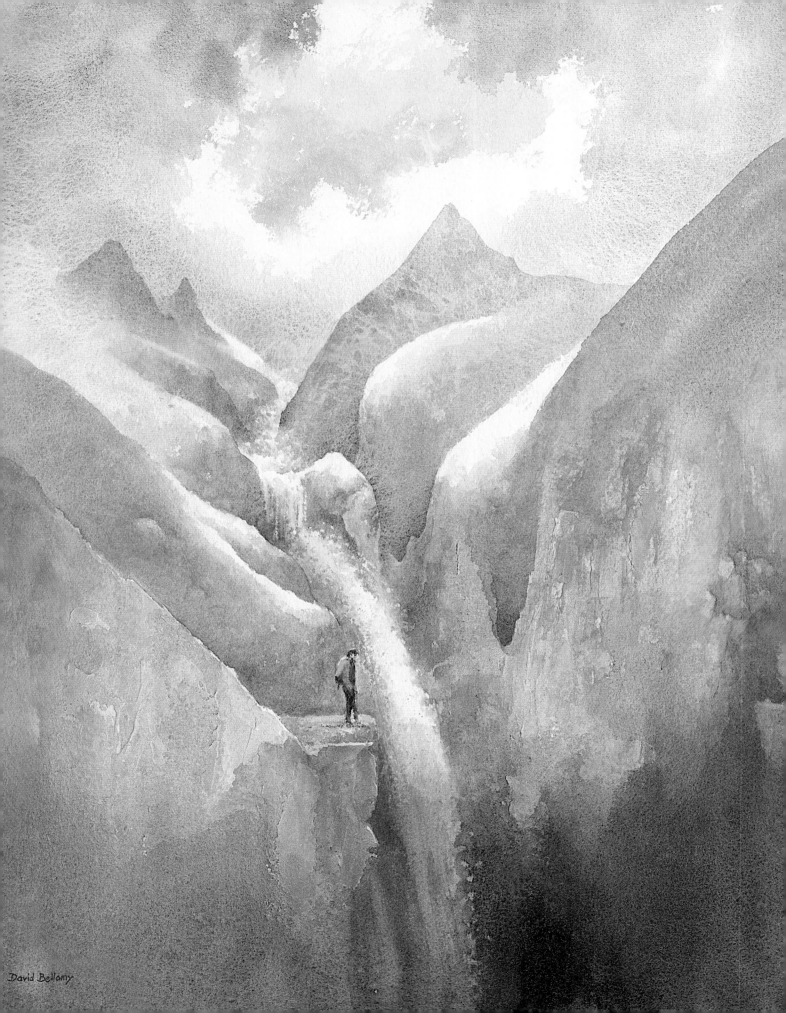

David Bellamy

THE GREENLAND ICE CAP

The inland ice of Greenland is almost exclusively formed of glacier ice, compressed by the weight of snow rather than by freezing. At its deepest in the central part, it is over 3km (1¾ miles) thick. While most of it is flat or smoothly undulating, it is deeply fissured with dangerous crevasses where it drops down sharply at the outlet glaciers around the edges. Normally these crevasses run parallel, but in certain places, the ice is so shattered that there are also crevasses at ninety degrees to these, forming a barrier impossible to negotiate on foot, sledge or ski. In the summer heat, meltwater lakes, streams and rivers form and great care is needed when crossing these features, which can also cut you off from retreat. Meltwater lakes can drain suddenly, the water disappearing into the ice cap. In a fast-moving meltwater river, if you are swept off your feet, it is almost impossible to recover before you are sent hurtling down a huge gash, or moulin, into the depths of the ice cap.

Because of the great dangers involved in traversing the ice cap, there are strict rules for expeditions, whether crossing by dog-sledge, skiing or para-skiing. The first person to cross the Greenland ice cap was Fridtjof Nansen in 1888. He took with him a sketchbook and drawing materials and carried out many sketches. In 2008, three Norwegian women, Ingrid Langdal, Saskia Boldingh and Silje Haaland, crossed from Narsaq in the south to MacCormick Fjord in the north, a journey of 2,300km (1429 miles), in thirty-three days. Calling themselves 'Girls in a Gale Expedition', they used kites and ski sails to haul their pulks (supply sledges), and on one day they covered an amazing 313km (195 miles).

Greenlanders, however, sensibly avoid the ice cap.

GLACIAL POOL ———————

GLACIAL STREAM ON THE GREENLAND ICE CAP
As the sun melts the ice, these streams grow larger throughout the summer days.

CROSSING THE ICE CAP WITH A PULK
Here Kim is towing the pulk, followed by Will Williams.

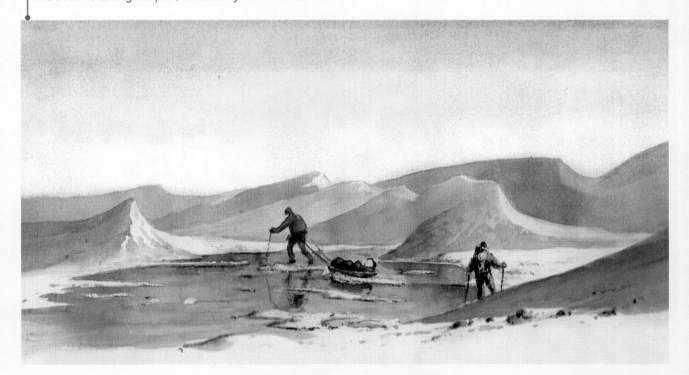

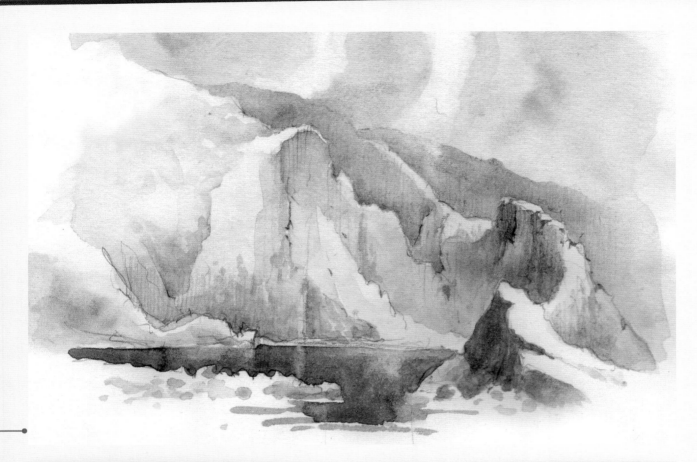

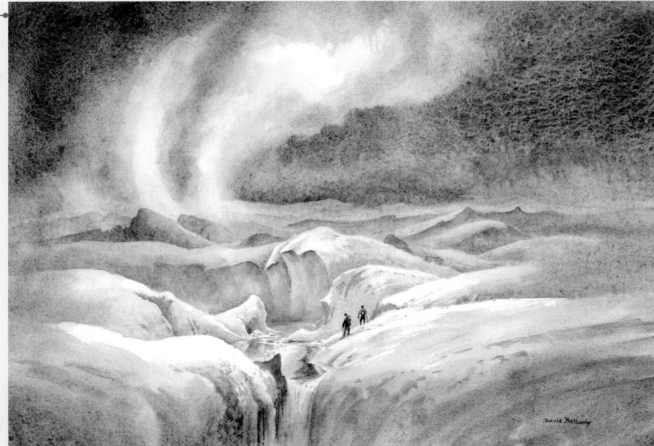

David Bellamy

Such places are hard to capture in paint, and seem to impose their will on you. You can't improve on them, and it is difficult to do them justice. We sat some distance away to get in the whole scene, and enjoyed the warm Arctic sunshine. After some time, Will wandered down to take a closer look, giving me the opportunity to include him in the picture, to provide a sense of scale to this awe-inspiring place. Alas, as I tried to photograph and sketch him, he was typically bent over, eyeing up some Arctic beauty, for there were many fascinating blooms in the area. I yelled and waved to attract his attention, but my shouts were drowned in the cacophony of crashing water. Sadly he appeared not to be in the mood to adopt a more heroic pose like some Arctic expedition leader from the golden age of exploration.

Back at the airfield, we prepared for our journey onto the ice cap with a company that specialises in local adventure excursions. They would run us up to the ice on one of their tour buses, and then their chief guide, Kim Petersen, would come some distance onto the great ice desert with us and show us some interesting features to sketch.

SKETCHING A MOULIN ON THE ICE CAP

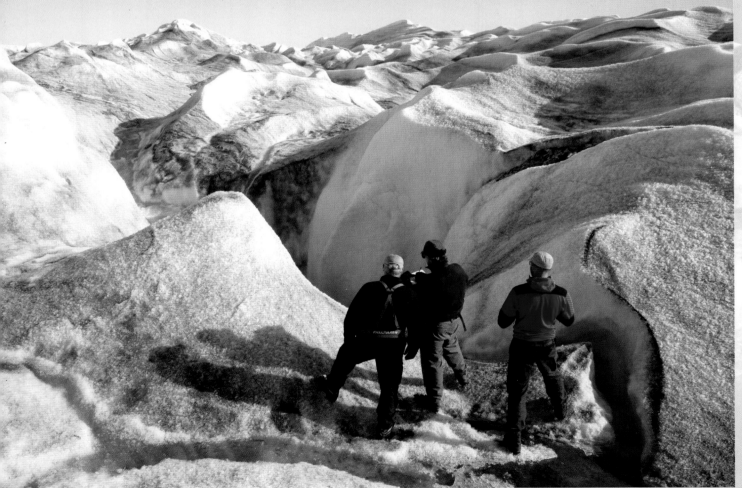

Photograph by Will Williams

David Bellamy

INSIDE THE ICE CANYON

The canyon cut through the ice cap, and we worked our way along by digging the crampons into the sides, above the false floor, which seemed to vary in thickness and transparency in this stunning world of ice.

The edge of the Greenland ice cap varies in character. We got onto the ice at Point 660, where many of the ice cap crossing expeditions start or end. To the south of this, the Russell Glacier descends more steeply, with huge ice seracs covering vast areas above the valley. I took note of these spectacular scenes to seek out on the return journey. Once on the ice, we strapped on crampons, and with Kim's fellow Dane, Jens, completing our four, we set off with full backpacks, Kim towing a pulk. At this point the ice cap undulates gently, much of it covered with a dirty black sediment.

Soon we reached a narrow stream funnelling along an icy trough before plunging down an evil-looking hole into the dark depths of the ice. Every now and then I stopped to sketch, the stream providing the most interesting compositions. Ice ridges lay across our path, giving us the opportunity to see the ice cap unfolding before us like a sea, with cloud shadows alternating

ILULISSAT ICEFJORD

The Ilulissat Icefjord is the most spectacular in Greenland, with its mountainous icebergs trapped by a moraine bank at the fjord entrance. Many of the bergs are simply great lumps of ice, while others boast fantastic shapes. These shapes are accentuated by strong sunlight, and light mist can create mysterious and exciting effects, especially when viewed from a boat. At the mouth of the fjord, the moraine bank is only 200–225m (656–738ft) deep, whereas the fjord is estimated to be around 1km (3280ft) deep in the centre. Icebergs are formed by calving off the outlet glacier into the fjord, and then it takes around 12 to 15 months for an iceberg to drift from the glacier snout to the mouth of the icefjord. In 2003 a massive 14km (8½ mile) section of the glacier, which had been floating on the fjord, broke off. Glacier speeds can vary even within one glacier, and over the last twenty years, this one has doubled its speed from 20 to 40m (65 to 131ft) per day during summer months.

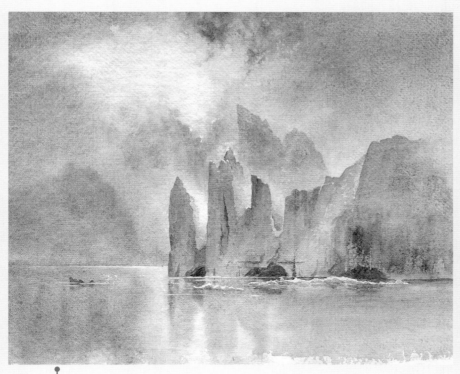

ICE CITADEL
The ice architecture of the Ilulissat Icefjord comes in all kinds of shapes, some quite unbelievable. The early explorer-artists returned with fantastic drawings of what seemed to be implausible icebergs, yet in fact even the most imaginative were not far off the mark.

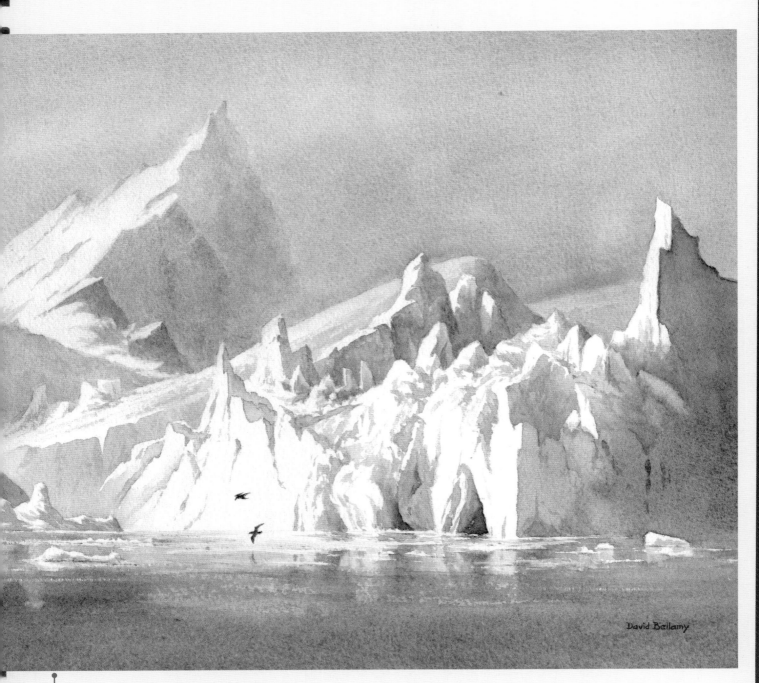

FULMARS OVER THE ICEFJORD

with brilliant white patches of ice, all undulating like the dunes of a desert. This sombre beauty stretched ahead of us for over a thousand miles.

On we hiked. The ice cap temperature was much cooler, and stopping to sketch out of direct sunlight was decidedly chilly. We crossed several streams and each time we reached a moulin – a hole in the ice down which they plummeted – it invited a sketch. Much of the sketching was done in watercolour in order to capture the subtle colours in the ice and water, but when it was not critical to speed things up, I simply made colour notes on a pencil drawing, intending to apply colour in the tent that evening.

Walking with crampons on this terrain demanded great concentration as it was easy to trip up. On the rock-hard ice, banging boots down hard to ensure a safe grip tended to jar the knees badly. We climbed up ridges, never sure of what we would find on the far side. Several times we reached the top to discover a sensational drop with the fearsome slit of a moulin at the bottom.

AMONG THE ICEBERGS

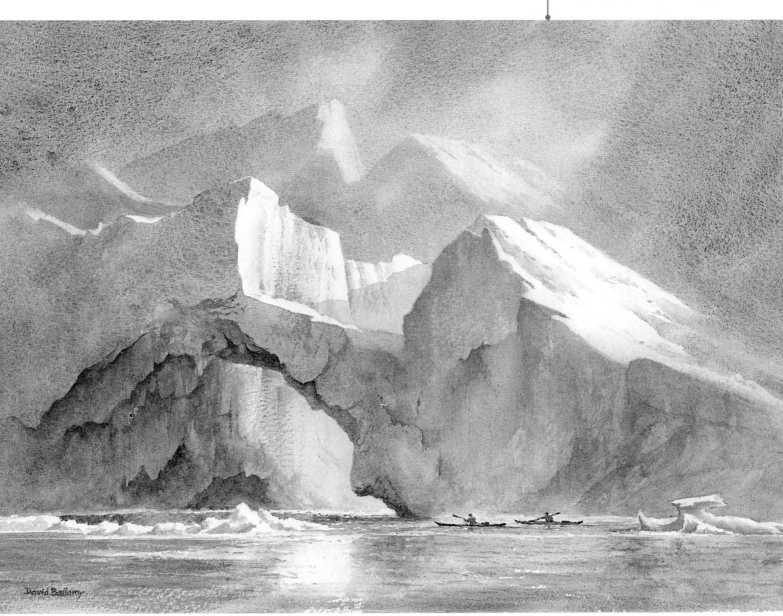

David Bellamy

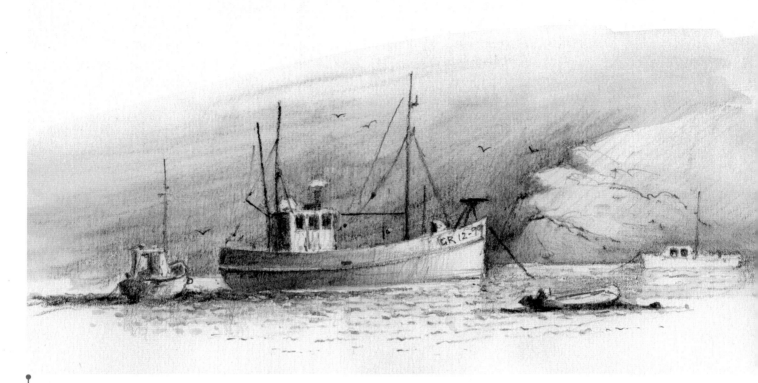

FISHING BOATS IN ILULISSAT HARBOUR

We came to a flattish area beside a small stream, and here we erected the dome tent, which had plenty of space for all four of us. Its orange outer shell stood out like an alien spaceship against the surrounding white icescape.

Kim suggested we explore some interesting features close by, so after refreshments we were away again, this time with light packs. After a while, we climbed a steep ridge, and down the far side the drama increased. Another stream plunged down a sinister-looking crack in the ice, with high ice cliffs on the far side. We stopped to sketch this, but Will dropped his paint-water container and it slid down to the crack and disappeared in the unfathomable icy depths.

When the sketches were done, we rounded a great block of ice, and before us stood the entrance to a large ice canyon that brought to mind the lair of some Nordic ice monster. We moved into the opening, and as it curved round ahead of us, a massive ice block formed a roof above us. The light blue sides were scalloped by the action of water, while the bottom looked highly unreliable. In places, between the more opaque ice, the ice on the canyon floor was transparent – a series of beautiful blues revealing a drop below. This was probably fresh ice and I was not keen to test it, so we kept our crampons well banged into the ice on the sides of the lower walls, straddling the suspect ice as we moved along this chillingly enticing canyon. Pools of icy water lay in our path and open crevices lurked here and there. In places the canyon was too wide to straddle, so we had many a testing moment as we gingerly worked round anything that looked as though it might collapse. The snake-like twists of the place ensured there was a surprise round every corner. The next hazard was fragile ice, which broke up under the prodding of my ski pole and called for some elaborate gymnastic moves to circumnavigate the problem.

Next we were confronted by a deep, crystal-clear pool which gave us a grim foreboding that we should leave it well alone. Here the canyon sides dropped straight down, so after yet another sketch, we retraced our route out of this fascinating but potentially lethal rupture in the ice cap.

We continued to explore in the vicinity until it was time to return to the tent. We filled our water containers from the stream, which would freeze when night fell, as we knew we would be desperate for a hot drink in the morning. Just before dinner, I sketched the glorious sunset as it turned the ice slopes into gold and pink; a magical sight to end a spectacular day. In the tent, however, there was much work to do, applying colour to some of the sketches, adding notes and writing up my journal. The extra-thick sleeping mat was welcome, as solid, cold ice does not make the most luxurious bed. Bare concrete would be more comfortable.

Morning brought a cold, dull atmosphere, much of the ice taking on a forbidding grey tinge. After a hearty breakfast of cereal, we headed further into the ice cap. Apart from an occasional sunlit patch, the day remained gloomy. In the distance, wisps of mist rose off the ice, hanging in the air in delightful strands that broke up the monotonous ice field.

Will and I sat and sketched a large glacial stream that was awakening from its frozen slumber, while Kim posed in the distance, an incongruous figure in a truly desolate setting. Painting waterfalls on the ice cap has its own peculiar problems, for there are no dark rocks or vegetation to contrast the white water, so we painted white against white. When sketching on steep slopes, I sat on a plastic foam mat and anchored myself and the important gear to an embedded ice screw to ensure I didn't slide off into oblivion. There was a profound sense of total relaxation as we worked in this icy wilderness of absolute peace and silence.

The going tended to be best when we walked along the tops of ice ridges with views all round, but most of it was up and down ice slopes. With these scenes often devoid of all but a few features, it helped to include figures to suggest scale, and the two Danes were happy to fill this role. After some time, Kim found a massive moulin below a semicircle of vertiginous ice cliffs, with an area of dubious stability on the opposite side, from where we could view and sketch the great hole, which was so wide that you could drop a double-decker bus down it. The thunderous crash of falling water added to our sense of awe. This sublime scene demanded a

WILL WILLIAMS ON THE EDGE OF A HUGE MOULIN

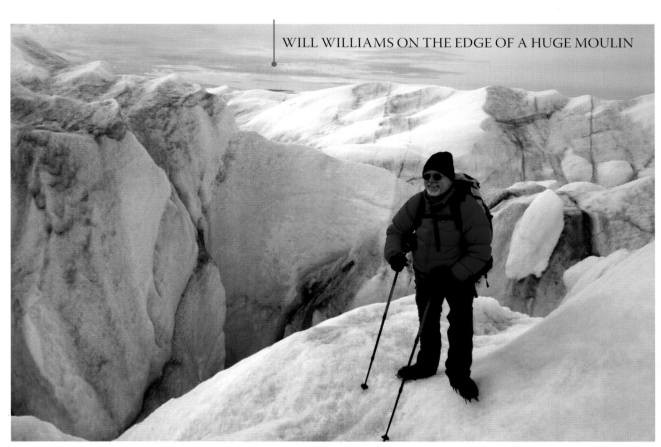

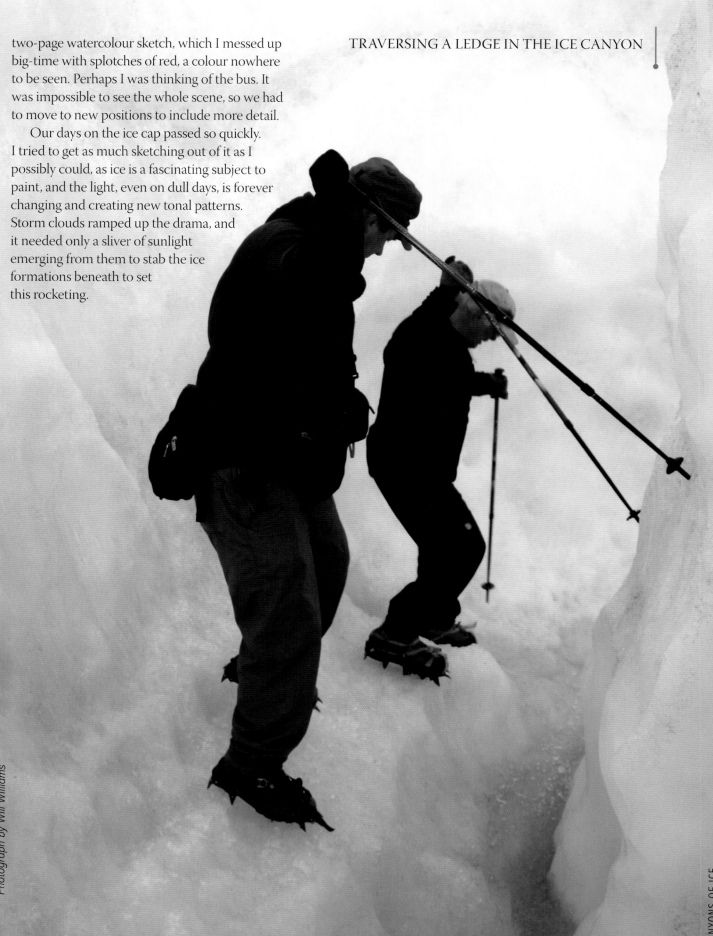

two-page watercolour sketch, which I messed up big-time with splotches of red, a colour nowhere to be seen. Perhaps I was thinking of the bus. It was impossible to see the whole scene, so we had to move to new positions to include more detail.

Our days on the ice cap passed so quickly. I tried to get as much sketching out of it as I possibly could, as ice is a fascinating subject to paint, and the light, even on dull days, is forever changing and creating new tonal patterns. Storm clouds ramped up the drama, and it needed only a sliver of sunlight emerging from them to stab the ice formations beneath to set this rocketing.

Photograph by Will Williams

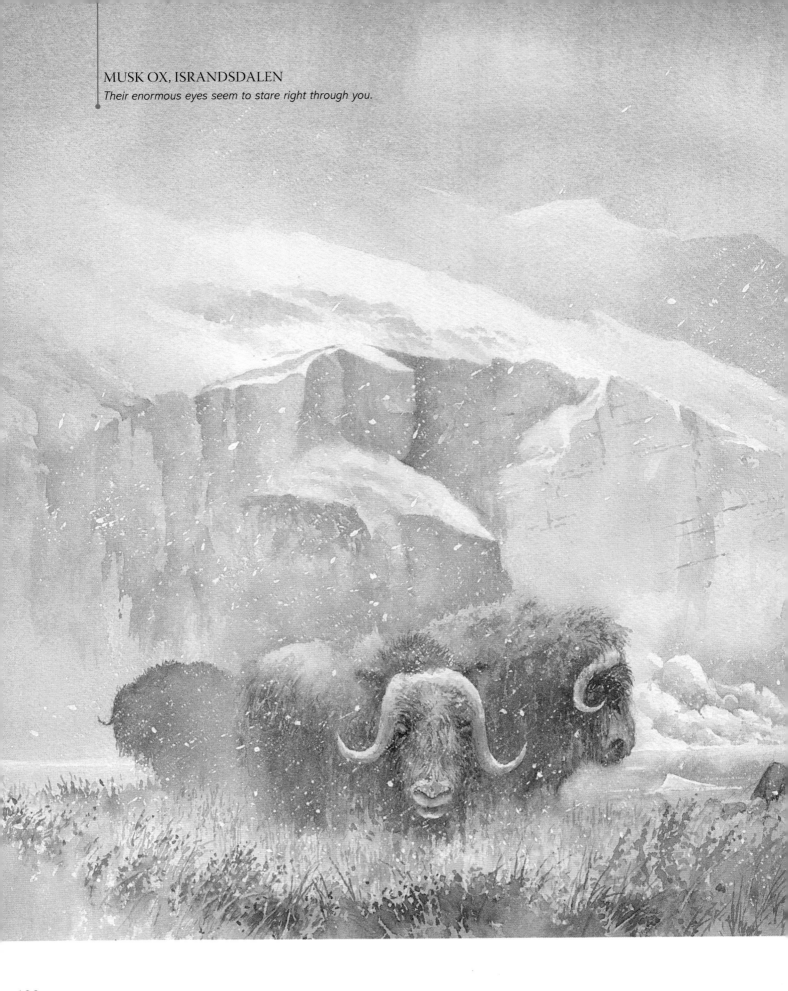

MUSK OX, ISRANDSDALEN
Their enormous eyes seem to stare right through you.

David Bellamy

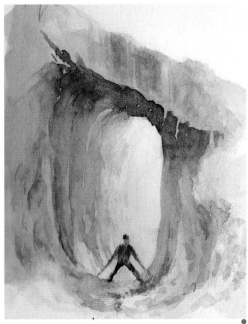

ICE BLOCK OVER CANYON
This tiny watercolour sketch shows our method of progress through the ice canyon.

When we came off the ice cap, Kim and Jens returned to Kangerlussuaq, while Will and I remained nearby to renew our search for musk ox. We hiked down the valley of Israndsdalen, sketched a glacial lake, then set up our tents just as the rain arrived. We had to camp near lakes as there didn't appear to be any streams and the rivers were full of glacial sediment. In the night it was sheer bliss, sleeping on soft and springy moss. I reflected on our time on the ice cap and how right we were to employ guides, for we would have been highly unlikely to find the amazing canyon and the largest moulin by ourselves. We now had a few days to search out other subjects.

One morning Will woke me up with the furtive words, 'David, get out quick – we're surrounded by musk ox!'

Sure enough, as I staggered out of the tent, I saw a herd of musk ox about 200m (658ft) away. Luckily they were bypassing our tents. Grabbing cameras, binoculars and sketching gear, I discreetly followed the herd at a distance. They moved slowly

along, grazing as they went. In the rear stood a massive bull, wary and keeping a beady eye all round. What made it even more precarious was the fact that also at the rear was a small calf. Musk ox dislike human beings – hardly surprising, given the number of musk-ox burgers in Kangerlussuaq airport cafe – and they are extremely protective beasts, so we needed to be careful. I checked the wind direction, and thankfully I was downwind of the herd – especially important given that I had been many days out in the back of beyond without a bath. I doubt that I could outrun a musk ox, so my only escape route was the prospect of leaping over a nearby cliff and plunging into the large lake below. Nothing I'd like better, of course, though in my late sixties, my Olympian athleticism is well past its sell-by date. In my youth I often had to shin up a tree with a Welsh Black bull in pursuit, but here the trees are barely 90cm (3ft) high and they bend with the weight of a pregnant grasshopper.

Hiding behind a boulder, I sketched away, hoping Will was also keeping a low profile.

The American artist, George Catlin (1796–1872), had the audacious technique of covering himself with a wolfskin while crawling along to sketch a buffalo herd. In the poor early morning light, my photography was truly abysmal, but I did manage some passable drawings over some time. Even slowly moving animals can present difficulties for the alfresco artist, and I abandoned many half-drawn beasts as they turned away, and started afresh. If the animal moved back into the original position, I then resumed the abandoned drawing. Eventually, after quite some time stalking the herd, we returned to the tents for a welcome breakfast.

At a more leisurely pace, we packed up the tents and our gear and wandered down the valley. Great sheets of ice descended from the ice cap to our left. Friendly looking green hills rose to the right as we continued

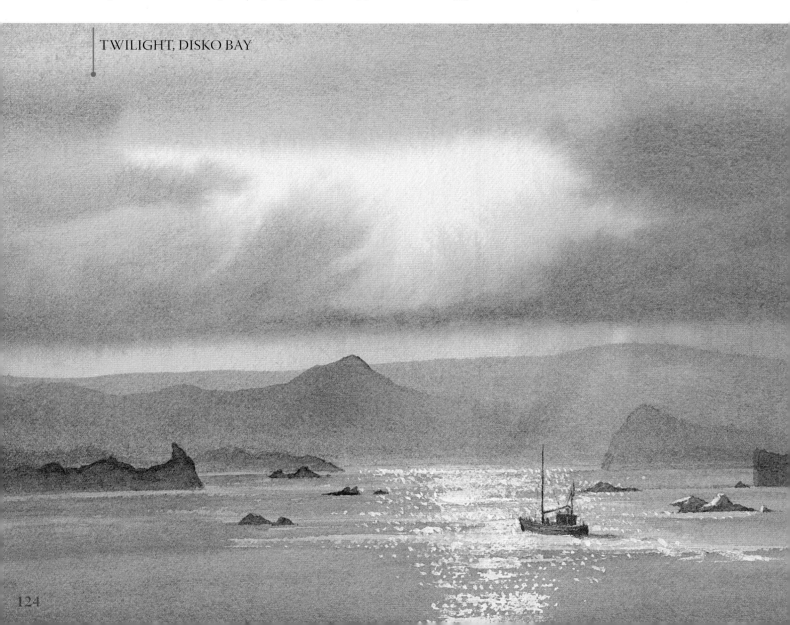

TWILIGHT, DISKO BAY

along the wide track in the direction of Kangerlussuaq. I spotted a picturesque waterfall on the glacial river that accompanied our progress down the valley, and we stopped to sketch it. The river offered the potential for further inviting scenes, so we followed it down to where it ran up against the huge ice cliffs of the glacier. Again we paused to sketch and eat lunch and were soon joined by a flock of Canada geese, which landed on the water. These made an interesting focal point, so further sketches followed.

Will was in his element, examining the plants and flowers that sprang up beside the river in colourful abundance. They created exciting splashes of colour, set against the stark ice cliffs on the far side of the river. At times it started to rain lightly, but the showers never amounted to much, though they were slightly annoying when you were applying watercolour washes.

We couldn't leave this part of Greenland without visiting the famous Ilulissat Icefjord, which produces some of the largest icebergs in the world, so we flew north to Ilulissat, the third largest town in the country and birthplace of the Greenlandic explorer, Knud Rasmussen. We stayed in a cabin on the rocky shore of Disko Bay, in a position where I could paint several fascinating scenes.

In the morning, we were off straight after breakfast, hiking the short distance to the start of the icefjord. The icebergs soared up over 91m (300ft), some like massive bare mountains with streams cascading off their plunging cliffs, some with spires, pinnacles, caves and arches, sculpted by nature into dazzling Baroque-like beauty. They sparkled and glistened, the light coruscating and dancing, throwing shadows and reflected colours of exquisite delicacy across the ice. Beneath the great ice cliffs in the still, dark waters, streams of broken drift ice punctuated the reflections, creating a convoluted masterpiece. The sheer beauty and immensity of what stood before us overwhelmed the senses and it took some time to get going with the sketching. This is where the iceberg that sank the *Titanic* in 1912 is alleged to have begun its journey. The rocky shoreline of the fjord provides an ideal viewing gallery for the bergs, where the larger ones are trapped, at this point near Sermermiut, by a moraine deposit across the fjord entrance, until they melt enough to pass it or are thrust over it by pressure from following icebergs.

Our progress along the shore was incredibly slow as successive subjects followed each other. By afternoon, as the sun moved round, many of the icebergs appeared as grey silhouettes, like a strange fleet of battleships. We returned to town by a circular route through a small gorge, where oddly we met a couple of locals looking for a lost parrot! With a satisfying bag of sketches for the day, we happily flopped down in a welcoming cafe and watched the Greenlandic folk going about their business.

GULLS ON A GROWLER

RAGING RIVERS

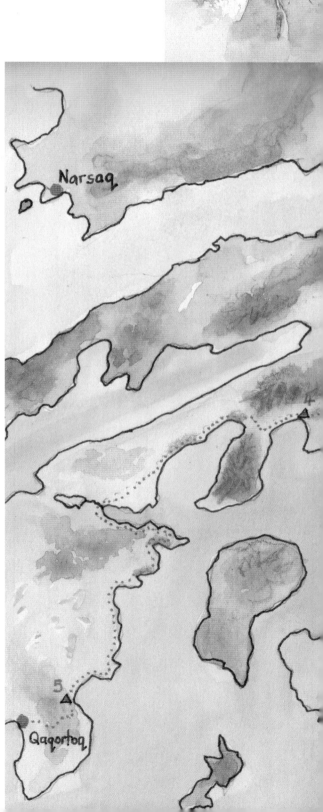

It would be a piece of cake. The hike from Igaliku to Qaqortoq is an easy four- to five-day stroll of around 60km (37 miles) through rugged terrain, or so the guidebook suggested. In July the weather should be perfect, and so it was when we arrived by launch at the jetty near Igaliku, a small, friendly settlement 48km (30 miles) or so south of Narsarsuaq Airfield in South Greenland. Torben Sorensen had again joined me on this new trip and we booked into Igaliku Hostel and did some mild exploring.

Next day was Sunday and there was a baptism in the church, so we wandered along. Torben and I settled ourselves into a pew near the back, trying to be as inconspicuous as possible. A Bavarian film crew, who were also staying at the hostel and who were not in the least inconspicuous, parked themselves at the front, with their ostentatious camera and equipment. The Inuit family arrived with little Jens, who was to be christened. Unfortunately the weather was too bad for the priest to make the helicopter ride from Qaqortoq, so a local lay preacher was standing in. The poor fellow went out into the lashing rain to ring the church bell for a saturating few minutes, then returned inside to play the organ, start the singing, and conduct the service in Greenlandic. The only word I understood was 'Amen'.

The service began. In sympathy with the weather, we stood up and sang a hymn in the most mournful and tuneless manner, the tempo considerably slowed down by the exceptionally long Greenlandic words. We sat down. Being used to the solid pews of St David's Church in Llanddewi, I dumped myself down with the usual aplomb, and found myself hurtling backwards, to land on the floor with a resounding crash that startled the entire congregation. The pews were a little on the light side, and not fixed to the floor. Thankfully the Bavarians were pointing their camera the other way. In fact they were determined to focus on Jens and poke their huge lens in his little face, until the preacher deliberately got in their way. With the grace of a Spanish bullfighter, he spent the next few minutes not only conducting the service and playing the organ, but deftly shielding young Jens from the Bavarian limelight.

Come Monday morning, we were climbing the steep hillside out of Igaliku, following a wide trail at the start of our hike. Low clouds kept us cool, ideal for walking with enormous packs, if less so for sketching. Views across Eriksfjord were excellent, with occasional icebergs cold white against gloomy cliffs. The track petered out, but we make good progress over rough terrain. Here and there we encountered splashes of red paint which acted as a guide along the route, but these were only occasional and easy to miss. Eventually

SKETCH MAP OF OUR HIKE
TO QAQORTOQ

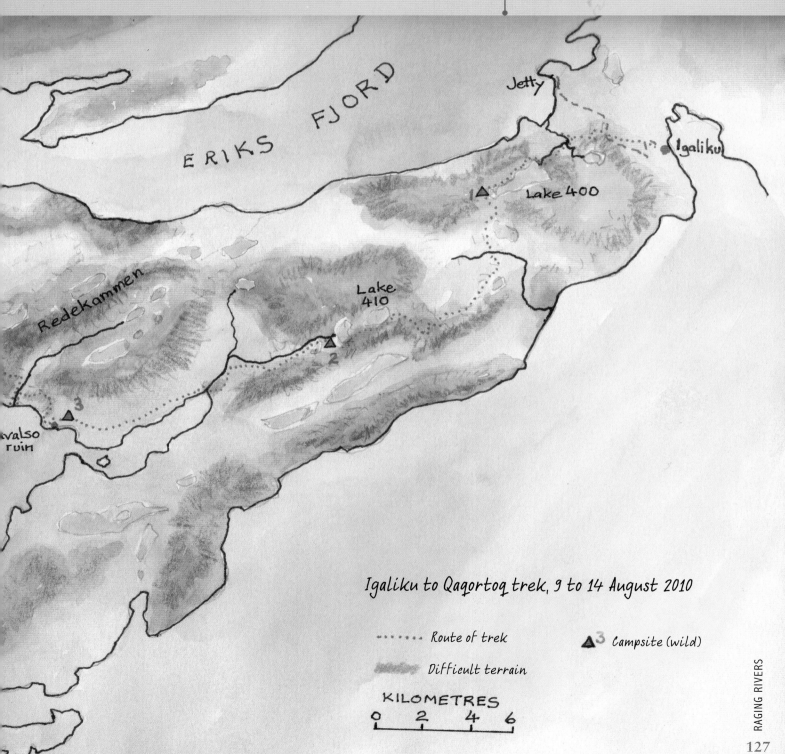

ERIKS FJORD

Jetty

Igaliku

Lake 400

Redekammen

Lake 410

▲ 2

Kvalso ruin

▲ 3

Igaliku to Qaqortoq trek, 9 to 14 August 2010

······· Route of trek ▲³ Campsite (wild)

Difficult terrain

KILOMETRES

0 2 4 6

RAGING TORRENT BLOCKING OUR ROUTE

Coming up against this formidable barrier to our progress, we wondered if we would actually be able to get across.

they disappeared completely, and we were faced with the purgatory of massed dwarf willows covering boulders, holes and nasty lumps, although navigation was no problem with a map and compass. We followed a stream tumbling down the hillside, and on cresting the top, saw Lake 400 revealed before us. Our objective for the day was to camp at the far end of it.

It began to rain steadily, a real nuisance when you are about to camp, but consistent with the rapid deterioration of just about everything on this hike so far. There was worse to come. We needed to cross the river at the outflow of the lake, where it is wide, but shallow. With trousers rolled up, I waded across, and made the far side without mishap. Now it was Torben's turn, but part way across he stumbled and his boots fell into the water. As he grabbed them, his water bottle dropped in too. It floated merrily off downstream, but I managed to catch it. Torben was across. The lake was about 3km (2 miles) long and it seemed to take ages to get to the far end. Thankfully we dropped our wet packs and set up the tents in a welcoming deluge. Wet, waterlogged and footsore, we were at our first day's objective on schedule.

LAKE 410

This watercolour sketch was carried out as the last rays of sunshine sparkled on the water and clouds started to blot out the upper slopes of Meqqutoqqat Qaqqaa. We were about to feel the edifying effects of a three-day Greenlandic monsoon.

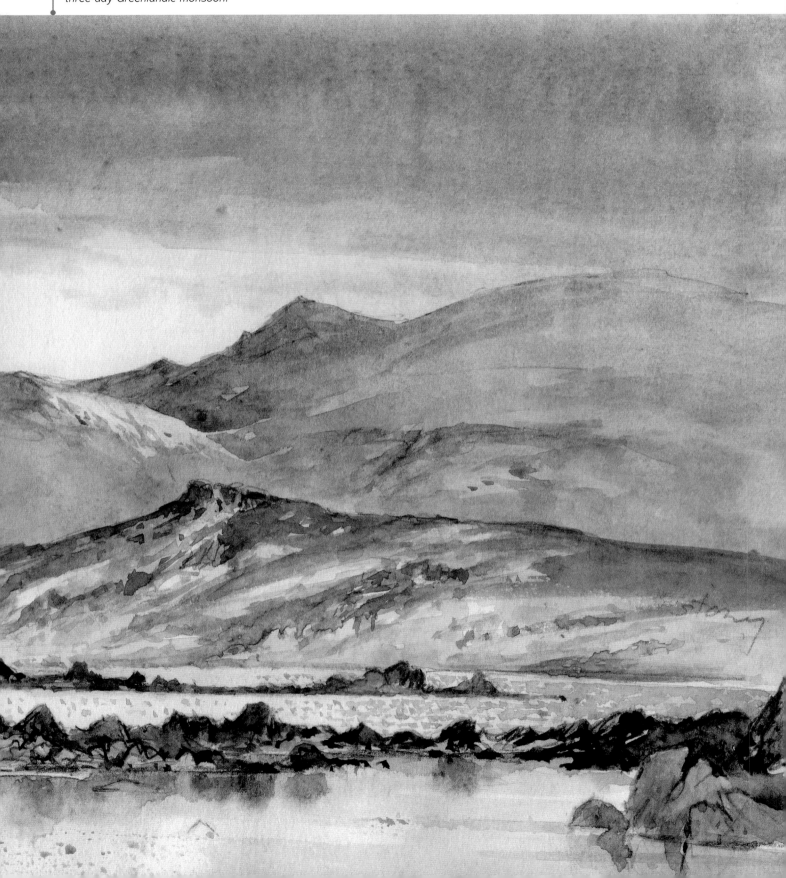

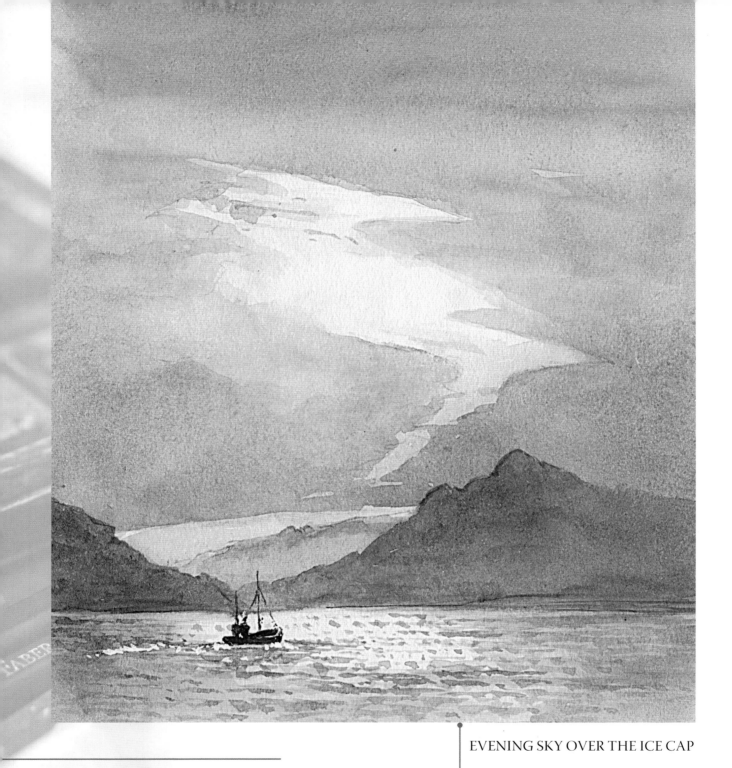

EVENING SKY OVER THE ICE CAP

SKETCHING AND PAINTING MATERIALS

The next day, I gazed out of the tent to see morning sunshine with low clouds swarming across the mountains in long ribbons. Torben, despite erecting his tent a good two metres from mine, had experienced a disturbed night because of my thunderous snoring. Breakfast on the lake shore was accompanied by a sketch, as the lake sparkled and the world was blissful. There is nothing quite like sitting beside a tent by a lake or mountain stream on a sunny morning, well away from the noise and bustle of cities. Alas, it was not long before reality intervened: we had to put on damp socks and trousers – not the most uplifting experience – but after a few moments, the cold dampness evaporated.

THE VIKINGS IN GREENLAND

Over a thousand years ago, Erik the Red arrived in South Greenland at Brattahlid, which is now called Qassiarsuk, on the opposite side of Eriksfjord to Narsarsuaq Airfield. After a dispute in Iceland, he decided to leave and he sailed with twenty-five ships, but only fourteen arrived at Brattahlid. In those days the country was very green, with much vegetation, and he called the new land 'Greenland' in the hope of enticing others to come. When Torben and I visited Brattahlid, we found Edda Lyberth, an Icelandic saga spinner, who was dressed as though she had come straight out of a saga herself. She related the story of Erik with amazing passion, standing on a high point at the reconstructed site to address her audience of about six Danes, two Germans and myself.

'Of all the Vikings, Erik the Red was the fiercest of all,' she began, rolling her 'r's with the passionate emphasis of a 19th-century Welsh Baptist minister. 'And men were terrified of his hot-headed temper. There was only one person Erik feared – his wife, Tjodhilde. She could put him in his place, was very strong-minded, and bore him three sons. Nobody, not even Erik, told Tjodhilde what to do.

'After fourteen years in Brattahlid, Erik sent his son, Leif, to the court of King Olaf Tryggvason in Norway, where the king preached Christianity to Leif and others. Leif Eriksson was baptised and sent back to Greenland with holy men to convert the populace to Christianity. This did not go down well with Erik and he would not see the holy men – in fact he was hostile to them. Tjodhilde embraced the new religion at once, and had a church built at Brattahlid. Erik was livid, especially when she banned him from her bed until he became baptised. That is how the fearsome Erik the Red gave in to his woman and Christianity.'

Edda told the story with great panache, often pausing for dramatic effect. As we departed on the traditional Greenlandic fishing boat *Puttut*, she was on the quay waving to us and singing with gusto, no doubt invoking the Norse gods to grant us safe passage across the fjord.

During the morning we descended to cross a wide valley and two rivers, enjoying the sunshine and scenery, then started up a gently sloping valley over rough ground. At the head we climbed steeply through a large boulder field to crest a ridge. Below us, Lake 410 shimmered, an idyllic spot for afternoon tea and a sketch. Little did we realise this was to be the last enjoyable moment of this hike. On the next climb my tiredness began to show. More boulders greeted us, but now we could see the fjord where we planned to camp, a long way below us and about 6.5km (4 miles) distant. Spots of rain began to fall, and just past the boulder field we found a superb campsite beside a stream, so decided to set the tents up here in comfort rather than slog on and receive yet another wetting. I was barely in the tent with a container full of water when rain started to hammer down on the tent outer.

With rain creating a noisy pattern all night, the stream was roaring in spate by morning. As it was one of many tributaries of the major river we would soon have to cross, we wondered how on earth we could get across. We might be trapped for days. We put away the wet tents, and our packs now seemed twice as heavy as when we started the trek.

We descended along the rim of a dramatic gorge into a broad valley, with views of the great river in the distance, livid with white water throughout its length – a monumental obstacle. In the absence of a path, we followed the line of least resistance through wet bushes and boulders. Close to the roaring river, its intimidating power was palpable. The water calmed down as it entered the fjord, but was much wider and still quick-flowing. We removed our socks and put our boots back on, then began wading across together for mutual support, like some peculiar circus balancing team without anybody on top. Mercifully we were unaware that around this time, several Norwegians were washed out to sea and drowned while doing a similar crossing further north. Steadily we worked our way across and climbed up the steep bank on the far side, where I poured the water out of my boots and sank gratefully into the saturated undergrowth with a welcome mug of hot soup brewed on the stove.

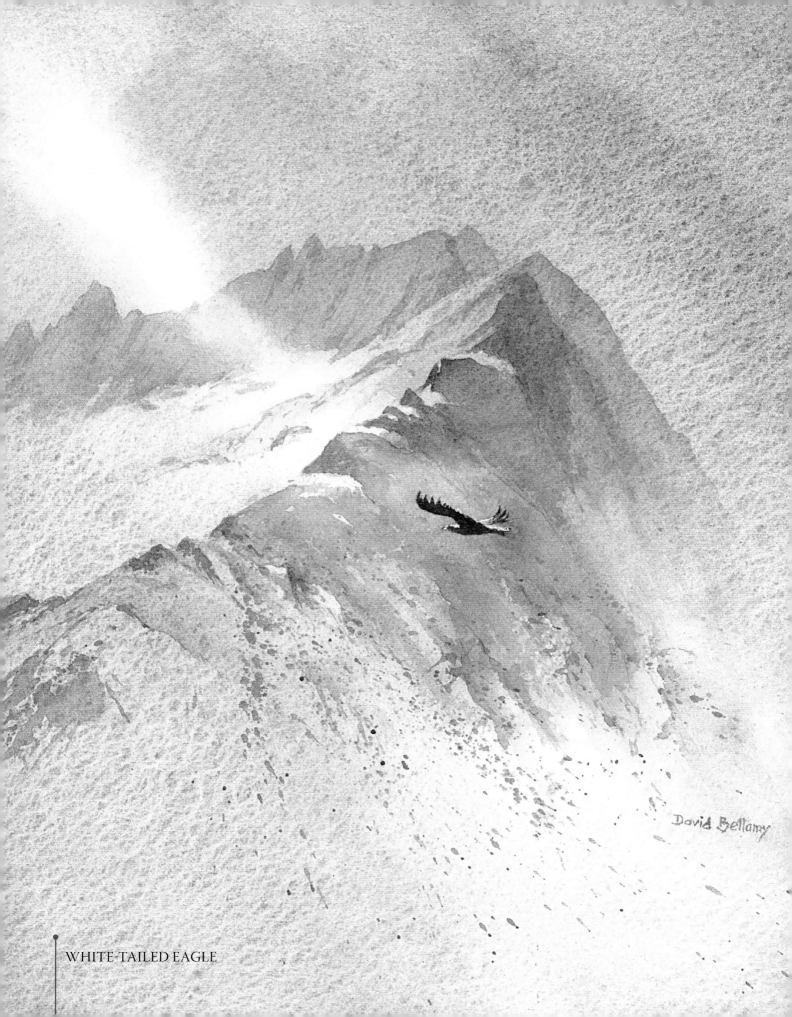

WHITE-TAILED EAGLE

Continuous rain added to the dreary slog along the shoreline. By tea time, we were pretty exhausted and decided to set up an early camp near Hvalso, the ruin of Greenland's first Christian church. Although we had made progress and were happy to be across that daunting river, we were well short of our planned objective for the night. Everything seemed to be soaked, and even my sleeping bag was wet in parts. Sensibly, Torben erected his tent further away this time, well out of range of my snoring. As we were camping only a few hundred yards from the shoreline, I wondered about the polar bear threat. In Narsarsuaq we had been assured that there would be no bears around this stretch of the coast, but in Igaliku we learned that the previous summer a group of archaeologists had been attacked while camping not far away. One can never be certain that bears might not appear, and we hadn't brought a rifle with us.

CROSSING A BOULDER FIELD

Acres of boulder fields slowed us to a crawl, much of them covered with dwarf willows which hid ankle-breaking crevices and tripped us up. High up on the mountainside, the enveloping mist made navigation difficult while we tried to keep our footing and stay on a straight course.

GREENLAND CRABBER AT NARSAQ
This vessel was stuck here with engine trouble and spare parts would be a long time coming, so the skipper was not a happy chap.

At dawn our hopes soared to see the rain had stopped, but low mist cloaked the mountain tops. We set off and at first all went well along fairly level ground until we turned up a steep slope festooned in more of those foul willow bushes. Incredibly, two or three splashes of red appeared to guide us into this dense green maze, only to disappear once we were thoroughly entangled in the stuff. There was no path, just a jungle of extremely wet vegetation over 2m (6½ft) high, that clawed at our packs, tripped us up and showered us with every shake. Black holes in between vari-sized boulders presented ideal ankle-breaking traps for the unwary. Progress became tortuous. At times it took three or four minutes just to get round a single bush. The ground steepened and I found myself climbing vertically beside a rock face, increasingly being pushed out over a precipitous drop by willow branches. I couldn't see where I was putting my feet. Strong branches pulled me backwards as a strap of the huge pack got caught, making me wobble at the edge of a cliff. If I bent the branches too far, I risked being catapulted over the edge.

This can only be described as the complete nutter's style of backpacking. We joked to keep up our spirits, but it was way beyond a joke. We had no idea how far this terrain extended, nor what further hazards awaited.

Then things got worse. Ahead rose a huge crag set into the steep mountainside, forcing us to climb over it via a steep diagonal traverse through densely packed, aggressive willows. We paused every few feet of ascent, thoroughly exhausted. I could hear Torben's agony behind me, but he was remarkably tolerant of this peculiar form of torture. Many would get angry or demoralised, but he is a great companion to have around when things get tough. While I had been initiated by many self-inflicted traverses of appalling terrain in search of painting subjects, this especially ghastly episode really shone through for both of us with the humour of shared misery – we drew tremendous strength from each other.

Once over the crag, further masses of willows greeted us, relieved occasionally by a welcome patch of bilberries. After some time, the angle of the slope eased a little. Gradually the cliff turned to the right, but we were still fighting those pesky willows. For once I felt safe from polar bears – no bear in its right mind would come up here.

A rough path suddenly materialised, and beyond a ridge we found another valley spread out before us like some heavenly prospect. This was the steep valley of Kuussuaq, which descends from the southern ramparts of Redekammen peak. Needing to maintain height, we followed the contour into the valley, aiming to cross the river and then climb up higher into the corrie above, where we had originally planned to spend the previous night. Progress was much quicker as we followed the path. Spirits began to rise, but slowly it dawned on me that the noise like low, continuous thunder I could hear was becoming more insistent with each step.

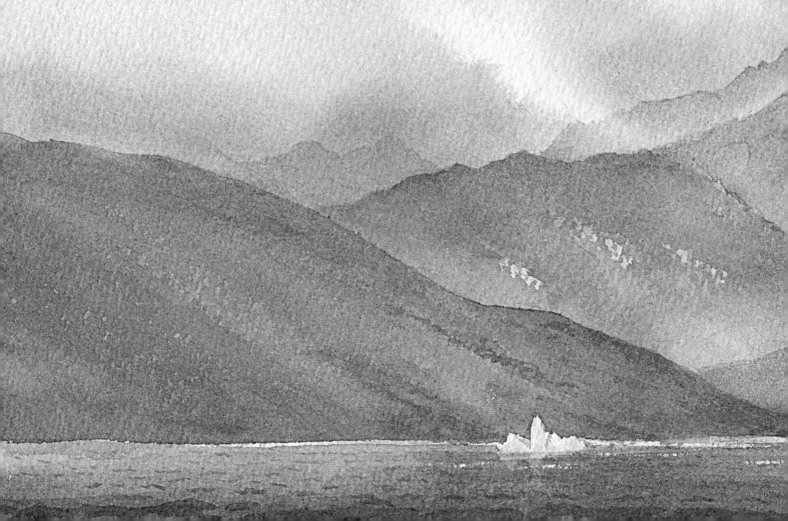

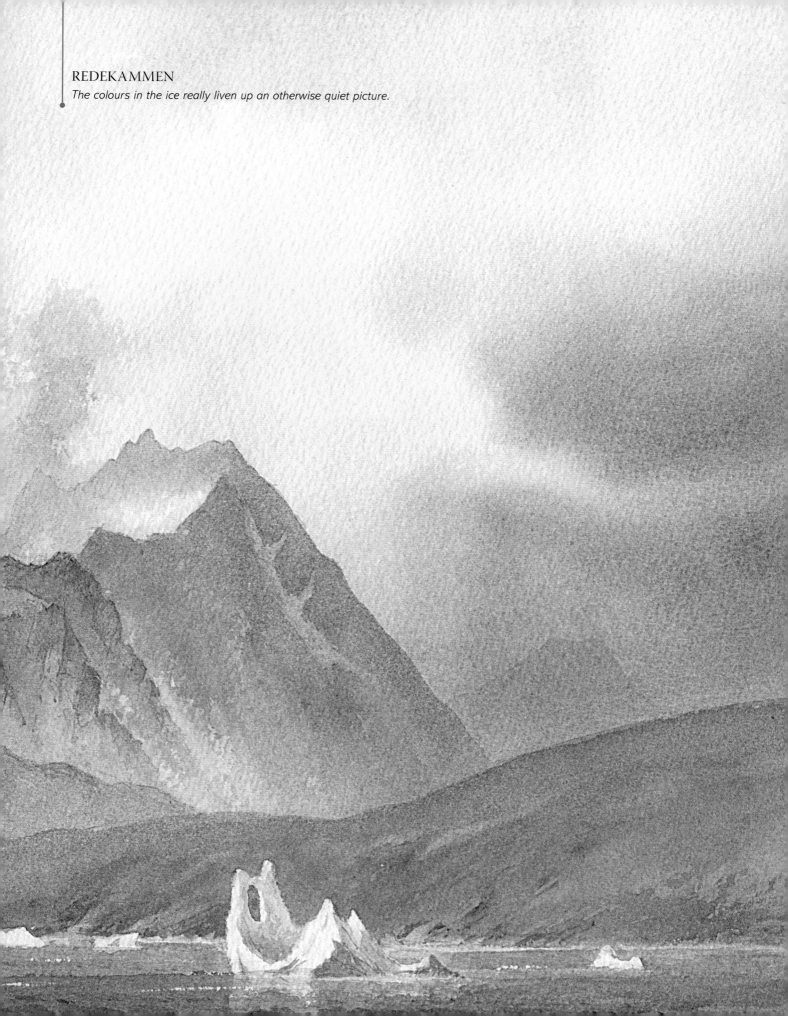

REDEKAMMEN
The colours in the ice really liven up an otherwise quiet picture.

We climbed up a low ridge and gasped at what lay ahead. The river came roaring out of the mist above us, glaringly white and foaming all the way down its rocky cascading course, in places tossing great waves into the air. According to the map, this was where we should cross, but nothing would survive in that torrent. There was no way we could get across this barrier. From this angle we had no idea whether we could cross it even by the fjord.

We decided to descend, and at the bottom found the torrent easier right at the edge of the seawater. With extreme care, we shuffled across together. The current was strong, but we kept upright, our packs ready for quick release if we slipped under the water. We managed to get across, and again celebrated with a mug of hot soup, which boosted morale.

After this, a stiff climb up to around 396m (1,300ft) was needed to take us over a pass, but although the path at this point was good, the gradient quickly became strength-sapping.

We climbed up the west side of the torrent, into the mist. On a clear day, the pass into the next valley would be easy to spot, but the mist was so dense that it was completely disorienting, with nothing in view beyond about 50m (164ft). We had to make sure that we turned westwards at the right place. By now I had abandoned any idea of climbing Redekammen Peak, even though it was one of my main objectives on the hike, for I wouldn't see a thing to sketch up there.

At a small cairn, the red splash must indicate the turn-off point. It was about the right height, and we now needed to follow a bearing of 260 degrees and climb around 122m (400ft) to get over the col. The 30-degree declivity in the compass at this point in the Arctic demands special concentration. Rocks, stones and boulders ranging in size from a football to a small house confronted us. There was no path, no red spots, no break in the mist – the only relief being mossy patches here and there as we continued up this rough slope. I used prominent boulders to help navigate on a course of 260 degrees, but the broken terrain forced us to go round some features, complicating navigation. How much higher did we have to climb?

ICEBERG IN SCOVFJORD

We encountered many icebergs on the journey from Qaqortoq to Narsaq, some of them dwarfing the fishing vessels. Not so long ago this journey could be done by sledge during the winter months, but more recently the ice has become too thin.

FANTASY ICEBERG OFF NARSAQ

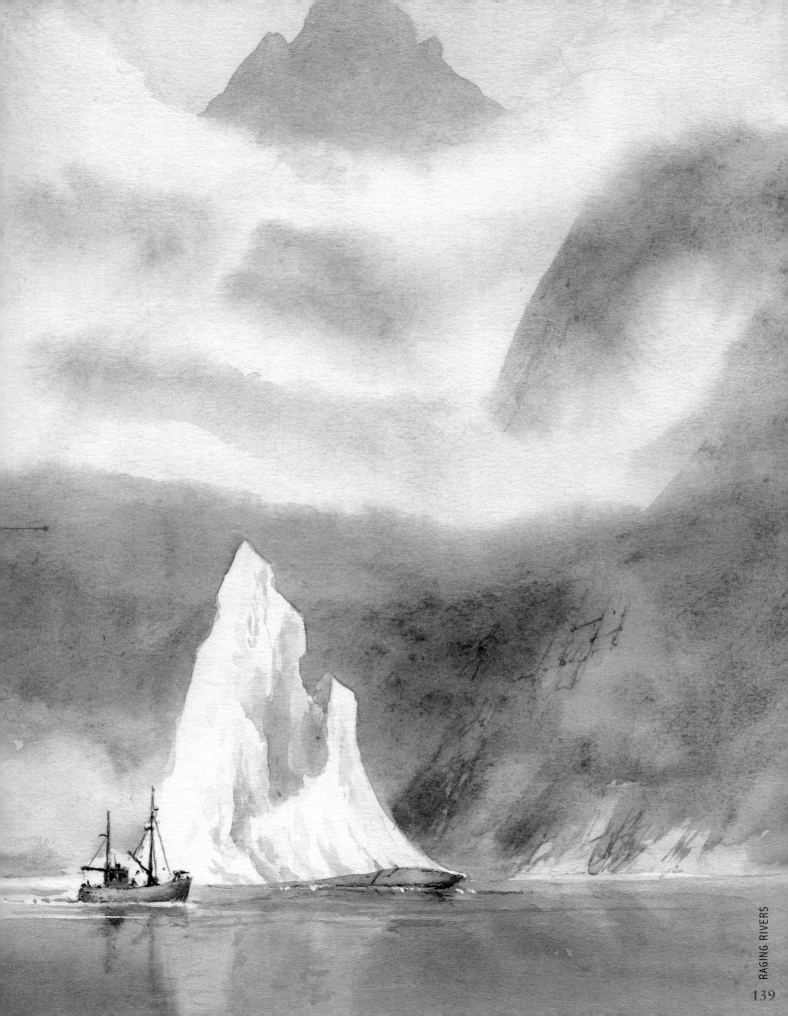

Passing over a ridge, we were elated: now we just had to descend. Alas, a little further along, the ground started to rise again. Visibility reduced even further, with vague images of boulders around us – this was a totally inhospitable world.

The gradient slackened. Was this the col? The terrain character changed slightly, with many pools of water, fewer boulders and a stream emerging out of the mist. Our pace quickened, with easy boulder-hopping and stream-crossing. Before long, we emerged from the mist – a marvellous moment when a vast landscape opened out before us into a corrie of supremely wild terrain as far as the eye could see. The scale made us feel humble and insignificant. We were on course.

Tomorrow evening we needed to be at Qaqortoq, so we pushed on as far as possible, but the sight of so many large boulder fields ahead was a blow. They slowed progress so much, and there was no way we could escape them. Torben was at a disadvantage, as he didn't have a stick, so we kept close together and at tricky points, passed my stick across to each other.

The boulders of pink stone, covered to various degrees in black lichen, were mainly concentrated in shallow depressions. They were awkward to balance on, especially with our heavy packs. The inevitable happened. Torben slipped and fell into a narrow crevice in the rocks. He hurt his side, but thankfully it wasn't too bad, and we continued.

It seemed to take hours to cross the enormous corrie, and at the far end, we reached a viewpoint from where we could see another, equally large corrie ahead of us. The sight alone was tiring, but we gathered enough energy for one more effort, aware that we were far behind schedule. Eventually, near the shore, we scrambled down low cliffs, engaged in a final battle with those dreaded willows, then reached a relatively flat area of grass and flopped down, exhausted.

In the morning, we set off earlier than usual, knowing it would be a long day's hike to Qaqortoq. The cloud base lay around 304m (1,000ft), but at least it was only spitting with rain. Yet another river crossing livened things up, and soon we were greeted by a forest of wet willows. A vague track ran through them, but we were constantly smacked in the face by wet branches, and this felt worse than continuous rain. On either side of us rose high, conical peaks, their great boiler-plate slabs glistening in the damp atmosphere.

We descended to the shore of another fjord and had to negotiate willow hordes right on the edge of small cliffs. At one point as I stood on one large boulder while trying to get round another by hugging it, I felt both start to wobble. In danger of crashing into the fjord with a ton of boulder on top of me, I took a flying leap across a void onto the grassy cliff edge beyond, and lay completely winded by my pack.

ANCIENT HUMAN REMAINS
VISIBLE UNDER CAIRNS

Photograph by Torben Sorensen

SKETCHING WITH A SPOTTER SCOPE

On easier ground, we made better progress. The day wore on, and although much of the going was easy, we both suffered from sore feet and tiredness – and occasional boulder fields added to the fun.

Redekammen appeared in the distance, so I paused to sketch it. As evening approached, we began to doubt that we would reach Qaqortoq by nightfall. By the time darkness was falling, there was still no sign of the town, so we had to find somewhere to camp before we lost the light completely.

We couldn't afford to be fussy about what we slept on, and quickly found a couple of spots just about large enough for a chicken to lay an egg. In the gloom, I managed to find a dubious water source nearby. All we had left to eat was some soup and a couple of cereal bars, but I was glad to crawl into my sleeping bag and enjoy the sharp lump sticking up in just the wrong place. I wondered when they would raise the alarm at Qaqortoq Hostel, as we hadn't turned up.

By 5.45 am, we were both up, needing to reach the town before they alerted rescue services. A helicopter buzzed by some distance away, and we hoped it was not looking for us. The mist was down to around 122m (400ft), but at least it was dry as we set off, making good progress along the path and thankfully without any horrors of boulders, willows or raging torrents to negotiate. Looking across the fjord, I watched the mist laying horizontally, creating beautiful atmospheric strands which constantly moved and reformed their shapes; a prospect of greys of varying intensity punctuated in one or two places by icebergs.

We followed the track inland, and over a rise spread out before us lay a multitude of buildings in yellow, pink, blue, purple and green – an amazing contrast to the grey, misty background. It was like walking into Toyland.

The track turned into a tarmac road and soon we met an Inuit girl who confirmed that this was Qaqortoq, though she has no idea where the hostel was.

Soon we found the place, high above the harbour, just as the town began to stir itself. Heidi, the Inuit hostel manager, gave us a wonderful welcome when she realised we were the two people who should have arrived the previous night. To our relief, no rescue had been put into action, and a couple of whiskies on the house brightened

things up further. Coffee, breakfast and a long shower improved matters, though the shower pained the raw spots on my feet and elsewhere. Both feet were swollen and covered in blisters. At lunchtime, we wolfed down massive plates of food and then wobbled painfully around town, sketching and taking in the sights.

After a couple of pleasant days in Qaqortoq recovering from our hike, we took a boat to Narsaq. This journey used to be possible by sledge in winter but these days the ice is too thin for a safe crossing. There we met some of the locals, including a priest and his wife and granddaughter, all dressed in Greenlandic costume – a tradition when the school term begins. They invited us to their home, where we joined them for a light tea and I managed a fleeting portrait of the little girl, though she jumped around rather a lot, so getting a likeness was a challenge.

On other days in Narsaq, I managed further portraits of the locals, and one day we took a boat to the nearest glacier, where we did some sketching and came across some ancient human skeletons under rock cairns nearby. Eventually we sailed up Eriksfjord to Narsarsuaq and caught a flight back to Copenhagen.

THREE YEARS LATER

A sea fret hid the peaks for much of the day. After a three-year absence, we were back in South Greenland, this time with a nautical flavour in prospect. Our aim was to sketch the outstanding mountains in the area around Tasermiut Fjord, a long waterway running up to the ice cap. The boat, a six-man Zodiac to ensure there would be ample room for Torben's Danish pastries, had been booked months in advance, but when we arrived to check it all out, the agency rather disturbingly wanted to know what experience we had with boats. Torben was an airline pilot before he retired and neither of us were well versed in the intricacies of boat handling, so they seemed reluctant to let us take their boat up a remote 80km (50 miles) long fjord, a potentially hazardous undertaking in a small, open craft piloted by two nautical neophytes. Nevertheless, they agreed to give us some tuition, so in the afternoon, an Inuit fisherman with the splendid Norse name of Thor, took us out into the bay, weaving in and out of misty icebergs the size of skyscrapers. He spoke no English, but rudimentary Danish, so Torben was elected to take the helm.

Opposite
SKETCH MAP OF
NANORTALIK AND
TASERMIUT FJORDS

LOW-FLYING FULMARS

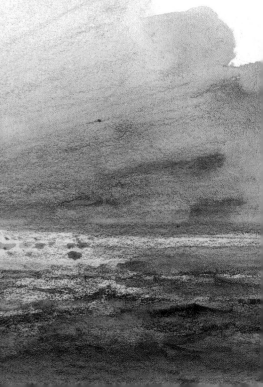

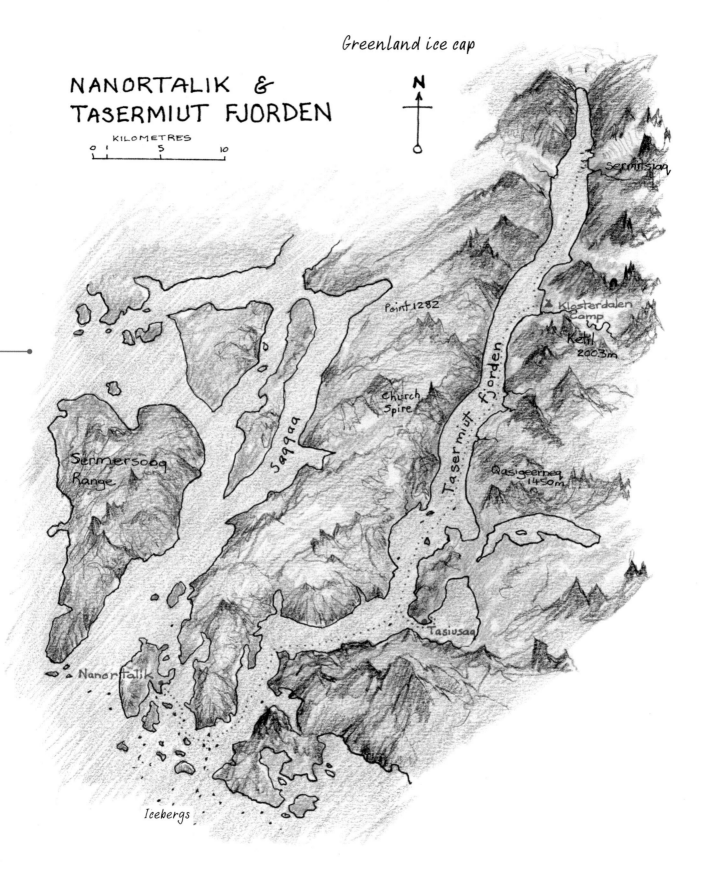

Greenland ice cap

NANORTALIK & TASERMIUT FJORDEN

KILOMETRES

0 1 5 10

N

Sermitsiaq

Point 1282

Klosterdalen Camp

Ketil 2003m

Saqqaa

Church Spire

Sermersôoq Range

Tasermiut Fjorden

Qasigeerneq 1450m

Tasiusaq

Nanortalik

Icebergs

···· Routes taken by the Zodiac

Cape Farewell

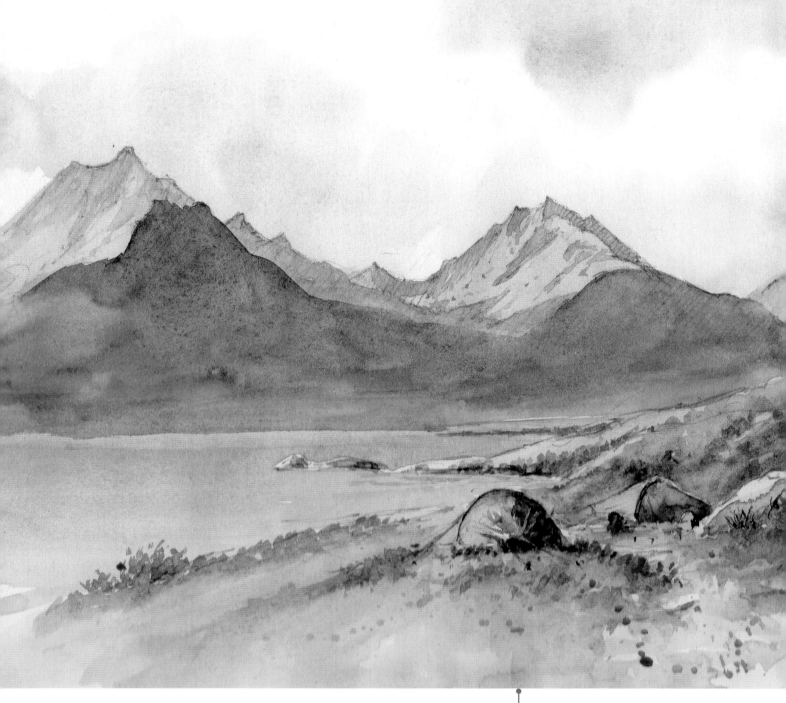

So brilliant was Torben's handling of the boat that we were given the thumbs up, but I like to think that my spasmodic outbursts of nautical jargon helped to impress them and perhaps even swayed the decision. We spent the rest of the day provisioning for the expedition. Torben needed a toilet roll, but could only find a pack of twenty-four, so the boat was packed to the gunnels with toilet rolls and abrasive pads, which again, only came in massive quantities in the local store.

CAMPSITE AT KLOSTERDALEN

Apart from the hordes of midges, which though annoying, don't bite, this was one of the most pleasant campsites I have set up. Few people visit this place. We were blessed with the most glorious sunshine, and in the far distance we could see the Greenland ice cap.

In the evening, the radio announced that several Greenlanders had drowned when their boat capsized off the coast. The timing of the announcement was immaculate from our viewpoint. Our confidence was further eroded when, as we are just about to weigh anchor, so to speak, we were informed that the boat had a hole in the bottom, but a small bucket was supplied for baling out! However, I had seen this done in movies, so knew we would be fine.

We had some difficulty starting the outboard motor, but soon set off at a cracking pace, the sea calm and the sun beating down. The icebergs stood clear out of the water and it was easy to steer away from them. It's the little growlers you have to watch for, as you can hit them before you see them.

Once across Nanortalik Bay, we entered Tasermiut Fjord. Huge cliffs closed in. Further into the fjord, the sheer cliffs fell grimly straight into the sea, so there was no friendly shore in case of emergency. This was a fitting place to encounter the mighty Kraken of Norse legends, but not even a minnow stirred the waters. We passed the occasional iceberg, and although we were hammering along, it took ages to reach landmarks that had been visible for a long time. No other craft disturbed the tranquillity. Torben manned the helm while I noted our position on the map and did the odd sketch.

Eventually the view ahead began to open out, with a line of jagged peaks forming a barrier in the distance. These are the mountains beyond Tasiusaq, the last settlement we would pass. I sketched furiously, which had the added advantage of taking my mind off the penetrating cold brought about by sitting in an open boat in the Arctic, though the sketching was limited by the need to keep baling out. The scenery became increasingly spectacular. Around midday, we approach our destination, the valley of Klosterdalen, where the Uiluiit Kuua River disgorges into the fjord down a beautiful cataract of white, foaming water. Soaring straight up above it rises Ketil, smooth-sided and absolutely sheer, world-renowned for its challenging climbs, though few climbers make it here.

TORBEN'S TOILET ROLLS

Torben needed one toilet roll, but the local Brugsen store sold them only in packs of two dozen, so his tent overflowed with them. He was comfortable for a couple of days – apart from the midges!

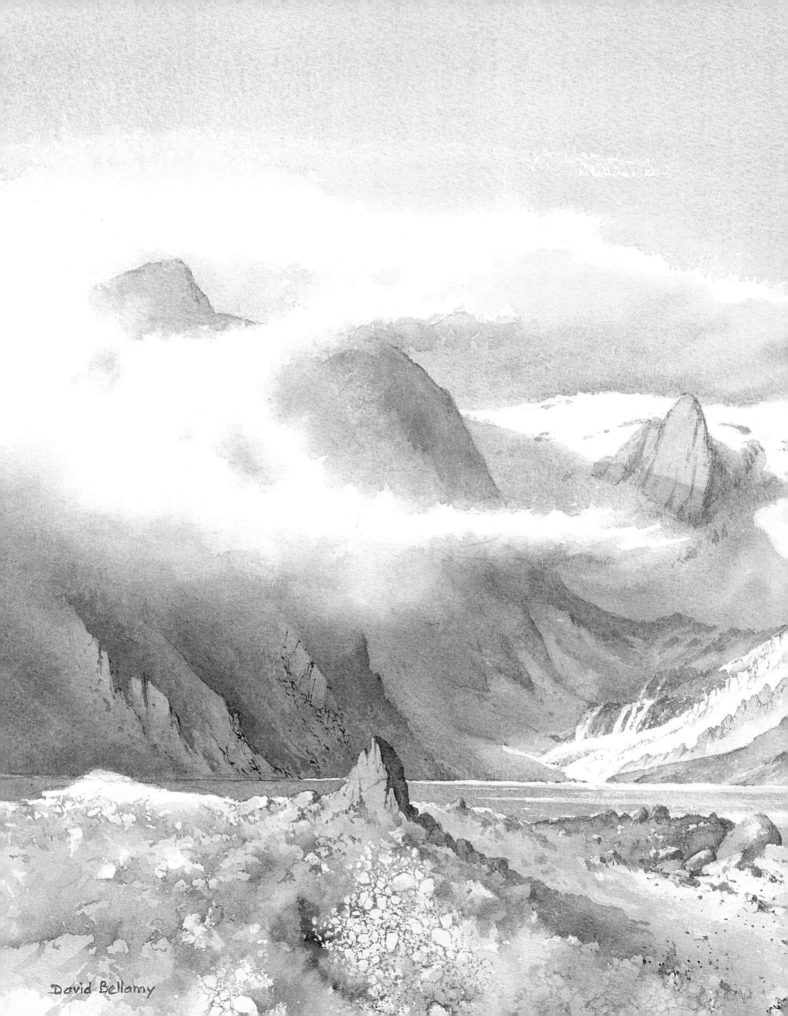
David Bellamy

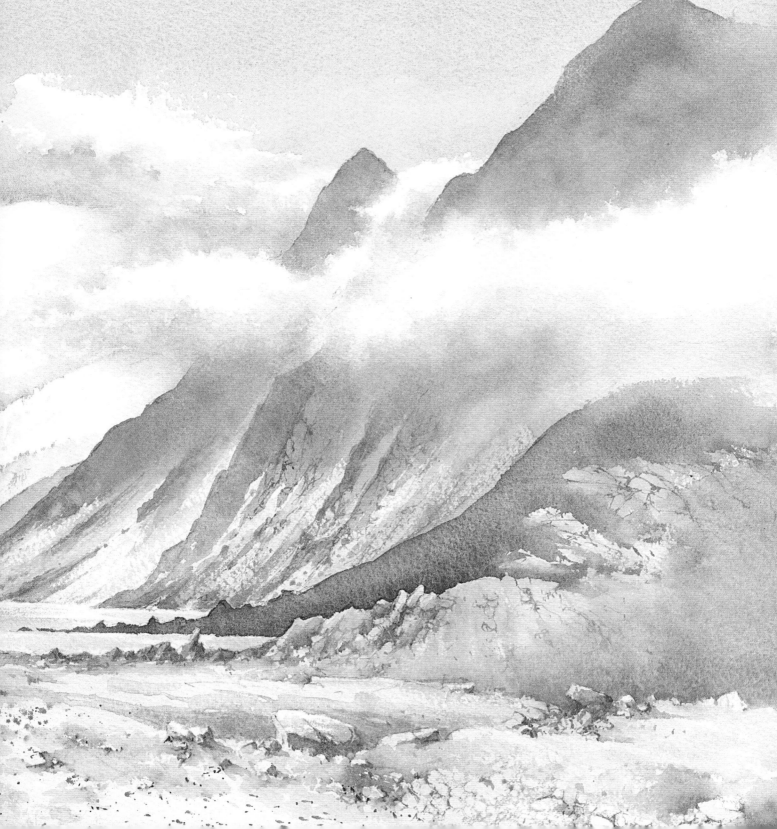

HEAD OF TASERMIUT FJORD
Here the ice cap drops down to sea level. The mountains are around 2000m (1¼ miles) high, which as the ice cap here is almost as high, gives a graphic indication of the thickness of the ice cap. Further inland, it reaches depths in excess of 3km (around 2 miles).

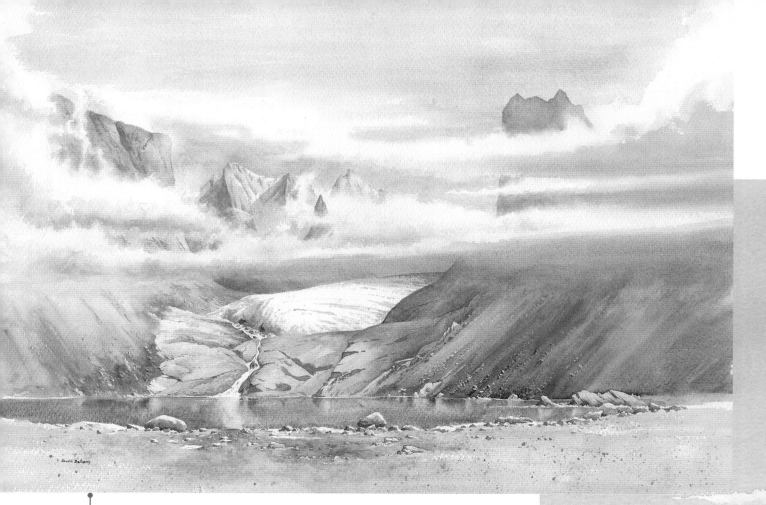

STREAMING CLOUDS OVER SERMITSIAQ GLACIER
The scale here is vast: the background peaks are over 6km (3¾ miles) away.

Our problem now was beaching the boat. A pleasant rock-strewn shoreline lay before us, with a low cliff of rock, earth and vegetation rising above it. In order to reach the beach, we had to cross a wide sandbank that was exposed by the outgoing tide; which was easier said than done. The boat grounded on the sandbank and I jumped out, having removed my boots and socks. The fjord water was icy, so I lost no time in wading onto the sand and hauling on the rope, a feat which brought the boat only a fraction closer to the shore. Torben handed me one of the spare fuel containers, which was heavy enough to anchor the boat in placid waters, so I tied it on and we offloaded all the expedition gear to lighten the craft. All this was then carried across the sandbank to the beach, before we hauled the boat a little closer. It was hard work, but at least it warmed us up. Little by little, we brought the boat up to the beach, but it took ages.

I sat and sketched, then with the help of the incoming tide, hauled the boat a little closer to the shore until finally it was well secured to the rocks. We heaved our gear up the cliff, including all twenty-four toilet rolls, and set up the tents in a pleasant green meadow overlooking the fjord. All around, shapely peaks presented many painting subjects. Nearby was a natural garden of wildflowers including colourful splashes of Arctic harebell, *campanula uniflora* and rosebay or *niviarsiaq*, the Greenlandic name for the national flower.

Before the day was done, we took a walk to check out our immediate surroundings. The view up the Kalkdalen Valley looked enticing, but was choked with those dreaded, dense willow bushes. After a delicious meal in the evening sunshine, Torben settled down in his tent with his toilet rolls while I brought my journal and sketchbook up to date.

KETIL AND KLOSTERDALEN

The sheer wall of Ketil presents a great challenge for climbers, and although it is world-renowned, very few make it here.

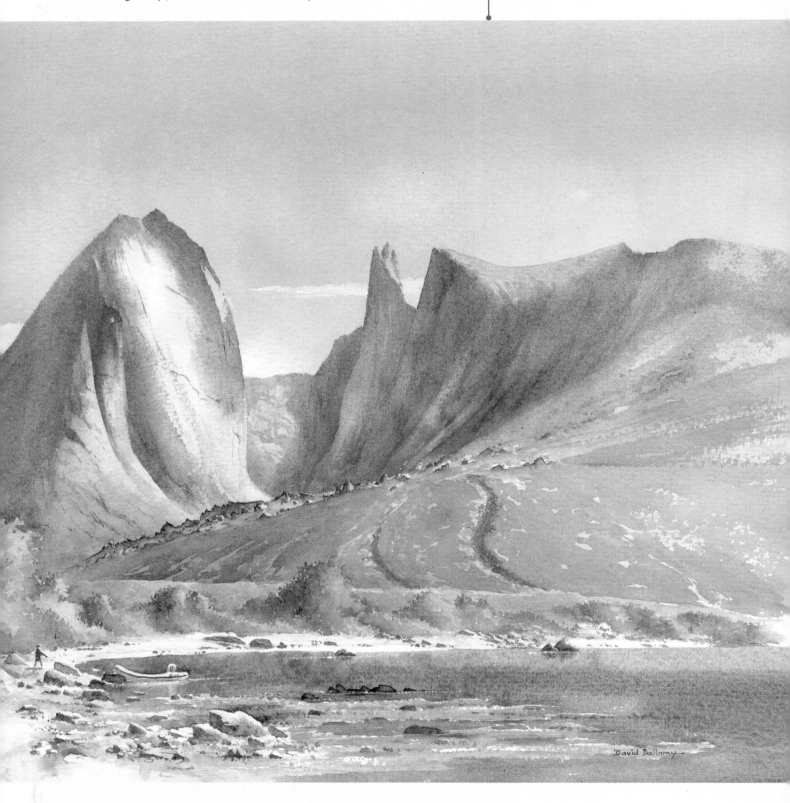

David Bellamy

149

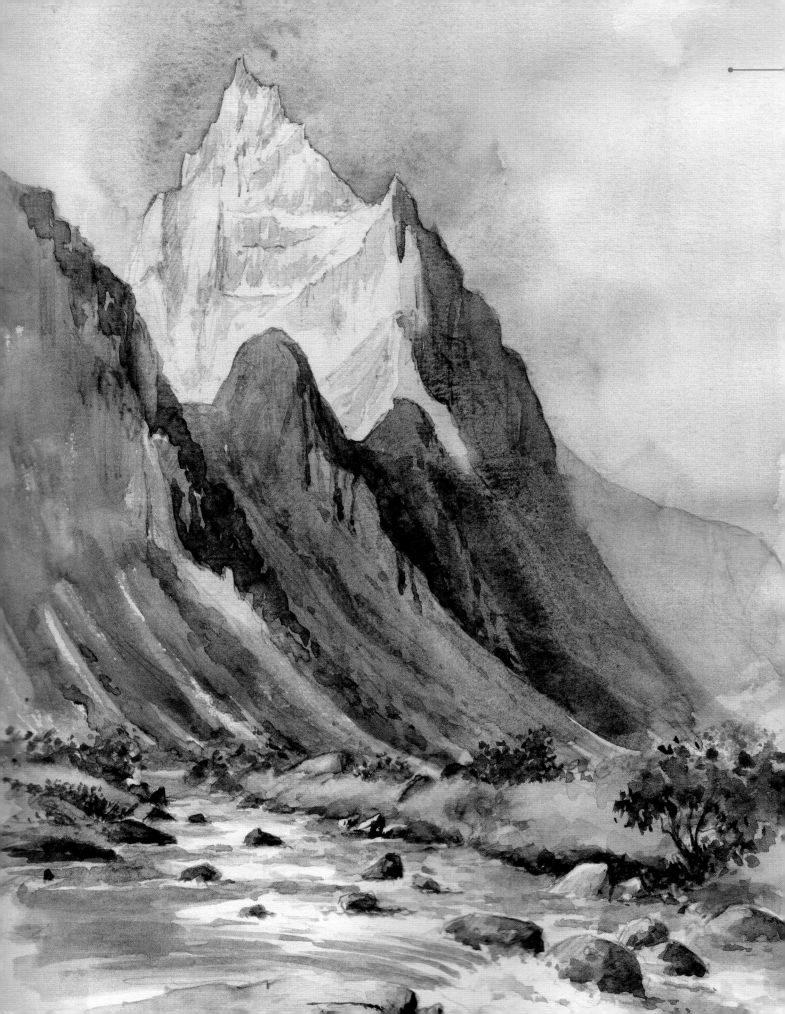

EVENING GLOW ON THE KLOSTERDALEN PEAKS

In the morning gloom, the peaks were hidden in low cloud, which had a level base at around 122m (400ft). We needed to get away early, before the tide receded and left the boat stranded. Our objective today was the Sermitsiaq Glacier not far from the head of the fjord, and to sketch the ice cap where it drops into the fjord. This was clearly visible from our campsite in fine weather, and as it dwarfs the mountains which rise to around 1829m (6000ft), it gave us a graphic idea of the thickness of the ice.

Leaving the tents, we quickly got the Zodiac moving. I managed to push off and leap in without getting wet, and as we congratulated ourselves on a perfect launch, I realised I had left my camera on the beach. Back we went. I took my boots and socks off, rolled up my trousers jumped into the icy water. In seconds I recovered the camera, gave the boat a shove and leaped in. As soon as my socks and boots were back on, it was clear we were going nowhere. The boat was firmly grounded. Off came my boots and socks again and once more I jumped into the water and started pushing while Torben shook with laughter. Eventually the boat was far enough out, so before I was out of my depth, I leaped in, and this time we were away. I was left reflecting on our not-quite-so-magnificent start.

GLISTENING ICEBERG IN TASERMIUT FJORD

Because this is actually two icebergs close together, the profile changes considerably when it is viewed from different angles and distances.

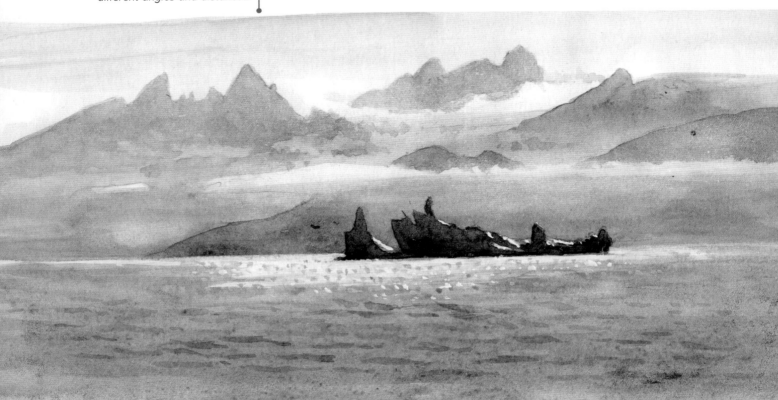

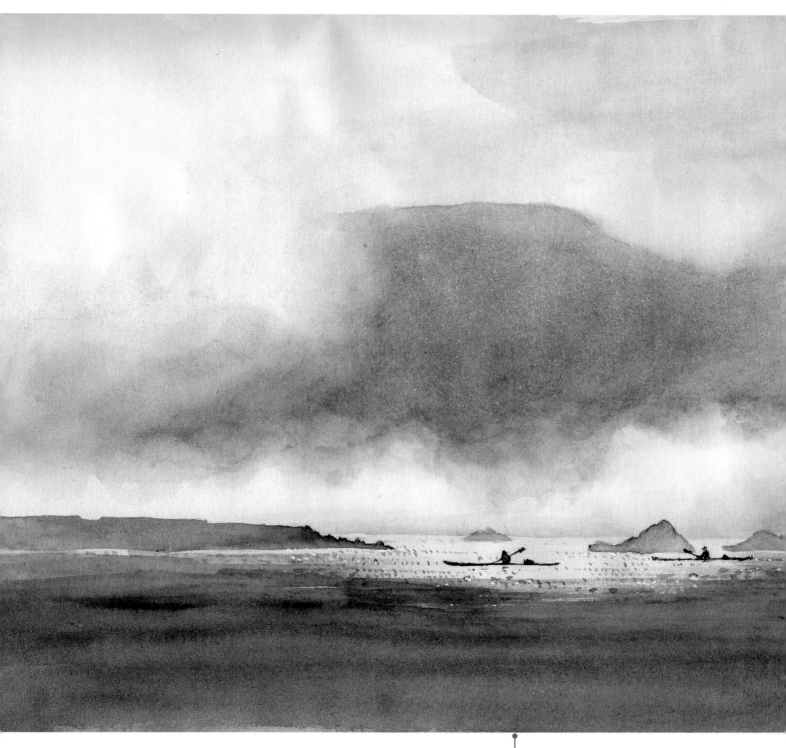

KAYAKS IN THE MIST

It took over an hour to draw level with the glacier. We caught only glimpses of it through the low cloud as we took the boat right up to some large rocks in deep water. I hopped out to haul in the boat and secure it to a rock. Hiking across an arid wildscape of glacial moraine, we headed towards the glacier. To our right, a series of roaring waterfalls demanded a sketch, then we continued until we reached a grey-green lake fed by the glacier. The cloud started to rise and sunshine broke through the gaps,

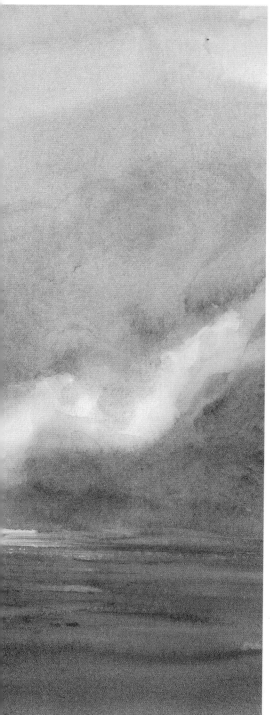

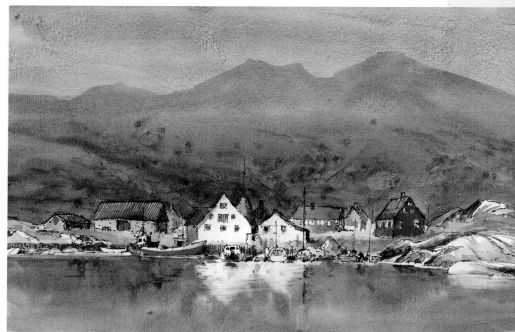

OLD COLONIAL HARBOUR, NANORTALIK

The old buildings now form part of a superb museum and I sat on the rough jumble of rocks that form the harbour wall, entranced by this scene. After a while a chap on a bicycle turned up. To my surprise, he left his bike at the end of the rugged wall and made his way towards me. There could be no other reason for his approach as there was nowhere else to go. It turned out that he had heard about my painting – how quickly word spreads round the settlements – and he invited us home for afternoon tea.

hinting at a spectacular scene about to unfold. I brewed a coffee and wondered why I couldn't get it into my mouth, momentarily forgetting the mosquito net over my head. By the time I had done little vignettes of interesting features on the glacier, it had been revealed in all its glory: a truly sublime and awesome scene. I spent the rest of the morning working on the composition. After a light lunch, we continued sketching, the head of the fjord providing yet another outstanding view.

At teatime, we returned to the boat and set off down-fjord for the campsite, knowing the tide would be perfect for us to sail right up to the beach. Back in camp, we relaxed in the warm sunshine, still clad in our mosquito headnets, as the air was full of the little blighters.

Our days in Klosterdalen were all blessed with sunshine. We tried to explore the valley, but despite many attempts to find a decent route, they all ended up against a massed wall of willows. I attempted to push through this dense jungle, and found myself confronted by a swamp. Gingerly I pushed on, using the willow branches to penetrate further, but it was tough going, with a good prospect of falling into evil-looking stagnant water. I reached the river and stopped to sketch. With miles of swamp and willow ahead, I decided to head back and explore the valley from higher ground. After a couple of false starts, I found myself up

against a sheer 4.5m (14¾ft) cliff. Clearing away some tree debris, I placed my boot on a rocky knob, but as I put my weight on it, the rock crumbled and I crashed to the ground. My second attempt relied on speed and momentum, and oddly enough this worked well. I ended up at the top of the cliff with little more than a graze on my leg. Getting down later on might be a different matter, however.

A grassy stretch opened up the views and I spotted Torben nearby. He had come up the easy, sensible route without the need for the rock gymnastics of my bull-at-a-gate approach.

A little further on, a view of the valley ahead appeared: a magnificent wall of jagged peaks with snow in the couloirs. The rest of the day was spent sketching several views in the vicinity before returning the easy way to camp.

Sunlight cast light spangles on the fjord and we marvelled at the beauty and restorative powers of the unblemished natural world, far away from the tormented continent of Europe.

Opposite

AMMANGUAQ PORTRAIT

Ammanguaq was dressed in traditional Greenlandic costume for the folk dancing and singing in the large school, largely for the benefit of cruise-ship tourists. Unfortunately for the tourists, they arrived in dreadful weather and were clad in the most ridiculous outerwear, including plastic bags and tattered cloaks of Draculean vintage. One Dutchman – or it might have been a woman – wore a sort of giant bumblebee outfit, complete with antennae. A large American lady stood asking a young Inuit girl how she made her yoyo go up and down, in such a foghorn voice that I doubled up with laughter. The question was received with total bemusement.

Continuation

NANORTALIK TOWN

Nanortalik is situated in one of the loveliest spots in Greenland, with a backdrop of spectacular spires and peaks. Our cabin lay on the edge of the bay, with massive white icebergs rearing up beyond the rockline just offshore.

Part of Nanortalik with the peaks island rising in the distance

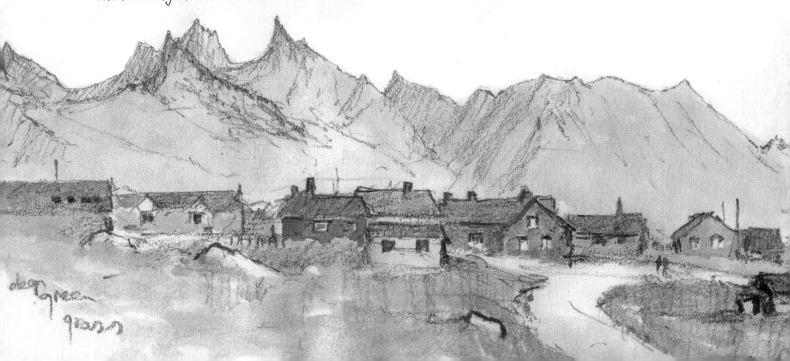

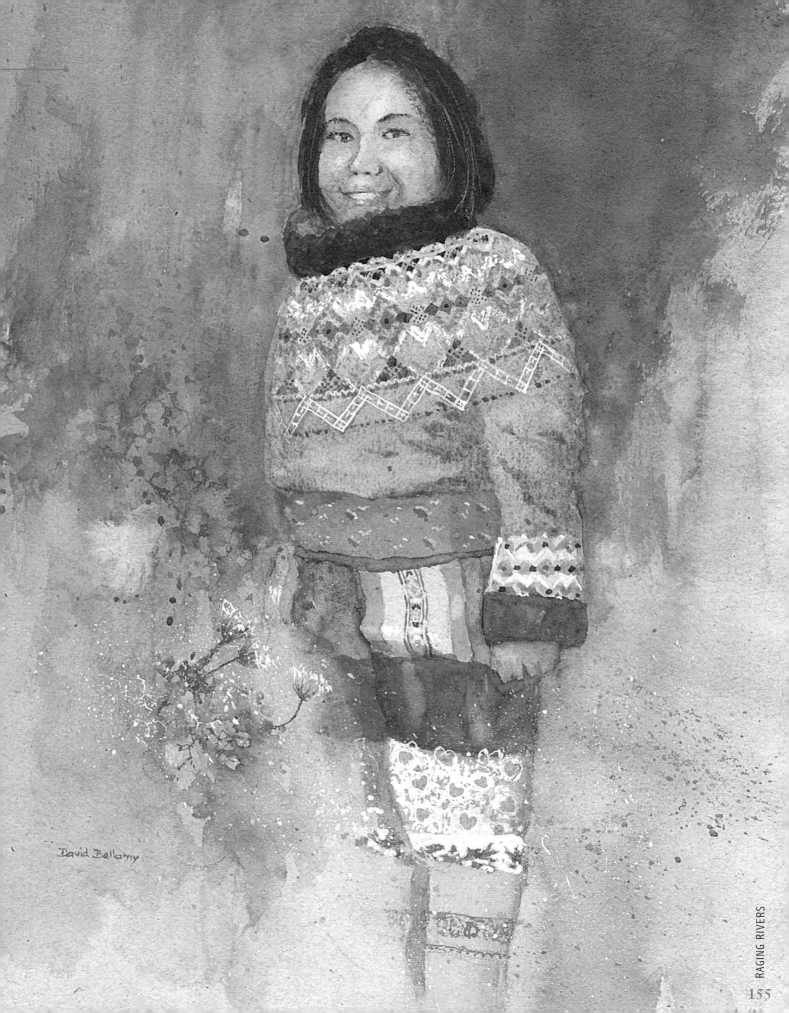

David Bellamy

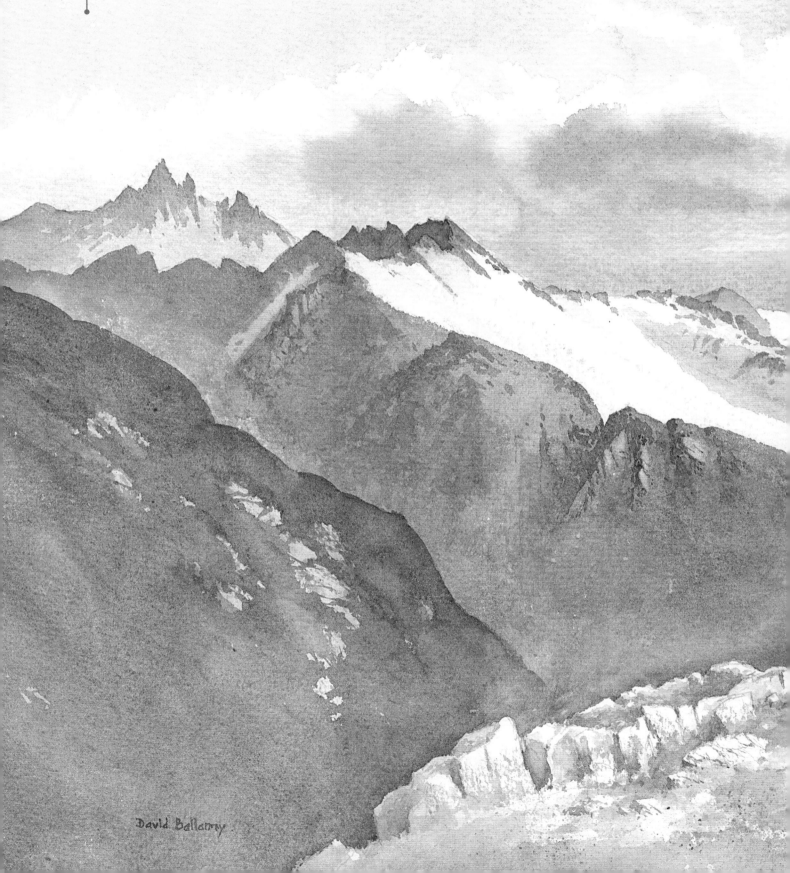

TORSSUQATAQ SPIRES

I sketched this from the top of Qaqqarsuasik. Cape Farewell, the most southerly point of Greenland, lies not far beyond.

David Bellamy

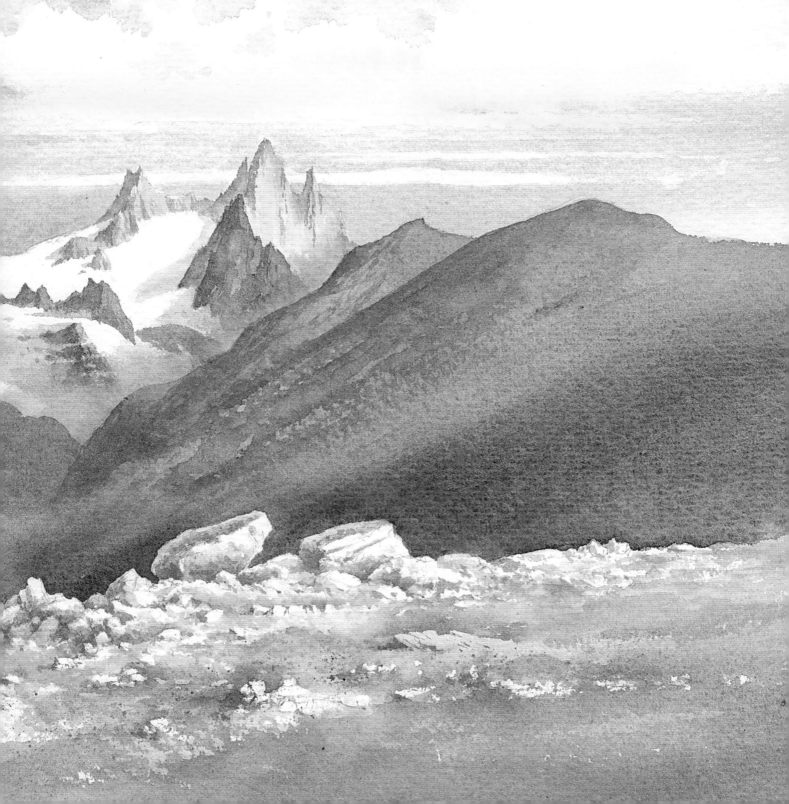

After our stay in Klosterdalen, we prepared to head down the fjord to Tasiusaq. The Zodiac was refuelled from our containers and we loaded up at high tide, then floated gently out into deep water. With no sun, we wrapped up well, but we had no protection from the wind, and the cold bit into us. The cloud base lay at around 91m (300ft), so there were no mountains to sketch and all attention could be given to baling out water. An iceberg showed up in the distance, but it took an hour to reach it, by which time we were chilled to the bone.

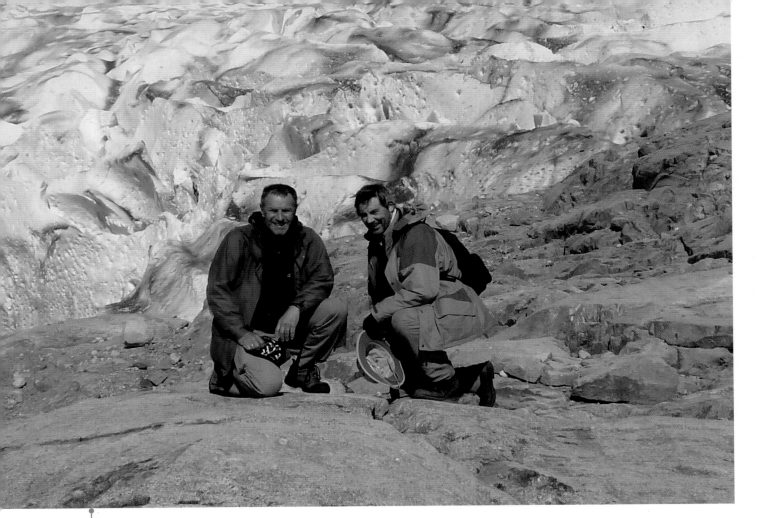

TORBEN WITH THE AUTHOR

It was nearly three hours before we reached Tasiusaq and heaved our frozen bodies onto a rocky shore. The local headman said we could camp anywhere, but with lots of animal droppings and kids playing football, the prospect was not so bright. He suggested we stay in the cabin used as a hostel, and as it was a light-filled building with magnificent views over the fjord towards the mountains, we jumped at the opportunity. It was the perfect retreat for an artist and writer and I recall our days here with particular affection. If we needed a shower, we had to go over to the school, which had only seven pupils!

I spent some time in the Pilersuisoq Store (a Greenlandic chain), pretending to look for things to buy, though in fact I was sketching the faces of the other customers, which caused Torben some amusement. Our days here were spent walking in different directions and sketching in a more relaxed way.

When it was time to leave, we found the outboard motor wouldn't start. Torben checked the fuel. The tank was empty. Someone had pinched the fuel. Luckily we had hauled the spare container to the hostel when we arrived, so we filled up again, and to our relief, the engine started.

We returned to Nanortalik, where the agency was visibly relieved to see their boat back in one piece. Our home for the next few days was a splendid wooden dwelling near the museum. The town was friendly, and a number of people approached us to see our artwork, while a few tourists wandered in, thinking we were part of the mueum exhibits. A local Inuit photographer invited us to his home for tea. He showed us his photographs and then brought us two mugs of tea accompanied by one large raw turnip! I passed the turnip over to Torben, who took a few delicate slices with the knife before returning it to me for my share. It made a pleasant, if bizarre change from cakes and scones and it was only with great effort that we were able to maintain a dignified composure.

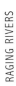

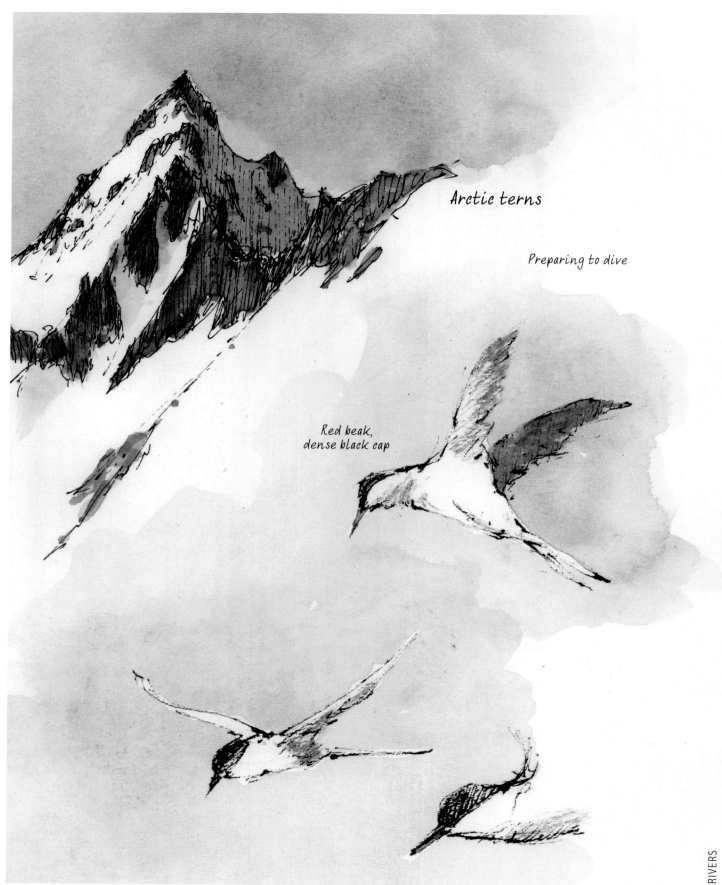

Arctic terns

Preparing to dive

Red beak,
dense black cap

SKETCHING AND PAINTING IN THE ARCTIC

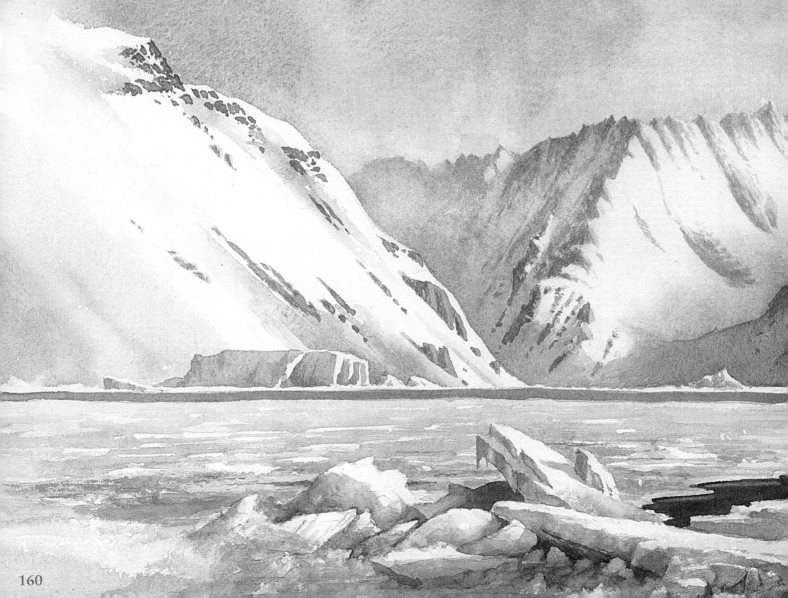

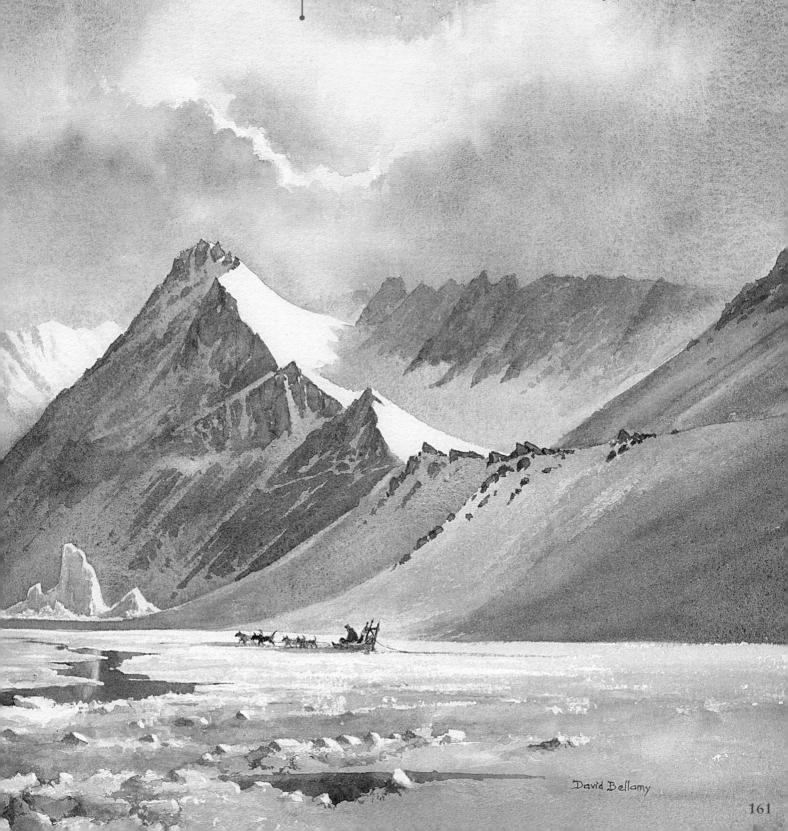

SLEDGING DOWN HORSENS FJORD

The absolutely clear Arctic light illuminated everything in brilliant detail, but to produce an interesting painting, I felt the need to 'fog things up a bit' and introduce a sense of mood. I achieved this by softening off the more distant parts of the mountains and losing much detail on the various faces. The sledge, of course, is the centre of interest and I emphasised the shape and colour of the iceberg just in front of it to support the focus on this area. I also added a dark lead running up to the iceberg.

David Bellamy

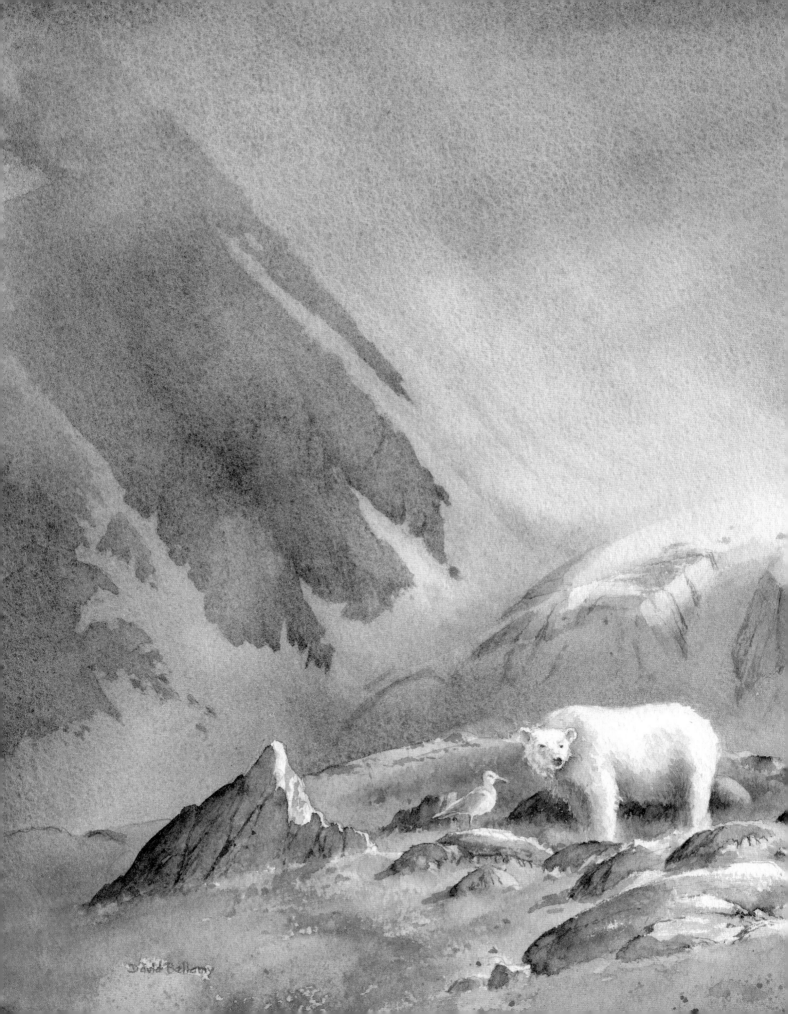

Sketching outdoors has always been a great passion for me, so when I started to take an interest in the Arctic, I relished the prospect of taking my watercolours there. Since the mid-1970s, I had been painting and sketching in the winter mountains, often in extreme conditions, so the Polar regions would push the challenge up a few notches. Years of working in less than ideal conditions had taught me how to cope with rain, blizzards, strong winds, intense desert heat, and the many distractions that can hamper the outdoors artist, and I was used to working below zero, but the Arctic could be far more demanding. Wet brushes instantly froze, their points as hard as spear points, so I stuck them into my armpits to thaw them out while I used another, but this was a pretty hopeless remedy. The practice of using gin, with its low freezing point, in the painting water had been with me since the early days, but in exceptionally cold conditions, even this had its limitations.

The Arctic has always imposed severe restrictions on the artist. A great many explorer-artists visited the region during the golden era of Arctic exploration, before the days of the camera. Many were officers and ratings in the Royal Navy who were trained in draughtsmanship in the military academies, but there were also civilian professional artists. They not only surveyed coastlines, but brought home sketches of landscapes, local inhabitants, wildlife, events and many other features. In Denmark, the emphasis was on

ARCTIC NATTER
Both bird and beast stood in this position for a while. Although they seemed to be close and perhaps holding a conversation, they were quite some distance apart and the gull was wary.

civilian practitioners rather than the Navy. Normal methods were to draw in pencil from the subject and colour in later inside the ship or base, having made notes on the colours or relying on memory. In the late 19th century, Dr Edward Moss, a surgeon with the Royal Navy, would sketch the image in pencil, wearing two pairs of worsted mittens, and then dive down below deck to apply colour by candlelight. Every now and then he would make trips up above deck to check the colours.

Why sketch at all, people ask, as surely cameras are more accurate and faster? Photography is certainly a tremendous aid to the artist, especially the wildlife practitioner, but you see and learn so much more when spending even a few minutes sketching a subject. Any problems in the composition, such as various features in alignment creating a strange coincidental line, can be sorted out on the spot rather than creating a puzzle back home when you have only a photograph to rely on. Also, I find that cameras lose subtle tones and colours, which in ice, snow and the sky can be critical. Seeking out colours in the landscape is not always easy, but I find it even harder to record them in a photograph of the same scene, and this is particularly relevant in the Arctic on days of flat lighting. With moving wildlife, a photograph can give a wooden or unnatural effect, while with practice, sketching moving animals produces some really dynamic results.

POLAR BEAR STUDIES

I drew these pencil studies in Fuglefjorden, adding a little colour afterwards. Some worked reasonably well, some didn't. The important thing is to keep sketching and ignore mistakes or drawings that are unfinished because the animal turned away.

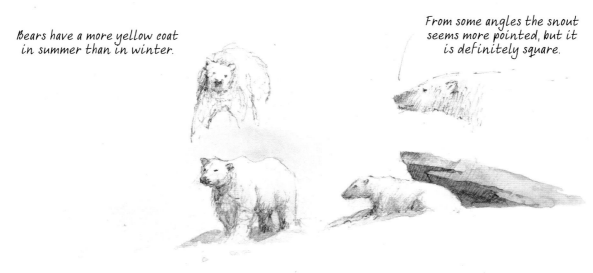

Bears have a more yellow coat in summer than in winter.

From some angles the snout seems more pointed, but it is definitely square.

The position of the eye is critical.

Wary gull.

Fur texture is more pronounced when wet, with profile edges harder.

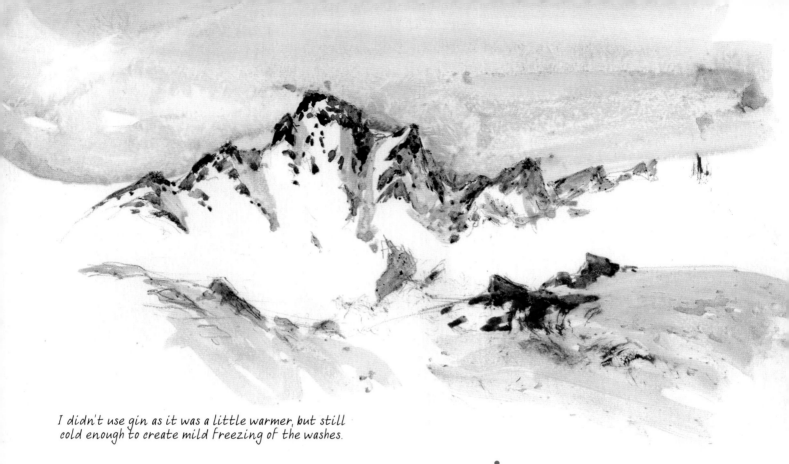

I didn't use gin as it was a little warmer, but still cold enough to create mild freezing of the washes.

MATERIALS AND EQUIPMENT FOR COLD CONDITIONS

As I have mentioned in the previous chapters, colour is so often a critical element in a sketch where subtleties exist, whether you are capturing the intense cold of an Arctic sky or sea, the warmth of evening light on an iceberg, or the myriad subtle colours in an ice formation – so working with an ordinary pencil is not always efficacious.

In the battle against the cold, the first consideration is preparation. On an expedition of this nature, the organisation and choice of materials and equipment needs careful planning. I carry a fast-response sketching kit in a waist bag which is instantly accessible – vital if I need to work quickly because of intense cold or an approaching storm. It contains an A5 hardback sketchbook, pencils, brushes, pens, a small box of twelve watercolour half-pans, clips and elastic bands to secure pages while sketching, and a water pot. In really cold conditions, I keep this pot in a gloved hand while sketching so that the warmth of my hand will help keep the water from freezing. I also carry one or two synthetic water brushes, which have hollow plastic handles that are unscrewed and filled with water: once you remove the cap from the brush end and squeeze the handle, water will flow through the plastic brush filaments. Adding gin or vodka naturally helps in extremely cold conditions. These are excellent for rapid work in the Arctic as the hand is again warming the water inside the handle, although the actual brushes are not as good as proper sable brushes, and are unsuitable for broad washes of watercolour.

PEAK ON THE YMERS BJERG RANGE

In this watercolour sketch, done on the spot, the almost instant icing up of the watercolour washes is apparent. While the initial sky wash worked fairly well, things deteriorated as the cold took hold. The intense blue splotches are a result of the solidifying of the colour due to freezing, at which point the brush became useless.

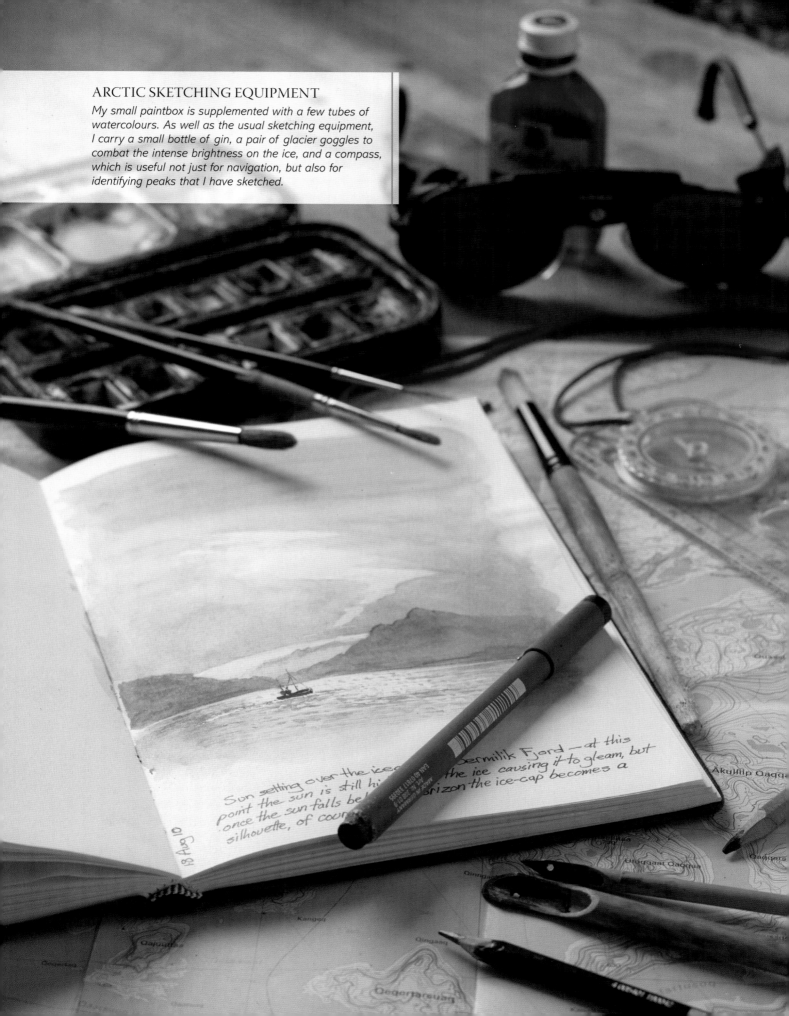

ARCTIC SKETCHING EQUIPMENT

My small paintbox is supplemented with a few tubes of watercolours. As well as the usual sketching equipment, I carry a small bottle of gin, a pair of glacier goggles to combat the intense brightness on the ice, and a compass, which is useful not just for navigation, but also for identifying peaks that I have sketched.

Sun setting over the ice... Sermilik Fjord — at this point the sun is still h... the ice causing it to gleam, but once the sun falls be... rizon the ice-cap becomes a silhouette, of cour...

18 Aug 10

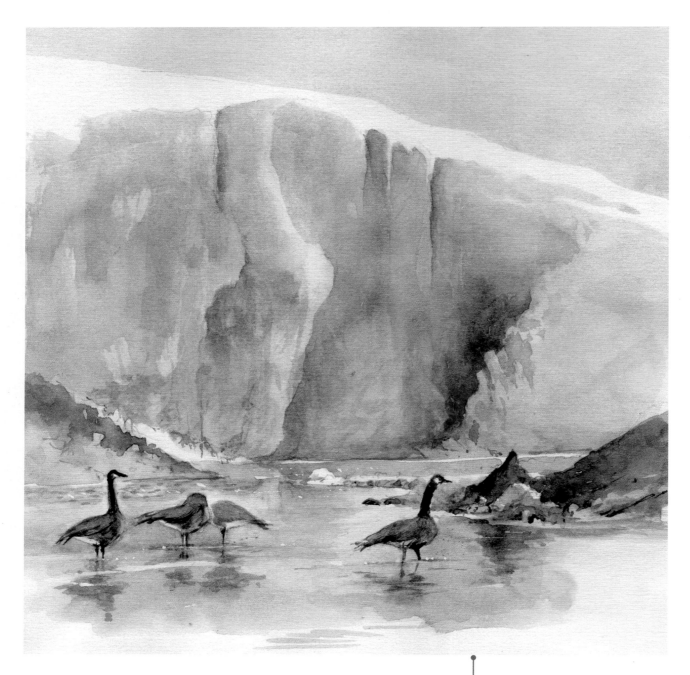

In addition to the waist bag, I keep large sketchbooks and loose paper in my rucksack, together with a second set of brushes and pencils, including a generous selection of watercolour pencils, spare tubes of my favourite colours, plus a square of closed-cell foam for sitting on. Should a brush case slide into a crevasse, at least I have spares. A homemade card folder containing a variety of papers, all secured with fine cord, is ideal for painting various types of scenes, where, for example, I might need smooth paper for fine detail or rough paper for strong textures. Most of them are excellent Saunders Waterford papers, which have the added advantage of being robust and reliable in rough conditions. I also include some tinted watercolour paper.

MORNING BREAK

Canada geese pause in a glacial pool in Israndsdalen for a break in their long flight south at the end of summer. In this watercolour sketch I rendered the detail of the birds with the help of binoculars, initially working in pencil. They remained for ages, moving round but allowing me to add colour almost at leisure with a fine brush. Background information was added after they moved on.

For Arctic use, I tend to increase the number of different blues I take along, and I include the obligatory bottle of gin. A neoprene pencil case dangles by a lanyard inside my fleece jacket. In it I put my brushes, water brushes and pencils – the water inside the water brushes benefits from body heat, so it is ready for action even if it does not survive in liquid form for long once out in the open. I stuff my pockets with stumps of pencils – useful for a rapid response. Also, I lose many pencils on expedition, and it's better to lose a small one.

For the alfresco artist, watercolour pencils are a real boon. One of my sketching techniques involves beginning with a fluid wash of colour across the paper, then immediately drawing into it with a dark watercolour pencil. This method allows me to work happily in falling rain or snow, as the image remains even if most of the colour washes off. It also speeds up my sketching, as I don't have to wait for washes to dry, whether it is raining or not. Occasionally I colour in passages with

SHOPPER IN NARSAQ PILERSUISOQ

The flattish profile of this lady's face fascinated me, and skulking behind the tinned sardines and rifle ammunition in the local supermarket, I managed a rapid outline in pencil, filling in most of the tone later.

LOOKING DOWN BRANDSGIL, ICELAND

In wild weather, I chose to carry out this sketch using a water-soluble graphite pencil on cartridge paper, as this works well in wet conditions. The darker streaks were caused by the pencil running through the occasional rain spots. Several colour notes are included, the 'I Rd' meaning Indian red.

SKETCHING AND PAINTING IN THE ARCTIC

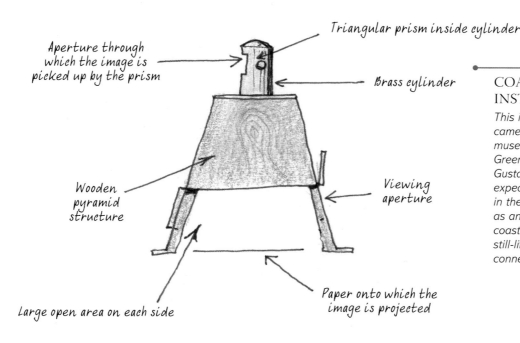

Aperture through which the image is picked up by the prism

Triangular prism inside cylinder

Brass cylinder

Wooden pyramid structure

Viewing aperture

Large open area on each side

Paper onto which the image is projected

Coast recording instrument made by Cornelius Knudsen and used by Gustav Holm c. 1884 in East Greenland

COAST RECORDING INSTRUMENT

This instrument, a type of camera lucida, stands in a museum in Narsaq, South Greenland. It was used by Gustav Holm during his expedition to East Greenland in the late 19th century as an aid to drawing the coastline. I enjoy carrying out still-life drawings of artefacts connected to expeditions.

watercolour pencils, then lay washes of clean water across the paper, turning the pencil colour into watercolour, and often blending colours into each other. This is an extremely useful technique in the Arctic when working in below-zero temperatures. I lay on the dry pencil colours, in places overlaying colours, and apply washes of water later in the tent or cabin. The second, and much cruder method is to lay on the pencil colours and then pick up a handful of snow to rub across the sketch. This system is only effective where you have little detail, although even this can be overcome if you don't mind the colours overlapping passages where they should not appear. You can then superimpose the detail with an ordinary pencil or pen.

Another useful tool is the water-soluble graphite pencil. It is just like an ordinary pencil, only once you have laid on some tone with it, you can brush over it with water to create wash-like effects. It is especially effective where you wish to inject atmosphere into a work. With these monochrome sketches, I add notes about colours and other important points. I also photograph subjects from several angles. Subjects range from wide panoramas to more intimate scenes such as a still life of a piece of hunter's equipment, a portrait or wildlife.

SKETCHING WILDLIFE

There is nothing quite like capturing images of wildlife in its natural environment. For wildlife and distant objects, I use either a spotter scope or a pair of binoculars mounted on a tripod, although on occasion polar bears, musk ox, walruses and Arctic foxes are so close that I dispense with optical enhancement. The walrus is a formidable poseur, as it stays in the same position for ages, then moves into a completely different pose, where again it remains until perhaps it feels you have achieved a suitable likeness in your sketch. Not so the Arctic fox, which hardly stops in its chaotic meandering gambols, but every now and again it will pause and gaze at you quizzically – rarely long enough to get down more than three or four pencil strokes. The musk ox is less predictable, and if you are so unwary as to make your presence known, it will either stare you out or charge, though they have been known to take flight. At such times I keep all my art materials and camera well secured for a quick getaway.

Although I do not regard myself as a wildlife artist, the creatures of the wild have always fascinated me and often they find me rather than the other way round. Many a time when I am quietly sketching,

some creature will come along and I will include it in the landscape. Many wild landscapes are devoid of a lot of detail, and so it can help enormously to include some form of wildlife – even if only in the distance – or perhaps a few V-shaped gulls. Many Arctic scenes are greatly enhanced by the inclusion of a bird or two, and these days I tend to make them more prominent in the work. Painting in a fulmar, for example, with its wing dipping down to break up the horizon line, is an effective device, as well as bringing life into a painting. Birds in flight, of course, can be notoriously difficult to draw, but with experience and practice, it can be mastered. Whenever I have observed the Arctic skua, I notice that the best time to sketch it in flight is directly after it takes off, as it lumbers along fairly slowly at that point.

Normally, sketching is a truly relaxing experience, but for much of the time in the Arctic, you need to be aware of polar bears. They can smell humans from 32km (20 miles) away, and are adept at sneaking up on prey to catch it unawares. The artist is normally totally engrossed in the subject, so it is easy to forget about the bear menace. Many a time I have suddenly realised that I have had my guard down for quite a while.

INQUISITIVE MUSK OX

I returned this stare with a vengeance, trying to keep the beast gazing at me while I rapidly captured the detail, concentrating on the enormous head, with only a suggestion of the body. Later I tightened up the horns and added spatter.

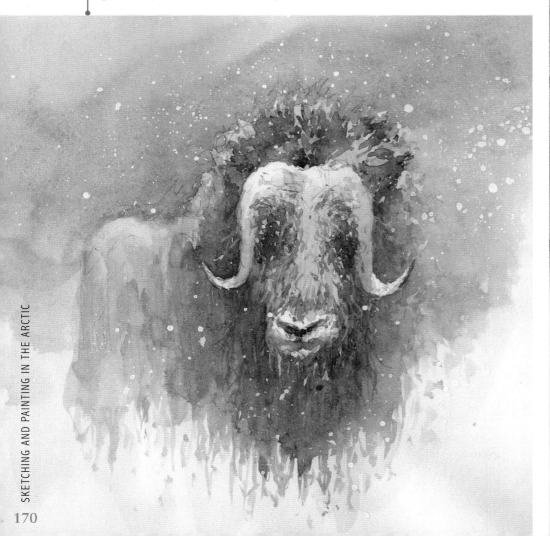

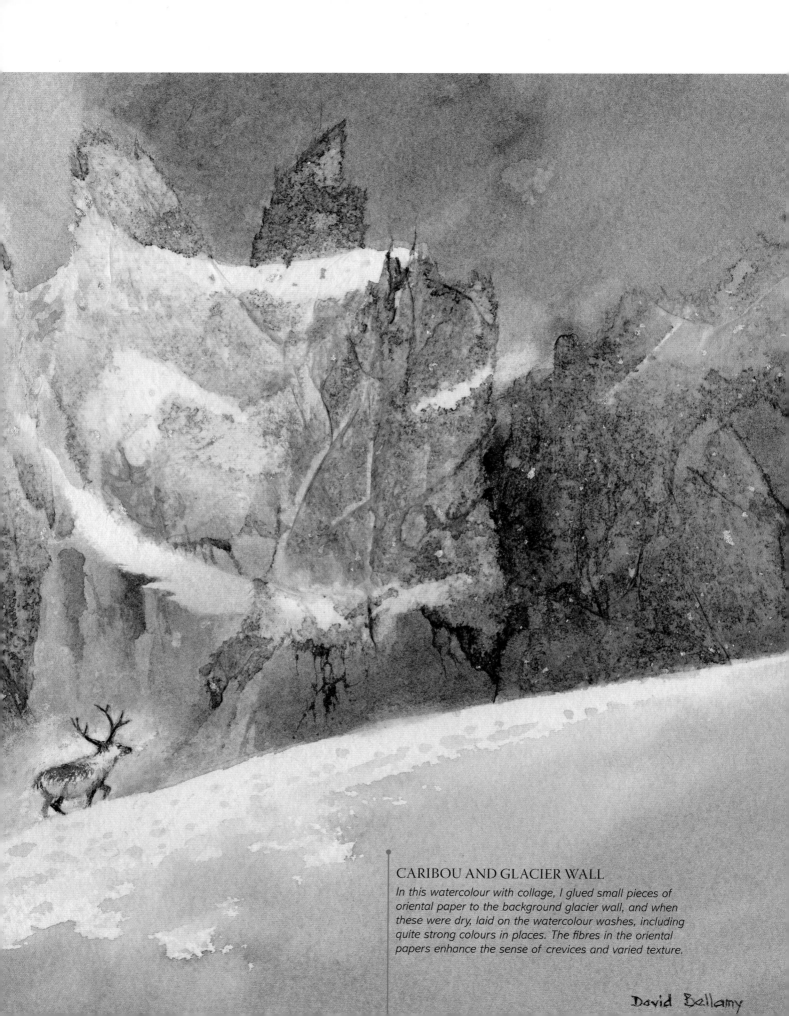

CARIBOU AND GLACIER WALL

*In this watercolour with collage, I glued small pieces of
oriental paper to the background glacier wall, and when
these were dry, laid on the watercolour washes, including
quite strong colours in places. The fibres in the oriental
papers enhance the sense of crevices and varied texture.*

David Bellamy

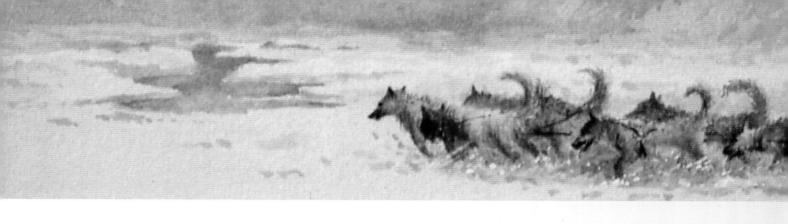

SKETCHING ON THE MOVE

In the clear air of the Arctic, you can usually see great distances, so it is quite possible to sketch on the move while you progress slowly along on a dog-sledge. Apart from really close features, the scenery isn't changing that quickly, and for much of the time the going is smooth – almost soporific at times. I make full use of these moments to work mainly in pencil, at times instructing the sledge driver to move slightly to one side or the other, or to maintain a certain position vis-à-vis another sledge so that I can sketch it in motion. Such sketches often need a bit of tidying up later, but they can give true spontaneity, with a real feel for the expedition.

At the opposite end of the scale are those moments when I need to anchor myself in a position where the exposure is so great that there's a danger of me sliding off down an icy abyss. For this, I place an ice screw into the solid ice and attach a 1.21m (4ft) sling, which I loop round me. I secure the more valuable bits of equipment to it with karabiners and a small cargo net.

Over the years I have enjoyed enormously the thrill one can get from sketching in a wild storm or blizzard, trying to capture the super-charged atmosphere of the moment. Arctic storms are a completely different ball game, though. The sudden and utterly savage ferocity of a violent Arctic storm can leave you stunned and gasping at the drop in temperature and the your consequent inability to control your hand movements as your art equipment disappears under swirling snow and your subject is obscured by a white maelstrom. I wear thin gloves inside outer mitts, taking off the right-hand one to sketch, but in really cold weather, this is impossible for long. Padded down jackets with many layers of thermal underwear are essential even on good days in the winter Arctic, and a warm hat (or three) is vital. Neutral-tinted sunglasses or goggles are another essential piece of equipment.

Sketching in such raw conditions is not for everyone. In the winter Arctic, Torben commented, 'Few people realise the incredible efforts and organisation we need to take off a glove, extract the art materials and then do the sketch in such hostile conditions – especially when using watercolour!' However, returning home with several sketchbooks full of exciting new work is so gratifying, even if over half of it is a complete mess. With so many overwhelmingly spectacular Arctic scenes, many of which lie well beyond our past experiences and imagination, we artists are hard-pressed to render such outstanding beauty, but if we get just a few right, we will have achieved something worthwhile.

Photograph by Torben Sorensen

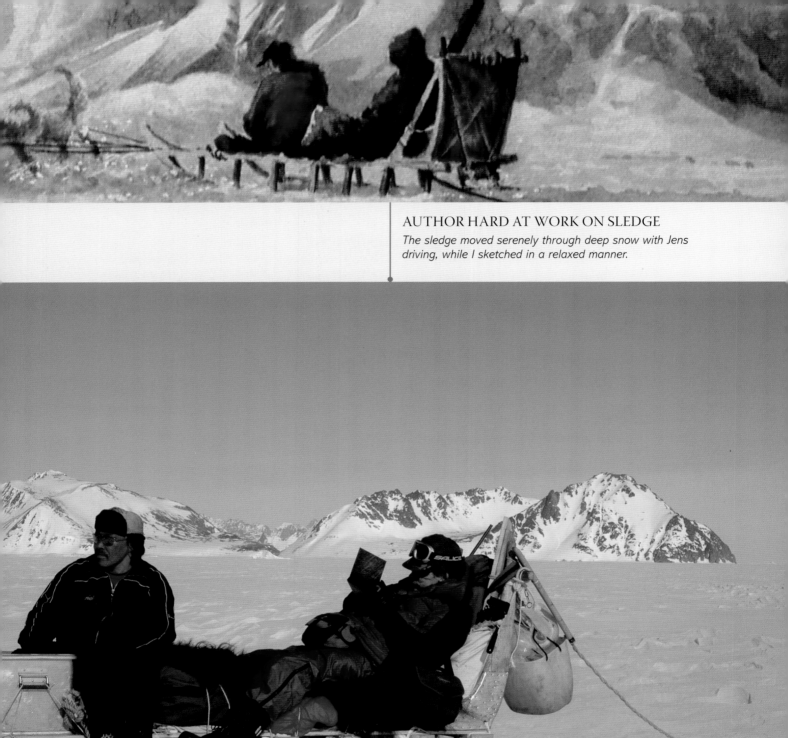

AUTHOR HARD AT WORK ON SLEDGE
The sledge moved serenely through deep snow with Jens driving, while I sketched in a relaxed manner.

Glossary

Belay A climbing term: to attach and secure a rope so that if a climber falls, his or her fall will be arrested.

Bog cotton (*Eriophorum angustifolium*) A flowering plant in the sedge family which grows in temperate, subarctic and Arctic regions.

Braided stream A stream made up of small, shallow channels that divide and recombine, making a braid-like pattern. This happens when sediment forms islands or bars between the channels.

Cairn A pile of stones set up as a landmark or monument.

Calving The breaking away of a mass of ice from a glacier, usually caused by the glacier expanding.

Col The lowest point on a mountain ridge between two peaks.

Corrie A round hollow in the side of a hill or mountain.

Crevasse A deep open crack in a glacier or other body of ice.

Drift ice Sea ice that moves because of wind or currents.

Fjord An inlet of the sea. These are usually narrow and hemmed in by high cliffs, but there are exceptions, such as Hurry Fjord (see the Into the Icy Wastes chapter, page 58), which is wide and has no high cliffs.

Fumarole An opening in the ground, usually in a volcanic area,which emits steam and gases.

Glacier A slowly moving mass or river of ice made by compacted snow on mountains or near the earth's poles.

Glacier snout The end of a glacier at any given point in time, also known as a terminus or toe.

Growler A small iceberg or ice floe just large enough to be a danger to boats.

Ice-axe arrest A mountaineering technique: a falling climber stops the fall by digging in an ice axe.

Ice floe A relatively flat piece of sea ice, 20m (66ft) or more across.

Isthmus A narrow strip of land with water on both sides, connecting two larger bodies of land.

Katabatic wind A wind that carries high-density air from higher up, down a slope under the force of gravity. These winds can move at hurricane speed.

Lead A long area of open water that develops when sea ice pulls apart.

Meltwater spate A sudden flood resulting from the melting of snow and ice.

Moraine A mass of rock and sediment debris brought down by a glacier and deposited at its extremity, usually in the form of ridges.

Moulin Also known as a glacier mill, this is a well-like shaft in a glacier or ice sheet down which water falls from the surface.

Polynya A stretch of open water surrounded by ice.

Pulk A sledge without runners, pulled by a person or dog and used to carry equipment and supplies.

Sastrugi Parallel wave-like ridges on the surface of hard snow, caused by winds.

Serac (ice) A block or column of glacial ice.

Spindrift Fine snow blown by the wind.

Tupilak In Greenlandic Inuit tradition, a talisman made from animal or even human remains. It was put in the sea to seek out and destroy an enemy.

Umiak A traditional Inuit open boat made of wood and skin, rowed by women.

Index

Other Books by David Bellamy

978-1-84448-703-5

978-1-84448-677-9

978-1-84448-583-3

Available from www.searchpress.com

DAVID BELLAMY'S
ARCTIC

DEDICATION

To Torben, a great companion whose
humour and enthusiasm unfailingly shine
through in the toughest of trips.

DAVID BELLAMY'S
ARCTIC
LIGHT